MODELING DIGITAL DINOSAURS

MODELING DIGITAL DINOSAURS

KEN BRILLIANT

CHARLES RIVER MEDIA, INC.

Hingham, Massachusetts

Publisher: Jenifer Niles
Production: Paw Print Media
Cover Design: The Printed Image
Cover Image: Ken Brilliant

CHARLES RIVER MEDIA, INC.
20 Downer Avenue, Suite 3
Hingham, Massachusetts 02043
781-740-0400
781-740-8816 (FAX)
info@charlesriver.com
www.charlesriver.com

This book is printed on acid-free paper.

Ken Brilliant. *Modeling Digital Dinosaurs.*
ISBN: 1-58450-209-6

All brand names and product names mentioned in this book are trademarks or service marks of their respective companies. Any omission or misuse (of any kind) of service marks or trademarks should not be regarded as intent to infringe on the property of others. The publisher recognizes and respects all marks used by companies, manufacturers, and developers as a means to distinguish their products.

Library of Congress Cataloging-in-Publication Data

Brilliant, Ken.
 Modeling digital dinosaurs / Ken Brilliant.
 p. cm.
 ISBN 1-58450-209-6
 1. Computer animation. 2. Dinosaurs in art. I. Title.
 TR897.7 .B75 2002
 567.9′0285′66—dc21
 2002005171

Printed in the United States of America
02 7 6 5 4 3 2 First Edition

CHARLES RIVER MEDIA titles are available for site license or bulk purchase by institutions, user groups, corporations, etc. For additional information, please contact the Special Sales Department at 781-740-0400.

Requests for replacement of a defective CD-ROM must be accompanied by the original disc, your mailing address, telephone number, date of purchase and purchase price. Please state the nature of the problem, and send the information to CHARLES RIVER MEDIA, INC., 20 Downer Avenue, Suite 3, Hingham, Massachusetts 02043. CRM's sole obligation to the purchaser is to replace the disc, based on defective materials or faulty workmanship, but not on the operation or functionality of the product.

For Tina and Katie

CONTENTS

ACKNOWLEDGMENTS

Thank you to Jordu Schell and Roger Lakhan for their incomparable friendship and humor.

A special thank you to all the artists who are generous with their knowledge.

PREFACE

Welcome! If you've picked up this book, then you probably have more than a passing interest in dinosaurs and/or computer graphics. Dinosaurs are immensely popular in our culture. They've been capturing the imaginations of scientists, artists, and everybody in between ever since the first fossils were discovered more than 170 years ago. And there's no doubt that the key factor in the staying power of these animals over mythical beasts is that they were once real.

Their fossilized bones are here as proof of their existence, but lacking any additional evidence, man has been compelled to flesh out these creatures with his imagination. Early depictions were done in painting or sculpture. But as technology grew to allow us to express ourselves in different media, we quickly adopted these new tools to bring more life to these ancient beasts. With the invention of the motion picture, dinosaurs could be brought to life in ways never before seen.

Stop-motion pioneer Willis O'Brien worked on numerous short fantasy films in the early part of the twentieth century, and most of these featured animated prehistoric animals. In 1925 the feature film *The Lost World* showed dozens of dinosaurs portrayed realistically, seemingly interacting with humans. Of course, *King Kong* (1933) cemented his work in history with its unsurpassed special effects artistry (it was a pretty good film, too).

Since then, dinosaurs have bounded across the screen in forms from wretched to wonderful. Men in lizard suits became a quick way to portray them, but for a while the most realistic representation had been done using stop-motion animation. Animators such as Ray Harryhausen and Jim Danforth helped raise this medium to the pinnacle of the craft.

In 1993 the stakes were raised with the release of *Jurassic Park.*
The full-body, moving dinosaurs were originally going to be cre-
ated using stop-motion, but ultimately were realized with com-
puter graphics. The results were by far the most lifelike and
convincing depictions of dinosaurs ever brought to celluloid—and
they've changed the way any fantastical creatures would be
brought to the screen since.

That's the big picture. On a more personal level, people of
every age have been bringing dinosaurs to life in many ways. Chil-
dren draw them with crayons and play with dinosaur toys. Per-
haps if the interest stays beyond childhood, more sophisticated
methods will be attempted. You might have built your own stop-
motion models out of clay or wire and latex, and filmed them, one
frame at a time, with an 8 mm camera. Not much can beat the
thrill of getting the film back from the lab, usually days or a week
later, and seeing the results, however crude, come to life.

And until very recently, emulating *Jurassic Park* by animating
dinosaurs digitally has been out of the average person's reach. But
rapid advances in computer technology and software have brought
this magic within the grasp of just about anyone. The hardware
has become faster and cheaper, and the software more abundant
and user friendly. Never before has it been easier to reproduce di-
nosaurs digitally and animate them right on your desktop. No
more waiting for film to come back from the lab only to realize
your thumb was over then lens for half the shot.

WHERE THIS BOOK COMES IN

Perhaps you are anxious to attempt some digital dinosaur model-
ing, but are not sure how to begin. Or maybe you've been doing
some modeling already, but would like to see some different tech-
niques from the ones you are currently using. Building a good 3D
animation model is the first step in bringing it to life, and building
one that facilitates the animation process will make that stage even
easier (and possibly enjoyable).

That is the aim of this book, to expose you to a variety of con-
struction and texturing techniques through the exciting subject
matter of dinosaurs. Each model in this book was chosen to repre-

sent a variety of modeling challenges. As the chapters progress, you will see the modeling become more complex. You certainly do not have to follow them in any order, but if you are just beginning to get into 3D modeling, you might want to start off simply and move to the more complex. As you gain skills, you can then go back and apply those new techniques to your earlier models.

Although the exercises in this book are laid out in a step-by-step manner, usually the construction process involves a bit of trial and error. This is actually an important step in learning. It's crucial to find out for yourself what works, what doesn't, and why. Do not be afraid to experiment with your own techniques once you gain some confidence. In most cases, there is no right or wrong way to build a model as long as the results are good. An arsenal of modeling approaches in your repertoire will give you that many more choices when tackling an assignment.

Lastly, this book was not designed to be software-specific. The tools and techniques described are reproducible in most software packages, from the free to the multi-thousand-dollar variety. Chapter 3 offers suggestions for software to use if you don't currently own any and are unsure of what features are desirable.

If you are ready to get started on the journey to bring a digital dinosaur to life, turn the page.

1

PRE-PRODUCTION FOR BUILDING A DINOSAUR

IN THIS CHAPTER

- Research Trip to Museums and Zoos
- Study Skeletons
- Comparative Anatomy of Modern-Day Animals

Before you sit down in front of the computer, put on your favorite music CD, crack your knuckles, and grab the mouse to make a dinosaur, there needs to be some pre-production work done—namely, research. This really isn't as boring as it sounds.

You probably have a decent impression in your mind of what a tyrannosaurus looks like, but if you just jumped into modeling without any guide work beforehand, you might find the process difficult. The results might also suffer due to a lack of realism. Since the dinosaurs were once real animals, we can design them around their skeletons. That's just the beginning, though. What about the details such as muscles, skin texture, and coloring? How can we determine those? Through the study and observation of modern-day living animals, we can fill in the blanks and assemble the illusion of a living dinosaur.

Don't worry; you don't need to know the name of every bone or every muscle, but the better your understanding of these things, the more you can confidently and convincingly incorporate them into your models. With a solid base of this knowledge, you will then be free to bring your own vision, sensibilities, and style to the work. Your artistry coupled with strong observation of the natural world will make a powerful combination.

SKELETONS

Visions of cool scale patterns, sharp teeth, and whipping tails might be dancing in your head, but first you need to go a bit deeper into the dinosaur, somewhere that won't ever be seen from the outside, at least at first glance. The skeleton is the structure upon which everything else is built. It determines proportion and guides the shapes of the muscles. It affects surface topology in subtle and not-so-subtle ways. To skip the study of the dinosaur skeleton would cause the whole model to suffer. Luckily, it's the aspect that we have most readily available for viewing in this modern world.

There are plenty of reference books with photos or illustrations of the fossilized remains of dinosaur skeletons, but if you can visit a natural history museum, taking a trip to observe them up close is

highly recommended. Nothing can replace the experience of viewing a dinosaur skeleton in person. They take on a totally different feeling than when viewed from a book (as does any natural wonder). Even in their stripped-down form, the sense of scale and power emanates from them. Have you ever stood under a sauropod? It's HUGE; bigger than any living animal you'll see today. Check out an allosaurus. It's not that big, but you'll quickly feel a knot in your stomach imagining one of those chasing after you. These emotions will trigger your imagination in all kinds of ways, much more than a small printed picture. As you work on your 3D models on a 17- to 21-inch monitor, you might want to recall what it was like to stand next to that gargantuan leg bone.

Of course, another reason for viewing the bones in person is the practical research. Bring a camera and take many reference shots, close up and from a distance. Observe teeth, toes, and horns as these might be seen outside the skin. (See Figures 1.1 and 1.2.)

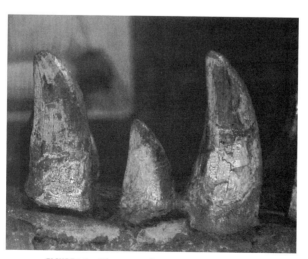

FIGURE 1.1 Close-up of tyrannosaurus teeth.

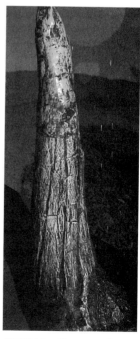

FIGURE 1.2 Close-up of a triceratops horn.

Take note of how the skeleton is built. Does it look light-weight, indicating a fast animal; or does it look heavy, indicating one that is slow and ponderous? Where are the eyes located in the skull? Can you make sense of those cavities and openings? (See Figure 1.3.)

Another useful item to have with you is a sketchpad. Make some sketches while looking at the bones, fleshing out what you think the rest of the animal might have looked like, or make quick studies of the bones and jot notes.

 One word of warning: These skeletons have been under tons of rock and dirt for millions of years. As a result, certain key areas, such as the head, might be a little flattened or squashed. See Figure 1.4 for an example. Take that into account and compare the bones to other reference material.

Also, common to many museums is artwork created by dinosaur experts. Original paintings and sculptures can often be found on display. These can further enlighten and inspire.

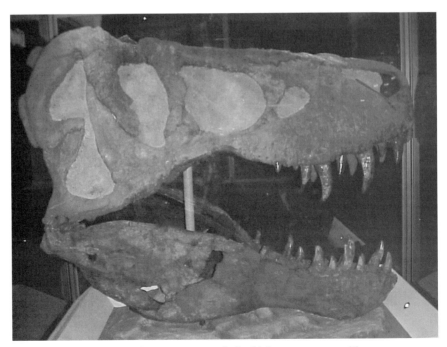

FIGURE 1.3 A tyrannosaurus skull with its numerous cavities.
Where would you place the eyes?

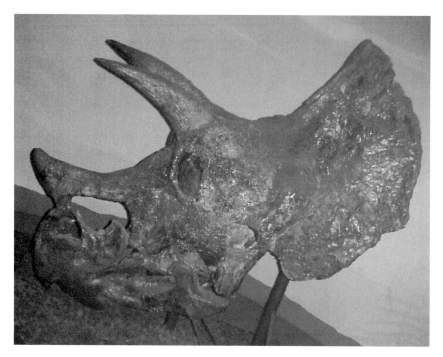

FIGURE 1.4 This triceratops skull looked good from the profile, but was quite flat when viewed head on.

MODERN-DAY ANIMALS AND COMPARATIVE ANATOMY

So you've had your fill of the bones for now. You want to take what you have and think about how it will be fleshed out. The muscles are the next logical step, but how do you figure out where they should be on an animal that's been extinct for millions of years? Paleontologists can determine muscle placement by studying characteristic surface markings, or muscles scars, on the fossilized bones. We don't have to go that far, but you can if you want. Instead, we can apply a little comparative anatomy of modern-day animals and skeletons to those of the dinosaurs.

Amazingly, there are quite a few similarities between animals that existed millions of years ago and animals, even humans, of today. A cursory glance at skeletons will reveal common landmarks such as the rib cage, pelvis, and scapula (shoulder blade). With these guides we can make more educated decisions on where the muscles would be. Thus, you'll have a better understanding of why the leg is

shaped the way it is as opposed to blindly guessing. This knowledge
not only makes the construction process easier and more enjoyable,
but also lends even more believability to the model.

Starting with humans as the reference point, we can find the
same muscles and bones in other non-human animals. Take a look
at a front leg of a dog. Initially it appears to bear little resemblance
to our arm. But if you dig beneath the surface, you'll find all the
same muscles and bones, just in slightly different proportions. This
is easier to see when compared to a person bent over as shown in
Figure 1.5.

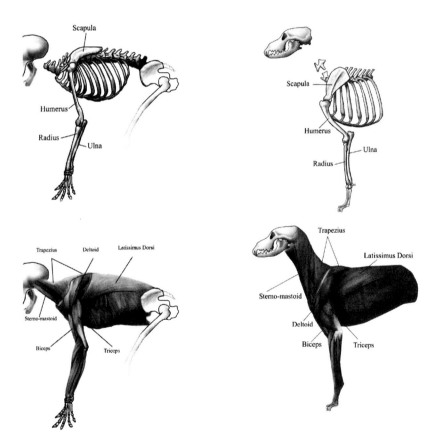

FIGURE 1.5 Portion of a human
skeleton and muscles bent
over for comparative anatomy.

FIGURE 1.6 Portion of a dog skeleton
and muscles.

Notice the scapula. On four-legged animals it is on the side of the body, whereas on humans it is more on the back. But the rest of the arm bones are remarkably similar. Compare the humerus, ulna, and radius. The dog even has "hand" bones, but in a different configuration. (See Figure 1.6.)

We can then look at a similar section of a dinosaur skeleton. For this example we'll use an apatosaurus. By now, you should have some familiarity with the common bones and be able to locate and identify them in the dinosaur. Now it's easier to determine where the muscles would be. (See Figure 1.7.) This comparative anatomy approach can be applied to the rest of the body.

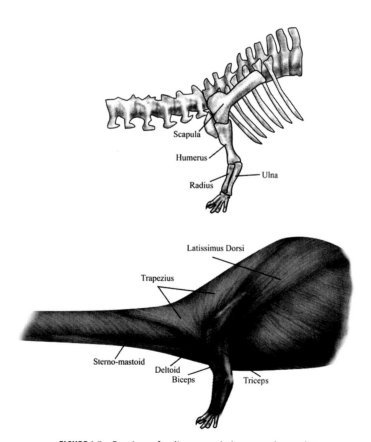

FIGURE 1.7 Portion of a dinosaur skeleton and muscles.

REAL-WORLD OBSERVATION

So far, we've developed some good textbook technical knowledge of animal anatomy. This is useful, but not enough to bring a creation to believable life. We aren't going to model a skinned dinosaur, after all, and really how much of the muscle and bone information reaches the surface? Observing modern living animals in person is perhaps the best way to get a sense of this detail. Just because you know where a muscle is, doesn't mean you should include it in the model.

A trip to the zoo is in order. There you'll find a great variety of animals to study and gain much more information than just watching your dog scratch himself. At a zoo, you'll observe a variety of true-life anatomy moving, flexing, and breathing. You will also see how the surface topology of a gazelle differs from that of an elephant. That may sound like an obviously silly statement, but seriously look at similar areas on each animal's body. Fleet, fast moving animals tend to be leaner and have more muscle definition, while much of this is lost in the heavy skin and folds of the lumbering elephant. When applying your comparative anatomy to the dinosaur, you can then make a decision that better suits the animal. Perhaps the surface anatomy of an apatosaurus will more closely resemble that of an elephant. A smaller, faster predator might have more of that "thin skin" look where much of the muscle detail is visible. Pay attention to similarities as well. For example, most animals have a good deal of skull information visible, even the elephant. (See Figure 1.8.)

As in the museum, bring a camera and even a sketchpad to the zoo. A camera can help you record full-body examples as well as close-ups of skin detail that you might find useful. (See Figures 1.9 and 1.10.)

Use the sketchpad to do quick sketch studies, since most animals are in constant motion—unless they are sleeping. Even if you only manage to sketch a portion of the animal before it moves, it is still useful information. Think of how valuable sketches like those shown in Figure 1.11 might be. Sketches are helpful for getting down weight and gesture. Train your eye to not only reproduce the shapes it sees, but understand what's underneath making those shapes. Try to visualize the animal's bone structure. With

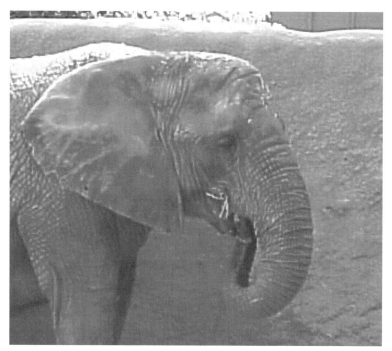

FIGURE 1.8 The skull information is clearly visible on an elephant.

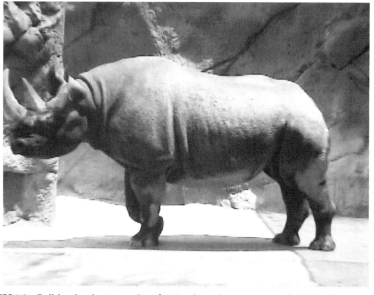

FIGURE 1.9 Full-body photographs of animals at the zoo are useful for body makeup.

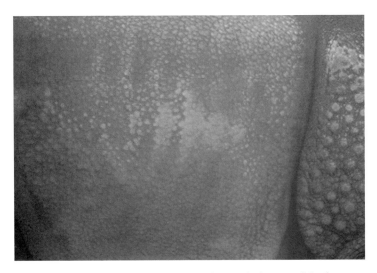

FIGURE 1.10 This close-up of rhinoceros skin might be a useful reference.

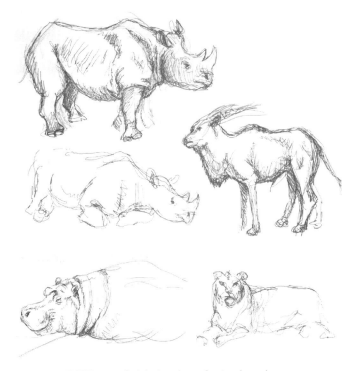

FIGURE 1.11 Quick sketches of animals at the zoo.

study, automatic understanding of these details will click into place.

We can compare the muscles of dinosaurs with those of modern-day animals, but what about the skin? There are fossilized impressions of skin detail from an iguanodon that show the scale pattern (Figure 1.12). This is amazing and useful for the texture, but not color. This area is where the most speculation comes in. But again, we can turn to our modern-day friends for help.

Is the animal a carnivore or an herbivore? Will it need coloring for camouflage from predators or for attracting a mate? Will it use camouflage to help it sneak up on prey? Or will it be so big that it has no natural predators, thus needing no real coloring defenses? Modern-day examples range from zebras to lizards. Skin color is certainly an aspect with which you can experiment boldly and have a great deal of fun.

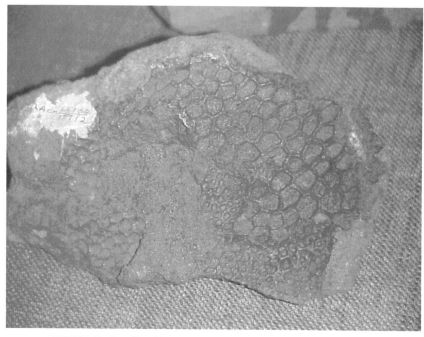

FIGURE 1.12 Fossilized impression of skin detail from an iguanodon.

SUMMARY

Take the proper time to research an animal, especially an extinct one, before attempting to replicate it. This is extremely important if you desire a realistic appearance. The research will benefit the final product and you will be able to build on your skills and knowledge to create any kind of creature, be it real, extinct, or imagined.

The study of nature and anatomy is a lifelong endeavor. Volumes of books are devoted to these subjects, in much more depth than we have time to devote here. Suffice it to say, it would be wise to start building a good reference library. Collect everything from *National Geographic* magazines to hard-core anatomy books. They're all useful and will serve you well.

All of this seemingly technical information and study is meant to enhance your imagination, not replace it. To ignore the scientific aspect, even for fantastical creations, would be a mistake.

> *Fancy alone is incapable of producing anything lasting. Nature has essential laws which it is absolutely necessary to know and to assimilate. The observance of these laws, far from hindering individual originality, only develops its intensity and allows it to be bold without danger.*
> (from *Nos peinters du siècle* by French painter Jules Breton)

REFERENCE SOURCES

There are tons of dinosaur reference and art books available, and any bookstore should contain a good collection. Unless you are looking for hard-core text reference, the children's section is the place to go for the best illustrated dinosaur books. If the choices are overwhelming, here are a few worthy suggestions:

Illustrated Encyclopedia of Dinosaurs
Dr. David Norman
ISBN #0-517-468905

National Geographic Dinosaurs
Paul Barrett
ISBN #0-7922-8224-8

These are books that are good references for living-animal anatomy:

An Atlas of Animal Anatomy for Artists
W. Ellenberger, H. Dittrich, H. Baum
ISBN #0-486-20082-5

Animal Drawing Anatomy and Action for Artists
Charles R. Knight
ISBN #0-486-20426-X

2

DESIGNING YOUR DINOSAUR

IN THIS CHAPTER

- Assembling Reference Material
- Drawing Over Skeletons
- Using Paint Software to Work Out Color Schemes
- Designs in Sculpture

ASSEMBLING REFERENCE MATERIAL

Now you have amassed all your reference material, done the research, and are ready to get down to it and design your dinosaur. This is the stage where you'll produce sketches and possibly sculptures to determine the individual look of the dinosaur. You'll bring what you've learned previously into the mix, as well as your own sense of design and style.

This design can be a simple line drawing or a fully rendered color image. You can do studies of different parts of the animal or alternate looks. You might even want to work out a version in clay before diving into the computer.

Don't be nervous. You're not being graded here. You don't even have to make any design first before opening your modeling package, but that's not recommended. Starting without even the simplest of guides can lead to unnecessary reworking of the model. This can be especially painful if the model is far along. Don't feel like you have to produce a rendering worthy of a museum before you start, but do yourself a favor and figure out the proportions on paper before modeling. The more drawn views of the animal you make, the better your 3D model will be.

EXAMPLE DESIGN APPROACH

Pick the dinosaur you want to model, then assemble the photograph and sketch references of the skeleton. These can be taken either from your research trip or from books. Many times, museum skeletons are posed in natural or action positions. These don't always lend themselves to the neutral pose that a modeler needs. In this case, you might need to create one image by assembling different appropriately angled views from photographs or from your sketches. A computer with 2D painting software will come in handy. Here you can cut, scale, and paste the elements of the skeleton into one correctly proportioned unit. Don't worry if it looks like a patchwork quilt, as it's just a guide. If you like, you can trace over the montage to create a clean line drawing of the skeleton. Be aware of the angle in which the skeleton

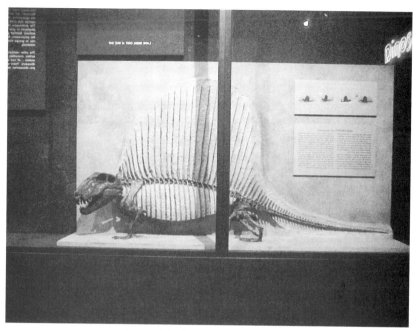

FIGURE 2.1 A dimetrodon skeleton.

was photographed; you want to avoid as much foreshortening and camera lens distortion as you can.

For example, Figure 2.1 shows a dimetrodon that was photographed at the Los Angeles Museum of Natural History. His body was in a fairly neutral position, but his head was turned. Using Photoshop, the head was scaled and pasted over the body. (See Figure 2.2.) Figure 2.3 shows a basic outline of the fleshed out dimetrodon, taking into account muscle and other masses.

You can decide to stop here if you like, or continue to work out more details. You can take this design phase as far as you like, from line drawing to full-color rendering; it's up to you. Even if you create a simple line drawing, it's not a bad idea to produce another drawing of a different angle such as the top or front. These will help lock down other proportions. If you decide to make another angle, make sure that the body landmarks all line up. For instance, lay the eyes in the same plane. If you don't, you'll constantly be chasing

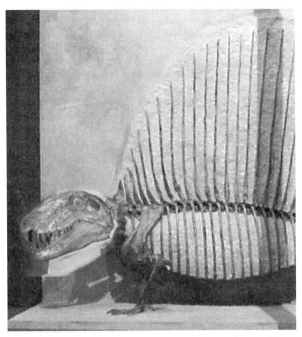

FIGURE 2.2 A better angle of the head is cut and pasted over the body using Photoshop.

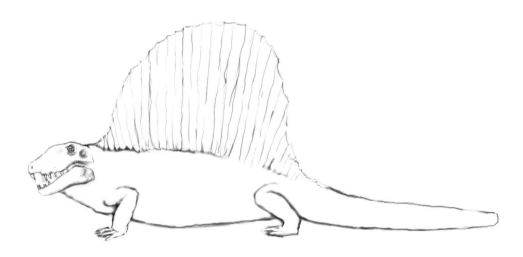

FIGURE 2.3 Line drawing done over the skeleton.

them around in the different view ports of your modeling package. You can use grid paper options, rulers, and guides in your paint program to help you with this. (See Figure 2.4.)

2D paint software can also be used to work out different color schemes. This way you can experiment with coloring and patterns prior to the more time-consuming texturing phase of the model creation. (See Figure 2.5.)

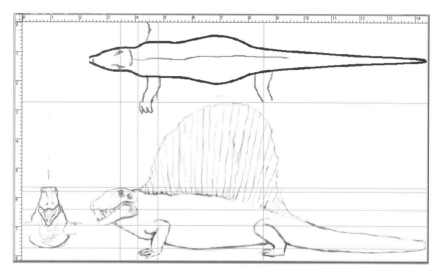

FIGURE 2.4 Guide lines are used to aid in drawing front and top views of the dinosaur.

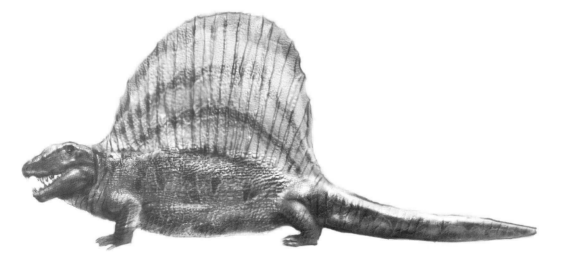

FIGURE 2.5 2D paint software is used to work out color schemes.

SCULPTURE

Advantages

For those wanting to go a step further, you can work out a design in clay. A real-world model has the advantage of truly being in three dimensions and easy to study from all angles. Even well done drawings are prone to misalignment in different angles, but not so with a sculpture.

Another advantage of clay is that there are very few rules for working with it. Changes are made easily. You don't have to worry about the technical aspects or restrictions of your 3D software. Most CG creatures in today's films begin life as a sculpture. Many times, these models are scanned or digitized into the computer and a workable 3D model is created from the scanned data.

Making a clay model also forces you to think in the round, which is what 3D computer modeling requires. Being able to visualize a shape in your head and translate it to any medium is an important skill. Working in clay will strengthen this.

Where to Start

So you'd like to try your hand at some sculpture, but have never done it before. Where do you start? Perusing the art store shelves, there's quite an assortment of clay and it can be confusing. In reality, modeling clay can be broken down into three categories, each with its own characteristics and guides for working.

The Three Clay Medium Categories

Oil Based

Oil-based clay has the advantage of not drying out when exposed to air. It will stay pliable for quite some time. There are numerous brands, colors, and grades of hardness. If you plan on doing small or very detailed work, stay away from soft clay. Hard clay can be softened in an oven, microwave, or an aluminum-lined box with a light bulb over it to make it easily workable in the early stages. Chavant brand clay is a high-quality clay perfect for small model work.

Water Based

Water-based clay has the advantage of being inexpensive. Its natural state is extremely soft, and it hardens as it dries, which it will do if left uncovered and exposed to the air. A work in progress can be kept soft by wetting it periodically with a spray bottle and keeping it covered with plastic wrap when unattended. The drying aspect of water clay is both a pro and a con. The con is that you need to monitor it and not let it dry out too soon. The pro is that it's easy to work with in the soft stages, and detail work is possible as it firms up. That's the best of both worlds. WED clay is a good brand of water-based clay for this work. It was developed originally for Walt Disney Studios and contains a retarder that slows the drying process and enables you to work longer without having to worry about drying and shrinkage.

Polymer

This type of clay closely resembles oil-based clay with the added advantage of becoming totally hard when baked at low temperatures in a kitchen oven. The finished pieces can be painted and handled with little fear of damage. It is the most expensive of the clays mentioned here. Sculpey is the most common brand of polymer clay. Regular Sculpey is white and quite soft; Super Sculpey is firmer. It also comes in a variety of colors. The triceratops in Figure 2.6 was sculpted in Super Sculpey.

Guidelines to Working with Clay

Again the subject of working with clay would fill a book of its own, but there are a few guidelines that can be mentioned here.

Work on an Armature

Unless your model is very small, having a wire framework that represents the basic shape or skeleton will help conserve clay and keep it from collapsing under its own weight. Although any type of wire can be used, aluminum armature wire that can be found in art stores is the best. If your model stands more than twelve

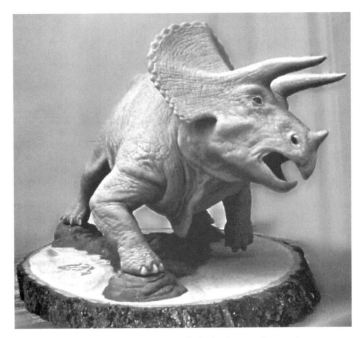

FIGURE 2.6 A triceratops made in Sculpey polymer clay.

inches tall, you should consider outside supports connected to the armature. These can be as simple as plumbing piping screwed into a wooden base. The wire armature can be further padded out with aluminum foil. The foil will conserve clay, and keep the model lighter.

Water-based clay has a few disadvantages when working it on an armature. Since this clay shrinks as it dries, it will crack if left to dry too long on an armature. Usually a mold is made of the model before this point. For this reason, water-based clay can also be worked without an armature as long as the piece is small enough. It might need supports in the early stages while it's still soft, but as it firms it will be able to hold its weight better.

Tools

Clay-working tools include toothpicks, dental tools, and traditional store-bought varieties. Most of this is a matter of personal preference. It's best to experiment with a variety of tools to feel what suits you.

Clay Sketches

As with the sketching phase, a sculpture doesn't have to be brought to completion down to every last scale—it can be a quick study. Figure 2.7 shows a quick dimetrodon clay "sketch." These clay studies are helpful in determining form and character.

SUMMARY

Whatever methods of designing your dinosaur you choose, remember that they are only steps in the process meant to help you visualize your creation before you get into the 3D modeling. You'll find the time spent in this stage well worth it.

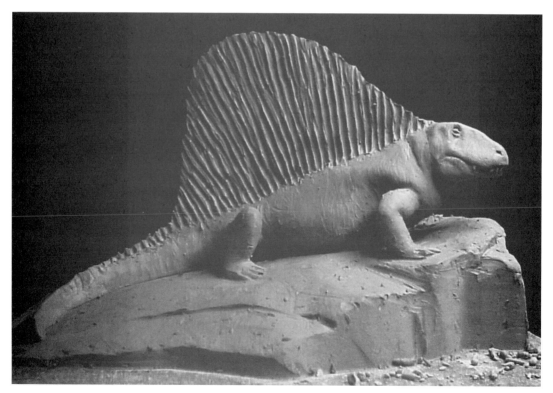

FIGURE 2.7 A clay "sketch" of a dimetrodon.

SUPPLY SOURCES

Art Supplies

Most art stores will have a variety of clays and tools. However, depending on where you live, you may have trouble locating what you need. That is where the Internet comes in handy. Here are some Internet-based art supply dealers:

Douglas and Sturgess, Inc.
Sculpture Tools, Material and Supplies
Water- and oil-based clays
http://www.artstuf.com/home.html

The Clay Factory
Polymer clays & tools
http://www.clayfactoryinc.com/s-ss.htm

GETTING DOWN TO BUSINESS

IN THIS CHAPTER

- Techniques Covered in This Book
- Polygonal Modeling Techniques
- Common Modeling Tools
- Texture Mapping Techniques
- Paint Programs
- 3D Software
- Useful Hardware
- Good Work Habits

F inally, it's time to get cracking on the computer! As was mentioned earlier, this book is not software specific. The tools and techniques described are reproducible in most software packages. Later in this chapter is a list of software that will work with the tutorials in this book, if you are not sure where to begin. Become familiar with the tool set of the software you choose so you can make the comparison and connection to the ones used in this book.

TECHNIQUES COVERED IN THIS BOOK

The techniques in this book use polygonal models. No NURBS (Non-Uniform Rational B-Splines) or spline-patch modeling will be covered, because these modeling methods involve drawing rubber band-like curves to define the surfaces and contours of the model. The model's "skin" is built off of these curves. Creating a detailed, whole model with these curve patches can be quite a complex process. Polygon modeling is easier and, coupled with subdivision techniques, (discussed later in this chapter) quite powerful. Studios such as Pixar have switched from NURBS-based models to subdivision polygonal models.

No character rigging or animation will be covered in detail, because these are deep subjects worthy of books of their own. However, good techniques in modeling will facilitate better rigging and animation. Clean, well laid-out polygonal meshes will deform well and make editing them easier. It all starts with good geometry.

POLYGONAL MODELING

All examples in this book and the resulting models will take advantage of the software's subdividing capabilities. The smoothing algorithms can differ slightly from program to program, but the basic principles are the same. A low-resolution model is built, then subdivided, that is, its polygonal resolution is increased to eliminate the blocky and jagged-edge look of the low-resolution model. This has several advantages: It's much easier to build and edit a low-polygon model than to work directly with a higher count

mesh. Typically, the low-resolution version (controller or "cage") is used to drive the higher resolution (controllee) during animation. The controller isn't rendered; instead, the controllee is at a user-defined resolution. Because the controller polygon count is low, it usually can be displayed in real time while working.

Understanding how the polygons subdivide is crucial in constructing your model. Most subdivision algorithms can produce apparently smooth results from a messy control cage. This is both a blessing and a curse since it can lead to bad habits and poor construction techniques. As long as the final model looks smooth, who cares how the mesh appears, right? Wrong. It may be fine while static, but if it's deformed through bones or morph targets, the model may pinch or crease in undesirable ways.

Counting on the subdivision routine of your software to "clean up" the model isn't the best way to approach modeling. Good control meshes are clean and it's easy to make out what proportions the polygons define. This also makes "boning" or setting up the skeleton for animation easier. The way many skeletal functions in 3D programs work is that each bone has influence over a specified area of vertices defined by the user. When the model's geometry is cleanly laid out, it is not a problem to determine which vertices each individual bone should affect. See Figure 3.1 for an example of this applied to a dinosaur leg and body section. Clean meshes are especially appreciated if that task is passed on to another member of a production team.

How many polygons should a good control cage have? That depends on the model, but it's usually as many as it needs to define the forms. All the polygons should help define a shape on the model. If you can lose some polygons and still have the model look the same, then get rid of them. Building efficient models with the right amount of concentrated detail takes practice. This book will help you get that practice.

What are some of these techniques? Before we go there, let us take a look at how a polygon subdivides. In the example shown in Figure 3.2, a basic cube is subdivided once. In the wire frame, notice how for every one face there now are four. Also notice how the corners have pulled in, becoming slightly rounder. This effect is what will ultimately produce a smooth model. If the cube is

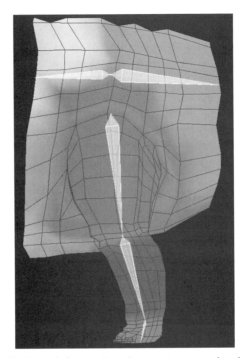

FIGURE 3.1 The bone influence is easier to set up on a cleanly laid-out mesh.

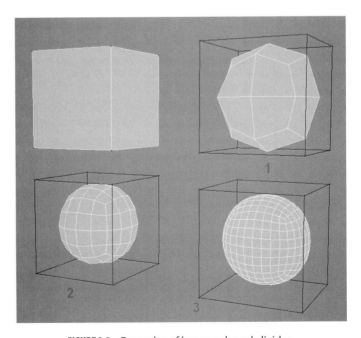

FIGURE 3.2 Examples of how a cube subdivides.

subdivided again, the polygons will increase and the edges will become even smoother.

Now observe what happens to the subdivided version when another row of polygons is introduced close to the top edge of the cube (Figure 3.3). Notice how that edge becomes sharper and the top flatter. This happens because more polygons are being divided in a tighter space.

We will take advantage of this effect when creating harder edges or creases on the models since smoothing operations can tend to soften the model too much if there isn't enough polygonal detail. On the flip side, this crease effect is another reason not to make your control cages too dense. You'll end up with unwanted edges and have difficulty smoothing them out. Just remember that when the polygons are close together, tighter edges and creases can be achieved.

Another factor that affects how polygons subdivide is the number of sides they have. The above examples all contained four-sided polygons or "quads." But your software's subdivision algorithm might be able to smooth a face with more than four

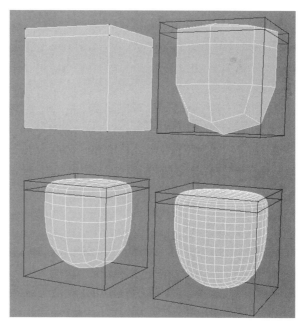

FIGURE 3.3 Another row of polygons is added to produce sharper edges.

sides. Not all 3D software can subdivide more than four-sided polygons. Having the ability to work with programs that subdivide N-sided polygons is a plus, as long as you understand the outcome. For example, observe how a simple shape subdivides when a fifth side is introduced (Figure 3.4). A five-sided polygon subdivides into five separate quad faces. This may or may not produce undesirable results in the smoothed model. Experimentation will tell.

So, how many faces should you work with? It's easiest to predict how a four-sided polygon will subdivide, so working with all quads and triangles (three-sided polygons) is a decent practice. For that matter, triangles should be kept to a minimum since they can cause pinching or surface irregularities depending on where they are placed. Again, spend some time getting to know your software's subdivision routine through experimenting with simple shapes, and you'll be more in control of the final results.

How many times should you subdivide the final model? That depends on the output. For broadcast television, two or three times is probably enough. Film resolution will be much higher. A good rule is if you notice faceted edges in your final output, then you should increase the subdivisions.

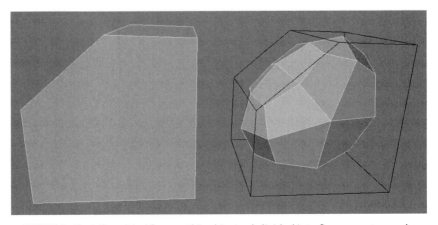

FIGURE 3.4 Each five-sided face on this object subdivided into five separate quads.

Common Modeling Tools

For the exercises in this book, modeling tools will be used that are found in just about all polygonal software packages in some form or another. They might have different names or have more or fewer variables in your particular software, but the basic functions are the same.

Lathe: The lathe function has been a part of 3D software since the beginning of time. Using it involves creating a profile outline then sweeping it around an axis, usually in 360 degrees. Wine glasses and vases are made this way. See Figure 3.5 for an example.

Extrude: Extrusion is performed on a polygon face or collection of faces. The selection is moved out at a user-defined distance and direction. New polygons are created along the edges, thus creating a thickness. Selected faces can be extruded as a group or individually. Extrusions can also be performed along a spline path or curve as a guide and with multiple curves as guides. (See Figure 3.6.)

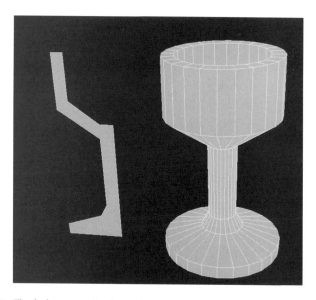

FIGURE 3.5 The lathe operation is used to turn a simple polygon into a wine glass.

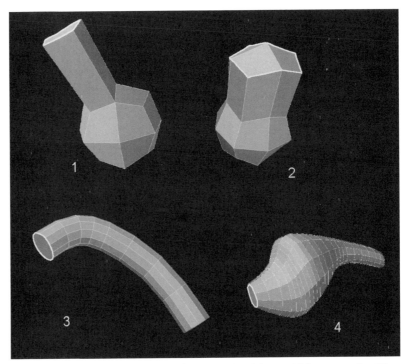

FIGURE 3.6 Examples of a single-face extrusion (1), a multi-face extrusion (2), a single-rail extrusion (3), and a multi-rail extrusion (4).

Cut: Not to be confused with the typical cut and paste operations, this function comes in numerous forms, but it essentially involves splitting, dividing, or adding polygons to ones that are already present. Some programs call this function connect, knife, or split. You select edges or faces and perform the operation. Some programs allow you to draw a line across the screen representing the projected cutting line, which is infinite along the axis perpendicular to the view initially dragged in. Other options automatically cut through a contiguous band of polygons. (See Figure 3.7.)

Join or Weld: These operations are performed on vertices, usually to connect separate faces. (See Figure 3.8.)

Point-by-point polygon creation: Individual points, or vertices, are laid down in 3D space and then connected to form a new polygon. This can also be used to connect separate parts or fill in holes in the model. (See Figure 3.9.)

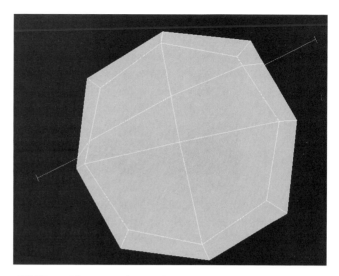

FIGURE 3.7 The cut tool is used to cut new faces into the model.

FIGURE 3.8 An example of faces welded or joined together.

FIGURE 3.9 Individual points are connected to form polygons.

Other useful, time-saving tools include:

Symmetry: Programs that have this feature allow the user to work on one half of the model, while a user-defined symmetry axis automatically updates the other half. This obviously is an extremely useful feature. Not only does it save time, but it also allows you to see the model as a whole. Without it, the user would work on half the model, and then mirror it to view it as a whole. Modifications would continue on one half, then the mirror process would be repeated. This is just a bit more effort for the user, but still quite workable.

Magnet: Magnet features are handy for moving, scaling, or rotating areas of polygons smoothly in given directions. A radial area of falloff is defined, and all geometry within that range is affected. Magnet features add a clay- or taffy-like feeling to the modeling process, which is desirable for organic modeling. (See Figure 3.10.)

Smooth or Tighten: This smooth is not to be confused with the subdivision smooth. Smoothing helps smooth out rough or jagged surfaces or points without adding extra faces. If this needs to be done manually, it can be time consuming. (See Figure 3.11.)

Texture Mapping

Unless you want your dinosaur to look like a plastic toy, you're going to have to put some sort of texture maps on it. These deter-

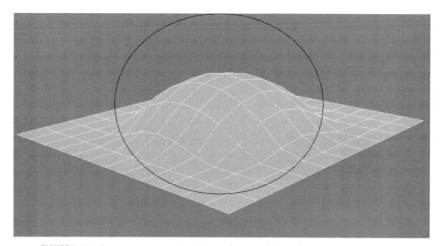

FIGURE 3.10 A magnet operation is used to quickly add a bulge to a flat grid.

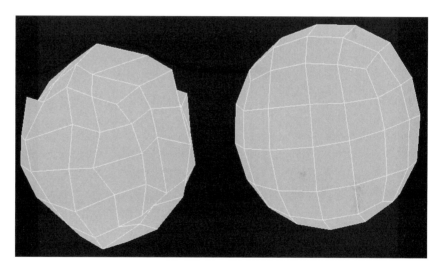

FIGURE 3.11 The smooth or tighten command is used to smooth out irregular or jagged surfaces without adding extra faces.

mine qualities such as color, specularity, and smaller details such as scales or wrinkles.

Although technically not modeling, it is important to think about how you will texture a model as you're working on it. And in the case of UV mapping, texturing can be a step in the modeling process. But we're getting ahead of ourselves. First, let's look at the different mapping types available in the software packages.

Image Map Projection Types

Your texture maps will appear to wrap and conform to the 3D shape of your model, but in reality the maps are just rectangular or square 2D images that are projected onto it in various ways. Choosing the proper mapping type that works for the shape of the model and its parts is important. Often, it will take a combination of several maps and projection types to properly cover a model.

Planar: Planar mapping projects an image onto a surface through a selected axis as if shown through a slide projector. This obviously works best for flat surfaces such as walls, but can be used on curved surfaces to a certain extent. If the angle of the surface becomes too great, the image map will stretch. (See Figure 3.12.)

Cylindrical: Cylindrical mapping wraps an image around the geometry in the fashion in which a soup label fits on the can. This can be on any axis as well. This method works well for the aforementioned can objects as well as creature limbs. Used alone, you will notice pinching at the top and bottom of the map. (See Figure 3.13.)

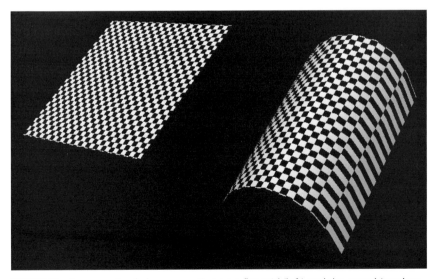

FIGURE 3.12 An example of planar mapping on a flat grid (left) and the stretching that occurs when it's applied to a curved surface (right).

Spherical: Spherical mapping wraps the image in a ball-shaped fashion on a selected axis. This is useful for round shapes such as planets or eyes. There will eventually be pinching at the poles. (See Figure 3.14.)

FIGURE 3.13 The cylindrical map works well on the sides of a can-shaped object, but it stretches on top.

There are some limitations to the above mapping methods, the first being that the projected image maps have no bearing to the actual shape of the model. If you were to change any aspect of your model, such as moving the mouth down, the painted texture of the mouth image would remain where it was. Any geometry changes after the image maps were painted and applied to the model would result in the need to repaint those areas of the texture maps. Couple this with many maps per model, and you have a good deal of work on your hands. The good news is that there is a mapping method that alleviates this problem, as well as other mapping issues, and most software supports this method.

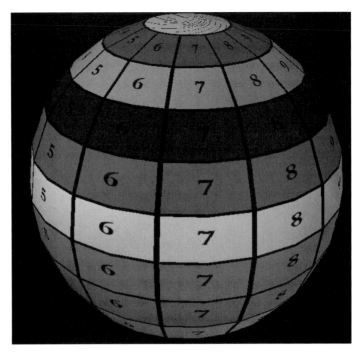

FIGURE 3.14 The spherical map works well on round shapes, but it has a pinching effect at the poles.

UV Mapping

UV mapping for polygonal models initially appears to have the same options and limitations as the traditional projection mapping. That is, when assigning a UV map, you are asked to choose from mapping types such as planar, cylindrical, and spherical. In addition to those three that we have already discussed, you now have atlas or box mapping. The first three methods suffer from the same stretching and pinching as projection mapping. Atlas mapping automatically breaks the model up into a series of planar maps that eliminate any stretching. That's one problem solved, but the flattened map when viewed in the UV editing window creates another. The geometric specifics become virtually indiscernible due to the scattered planar maps, so it's near impossible to use it as a painting template. (See Figure 3.15.)

Some 3D paint programs will let you paint across an atlas map in the 3D window, so you'll be able to take advantage of the atlas

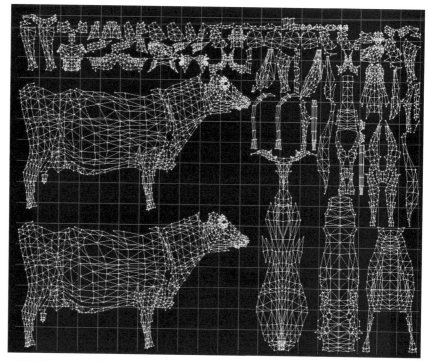

FIGURE 3.15 An atlas map of a cow model reveals some discernable geometry, but most of it is a disparate mess.

method, but 2D editing of the map is still difficult. With all these issues, what's the big deal with UV mapping?

When you apply an image to a model with UV mapping, the image is actually locked onto the geometry so that any topological changes will be reflected in relation to that image. U and V refer to the 2D texture map axes much like the 3D coordinates of your modeling windows.

Most software that supports UV mapping also allows you to edit the UV coordinates in their own window or module. Other programs offer plug-ins that allow you access to UV editing tools. There are also third-party software packages dedicated to UV editing. (See the software section in this chapter for program suggestions.)

Most UV editing interfaces are similar in features. A representation of your mesh, in the chosen mapping method (cylindrical, planar, etc.) can be displayed in addition to the texture map image. You can then move the vertices or faces around, and the

relationship of the texture image to the model will change. Remember that any of this editing is not actually changing the shape of your model.

Figure 3.16 illustrates the benefits of UV mapping. A texture map with a regular cylindrical projection is applied to a segmented cylinder. When the cylinder is bent, notice how the map stretches and doesn't bend with the cylinder.

When the same steps are performed on a cylinder with cylindrical UV mapping, the map conforms nicely with the changes. (See Figure 3.17.)

This is another example of the importance of thinking about your mapping methods as you model. If the final shape of a model piece was a bent cylinder similar to this example (such as snaking tubes or wires), but you waited until after it was all modeled to

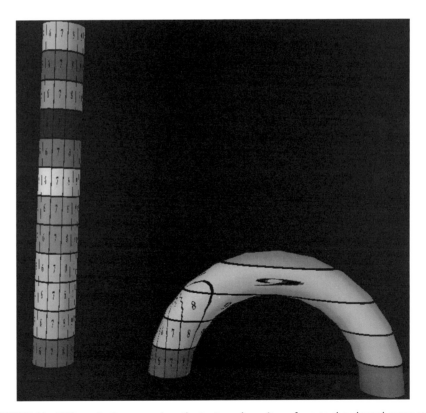

FIGURE 3.16 With projection mapping, the texture doesn't conform to the altered geometry.

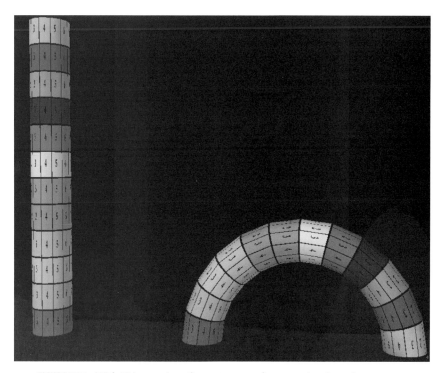

FIGURE 3.17 With UV mapping, the texture conforms to the altered geometry.

texture it, you'd have a rough time even with UV mapping be-
cause of the odd shape. But if you set up the UV mapping while
the cylinder was still in its straight position, you could then con-
tinue modeling it into more complex shapes without worrying
about the map not conforming properly. You don't even need to
have a texture map painted to apply at this stage; setting up the co-
ordinates is good enough.

The above example is simple, but the same principles can be ap-
plied to organic creature modeling. For instance, you can model a
body, cylindrically map it while it's still in the most neutral position,
and then continue to model it into a more "natural" position. You
can also perform the reverse; build your model into whatever posi-
tion suits your eye, decide on a mapping method, make another
copy of the model, but remodel it to best suit the mapping method,
assign the UV map(s), then morph the UV model back to the origi-
nal. Be careful not to delete any points or cut and paste. This will

change the point order and they need to be the same for morphing. Some programs will let you create morph states that are saved as part of the model and can be called up through a requester list. These are usually facial expressions and phonemes, but in this case, can be the UV state. Examples of these techniques will be covered in subsequent chapters.

Paint Programs

At some point, you will get down to painting your texture maps. What is the best program for this? There are numerous paint programs out there, and you might already have your favorite. But one feature that's essential is the ability to work in layers. As the name implies, layers allow you to place virtual clear acetate over an image. These can be built up infinitely, and transparency can be set for each layer. The most basic usage for us is to take a template background of the model mesh and use that as a guide to paint the textures, using the paint program, in a layer above. There, you will be able to see key landmarks in the model's mesh, and line up your detail accordingly. The use of layers isn't limited to that, though. You can use them to experiment with specifics of your texture design. For example, you might try out variations of spotted patterns on your dinosaur's back. Opacity and blending modes for each layer can be set to get different effects. Layers can be turned on and off, and you can jump back and forth between variations without disturbing the work underneath.

You might also use a 3D paint program to create textures. These specialized paint programs allow you to load and paint directly on a 3D model. Bear in mind that you are still producing 2D texture maps through these programs. The advantage is being able to see how the texture looks on a 3D model as you paint. The texture coordinates need to be set up properly before entering a 3D paint package, although some allow you to edit UV coordinates while in the paint program. The model is then saved again, along with the maps. Make sure to find out if this aspect is compatible with the object file format of your 3D software beforehand.

A word about painting texture maps for 3D models: It's important to perform numerous test renderings of your textures on the models as you work them, especially if you aren't painting them in

a 3D paint package. These texture images aren't meant to stand on their own as artwork to be framed and hung. This is a pitfall one can get into while just working on a 2D image; you tend to lose sight of the final destination for the piece. Unlike flat paintings, there isn't any shading required since the render engine of your software will take care of that. If you view your texture map on the model and it looks good, then stop painting, even if the actual 2D map looks crude or messy on its own. Keep in mind the final effect is what counts.

2D Paint Software

- *Adobe Photoshop ($600).* By far the most popular image-editing software used. It supports excellent layer features. A favored choice for texture painting. *http://www.adobe.com*
- *Painter ($480).* This natural-media paint software features a large variety of brushes that can simulate effects such as oil paint and chalk. Paper textures and pattern brushes make this ideal for creating texture maps. Version 7 improves the layer capabilities greatly. *http://www.procreate.com*
- *Deep Paint 3D ($795–$1,290).* This is a 3D painting program that has many of the best features of Photoshop and Painter, but with the added functionality of being able to paint directly on your 3D model and even edit the UV coordinates. *http://www. righthemisphere.com*
- *BodyPaint 3D ($595).* This is another 3D paint package with natural-type brushes and UV editing capabilities. *http://www. maxoncomputer.com*

Texturing Techniques

While we're in the neighborhood of paint programs, this would be a good time to illustrate a few common texturing techniques that will be applied consistently throughout this book.

With a simple airbrush tool, any texture can be hand-painted. But perhaps you don't feel you have the artistic skill to do this. The good news is painting every detail by hand is not necessary. The key ingredient in a good artist is observation—taking in and understanding what you are attempting to reproduce or convey. This

doesn't mean you have to be a master with a paintbrush. The digital medium gives us many brushes with which we can accomplish our goals.

To reproduce textures for our digital models, we must return yet again to nature for reference. This is an obvious decision when looking for textures. The natural course of thinking is that if you are going to make a scaly dinosaur, to look for an animal, such as a crocodile, to photograph and bring it into the computer. But it's not just a matter of taking a crocodile image and pasting it over the dinosaur model. For one thing, most photos have some definite source of lighting. If you did somehow stretch the crocodile image over your dinosaur, it would always look like it was lit by the light source of the photo.

A more practical approach would be to sample a section. (See Figure 3.18.) You could then "Stamp" this image around in your texture map. But if you look, you are still fighting lighting and tonal changes.

It would be best if this sampled texture could be tiled. That is, it's edges matched up on all sides, so that there would be no seam

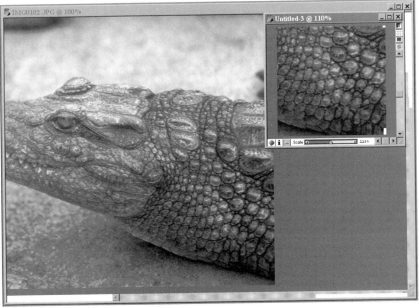

FIGURE 3.18 A close-up scale pattern is sampled from a photo source image.

as you stamped or cloned it around. Luckily, it's pretty easy to create a tile in paint programs. Use your painting program's offset or wrap-around feature to make the image continue off of one edge of the canvas and onto the other. For example, the right side will continue to the left, and the top to the bottom. Figure 3.19 shows an offset-tiled close-up of the crocodile scales. You will notice that the details do not match up as well as the tone. This is where you'll have to clone and paint areas of the image to blend with itself. A clone or stamp tool works for this. Go in with the Burn and Dodge tools to even out various tones, and to connect the detail from one part to another.

Unless you are capturing a texture for a specific color pattern, one such as this crocodile scale will most likely be used for the bump map. Bump maps only need to be grayscale images—the dark representing the recesses and the lights the peaks. Grayscale images also conserve memory and file size and you'll be able to judge the tonal consistency better. Experiment with the brightness and contrast settings, too. Figure 3.20 shows the finished map that was taken from Figure 3.18.

Additionally, these grayscale images can be used to provide effect for your color maps. You can get some varied and useful results.

FIGURE 3.19 Offsetting the image to make a tile reveals that the detail and tone don't line up.

FIGURE 3.20 The finished, adjusted grayscale tilable image.

FIGURE 3.21 A simple color image. See CD-ROM for color version.

For example, start with a simple color image (Figure 3.21). Paste a grayscale bump image, such as the one created earlier, in a layer above it. However, change the composite method from default to difference (a common blending method available in most paint software. Reduce the opacity and view the results (Figure 3.22).

FIGURE 3.22 The results of a grayscale bump image composite with the color image. See CD-ROM for color version.

Play around with the different composite methods in the Layers panel to try out different results. You really can get a good deal of mileage out of a technique like this without a ton of work. For these reasons, get into the habit of painting your bump map first, since it can impact the other texture maps to follow.

Another step that will be used throughout the book is the creation of painting templates. To accurately paint the maps, you'll need a representation of the model to work over otherwise you are just painting blind. One way to obtain a painting template is to do a screen capture of the wire frame modeling or UV editor window and paste that into your paint application (Figure 3.23). You can then crop and resize the template.

Back to being observant, develop an eye for textures that are all around you beyond the obvious sources such as a crocodile. Become aware of the items in your everyday life and their surface

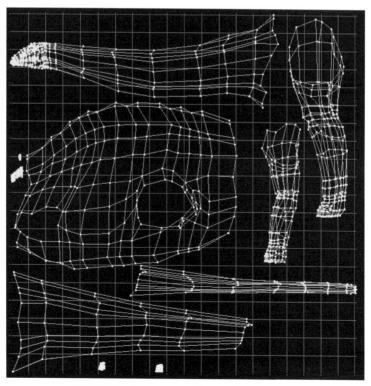

FIGURE 3.23 An example of a painting template.

FIGURE 3.24 A source object for texture.

FIGURE 3.25 The resulting tile image from the texture in Figure 3.24.

qualities. You never know where a useful texture will present itself. A briefcase or portfolio, as seen in Figure 3.24, might have a useful dinosaur texture if you look close enough. Grab your camera and capture a close-up. Then use the techniques just described to make an image tile. (See Figure 3.25.)

Pebbles in the garden, a piece of leather, a head of cauliflower—all good candidates for nice organic textures. After becoming aware of these options, you'll never look at the world the same way again.

Image Map Resolution

For memory and resources, it's important to keep tabs on your image map sizes and formats. Experiment to see how big your image resolution needs to be to attain the desired detail for your output, be it video, film, or print. If you can reduce it without a noticeable difference in the display, then do so. But if you can't paint fine enough detail, consider increasing the resolution.

 All grayscale maps should be 256-tone grayscale. Even color maps can be reduced from millions of colors to 256 colors in many cases, especially if the output is video. Do a test with an image and zoom in to observe the results. Can you tell? If not, then go with 256, but keep a backup copy of the high-color image. You can save a lot of memory by reducing the image color.

3D Software

You might already have your favorite modeling software on your computer, or perhaps you have a clean hard drive and are looking to fill it, but do not know where to begin. Here is a quick breakdown of some popular choices available. They vary in price and features, but fortunately, most have the common polygonal subdivision features used in this book.

- *Amapi 3D ($400).* This is mainly a modeler, with minimal animation capabilities. It has an unconventional interface compared to most, but it has plenty of powerful modeling features. A fully functional free version is available, but it is not the most current version of the software. *http://www.eovia.com*
- *trueSpace ($600).* A low-cost modeling, surfacing, rendering, and animation software package. *http://www.caligari.com*
- *Lightwave ($1,600).* This is a popular modeling and animation program. It features an excellent rendering engine and good character animation tools. Most of the examples in this book were created with Lightwave. *http://www.newtek.com*
- *3D Studio Max ($3,500).* This software is predominately used in the gaming community, but totally capable of creating photo-real high-resolution work. Max has a large user base and numerous modeling and animation features that make it good for character work. *http://www.discreet.com*
- *Maya ($1,999 for Maya Complete. $6,999 for Maya Unlimited).* A high-end, full-featured modeling and animation software package that is used on most major films these days. *http://www.aliaswavefront.com*

- *Softimage XSI ($13,000).* The newest version of the long-used Softimage software; it is a full, high-end package. *http://www. softimage.com*

Most software companies have demo versions of their programs available for you to try out. Some companies also offer student discounts should you qualify. If the lowest-priced software on this list is too much for your wallet, do not stress. There is very usable free 3D software available if you search around the Internet. For example, the apatosaurus demonstrated in Chapter 4 was made with Metasequoia, a Japanese-made modeler. There are no English documents, but all the menus in the program are in English, so with a little experimenting, you will understand the features. Metasequoia can be found at *http://www1.sphere.ne.jp/mizno/main_e.html*. As mentioned above, Amapi offers a free version of their modeling software, as well. UVMapper is a free UV mapping utility. There is also a low-cost ($50), larger version from the same site. *http://www.uvmapper.com*. For painting, Satori Paint has a freeware version that has layer capabilities as well as decent brush options. *http://www.satoripaint.com*

If you are working with several different programs and are concerned about converting model files to the various formats needed, check out Crossroads, a free file conversion program. *http://home. europa.com/~keithr/*

So, you see, there is no excuse for not getting into 3D modeling if you are truly interested. Do not let the fact that you do not have the hottest name-brand software deter you. Many of the basic skills you learn will benefit you when you move to another.

Hardware

Here are a few items of hardware worth owning.

Drawing Tablet

First and foremost, you must own a drawing tablet. Once you've painted with a drawing tablet, you'll never want to touch a mouse for painting again. A tablet lets you work as if you were drawing

naturally, and most are pressure sensitive, which means that the harder you press the pen down, the darker or thicker the painted line will be. Some even respond to pen angle. Wacom is perhaps the most popular manufacturer of drawing tablets.

Scanner

Flatbed scanners are useful for bringing outside image sources, such as photos, into your computer. Sometimes you can even lay an actual item on it to be scanned. These imported images can be used as reference or, with some manipulation, can be translated into texture maps. You can get a basic scanner for less than $100 these days.

Digital Camera

In many ways, a digital camera can save you the steps of processing regular film and scanning. Digital images can be directly loaded into your computer through a connection cable. Some digital cameras have the ability to save directly to floppy disks or a CD-ROM. There are many brands on the market with numerous features. In general, most consumer-level cameras won't give you the resolution of a traditional 35 mm camera, but that doesn't usually matter, as the highest resolution a standard digital camera can reach is more than enough for our purposes.

GOOD WORK HABITS

For the end of this chapter, some good work habits need to be mentioned so you can incorporate them into your hard wiring as soon as possible. Whether working as a hobby or in a production environment, these simple tips can save hours of headaches down the road.

Build to Scale

This means that if your model represents something that is sixty feet long, then build it to that scale in your software. A scale issue might never come into play, but then again it could. If you decided to stage an animation scene with several dinosaurs, it would be

nice if they loaded up in the correct proportion to one another. You could scale them individually for each shot, but that could be tiresome if creating numerous scenes.

Name Surfaces and Parts as You Model

The ability to name groups of polygons for selection or texturing is very helpful. Another good habit is to name these parts as you model, not when the model is finished. The reason is that a completed model is going to be more complex than one in the earlier stages, and it will be harder to make all the selections at a later stage.

The second part of this habit is to name the parts and surfaces *clearly*. When you are first building a model, most of it will be fresh in your head, so the attitude might be "Oh, I'll know what that is," in the naming conventions. But what if you load the model some time later, or along with other models? Will you know what the part "Leg" refers to? Which leg? Whose leg? A better name might be "Trex_Leg_L." That's pretty clear. The "L" means left in this case.

Lastly, be consistent in your naming conventions. If you've named the left leg "Trex_Leg_L," then don't name the right "Trex_R_Leg." Software can list the parts or surfaces alphabetically, and it's much easier to track down or decipher when the names appear logically close together. If you have numerous parts, then your eyes will be glad you've made it easier on them.

Move the Camera Often While Modeling

The camera can refer to the modeling view in this case. We all have our "good sides," angles from which we look best, and so will our models. But you should always keep the model moving around while working on it so you can make it look the best from as many angles as you can. Don't lock onto that favorite good side, and model it that way. For this reason, you should model in a perspective view often. Just about all software allows you to do this. Keep the virtual sculpture stand spinning.

Move Lights While Modeling

Another bad habit is to never adjust the light while modeling. Don't keep the default "head on" camera light as your only source. If you do, when you do eventually load the model in a scene and set lights, you might suddenly notice undesirable shadows or surfaces. By moving your light or lights around while modeling, you'll be able to watch how the light plays over the surface, and judge from there whether you need to pull a point in farther, etc. If your modeling package doesn't support lights, then periodically load the model into your rendering software and check it there.

Save Often and Incrementally

This is perhaps the most important. Nothing can fix lost work. Software crashes, hard drives fail, files get corrupted. These are all unfortunate realities. To prevent that horrid realization of having to redo hours of lost work, train your fingers to hit the save hotkey often. Don't be lazy about it; a gesture that takes a second can save days of work.

Also, save the files incrementally. This has to do with the naming convention. For instance, name your files "Trex_01," "Trex_02," "Trex_03." This has a number of purposes. You can experiment while modeling and save out different versions. If you end up not liking one, then you can go back to a previous. It is a form of backup as well. It can help you keep track of the latest version. When you are done modeling, you can delete or move the earlier version so as to avoid confusion and rename the final model. Or you can create a "work in progress" folder where you keep all your incremental versions, then move the final to a root directory.

Along with saving often, back up your files often. There are all kinds of storage devices available. Read-write CD-ROM drives are fairly low in cost now, and CDRs are very cheap. Many models, minus textures, can even fit on a floppy disk. So, there's no reason to lose data.

SUMMARY

This covers the very basics of modeling and texturing polygonal models and the programs needed to work with them. As you can see, there are many options concerning the software and the tools available within. You should also be able to see many similarities and do not feel too overwhelmed if you are just starting out. Decide on your software packages, learn the tools, and you will feel much more comfortable when proceeding to the following chapters.

That takes care of the dry, technical information. Now, let's build some dinosaurs!

APATOSAURUS

IN THIS CHAPTER

- Modeling with Lathe Shapes and Simple Primitives
- Planar UV Mapping for the Entire Model
- Using Real-World Photos as Textures

The brontosaurus (or apatosaurus) has the classic dinosaur shape and is probably the best known. It was approximately sixty to seventy feet long, with its tiny head perched at the end of an extremely long neck. The neck grew thicker as it led to a massive body supported by four thick legs, which then tapered to an equally long tail.

A member of the sauropod family that existed in the late Jurassic, apatosaurus was originally thought to spend most of its time in the water, but it's now generally believed to have lived its life on dry land. Their long necks would have allowed them to feed on treetops, stripping off leaves with peg-like teeth. Early restorations also had its tail dragging heavily on the ground, but more recent studies suggest that it extended outward as a counterbalance for the neck and body.

Size may have been the apatosaurus's best defense against predators, but it also had large claws on the inner toes of the front legs, which if it was able to rear up on its hind legs, would have made formidable protection.

CONSTRUCTION OVERVIEW

The apatosaurus construction will be based on making the bulk of the shapes with one of the most common and basic modeling tools around—the lathe. The lathe takes a drawn profile made up of a segmented line, spline, or polygon and sweeps or rotates it around an axis with a predefined number of sides. This is usually done in a complete 360-degree arc, but can be less. In our case, we will be only using the full 360 degrees, unless you are planning to model an apatosaurus with a large chunk missing.

Since the lathe operation creates a symmetrical object, we will need to go in and shape out the rest by hand, but that's easy enough. The body and limbs will be made separately, and then joined together. After the basic model is blocked out, detail is added with the cut operation.

The whole model will be textured with planar UV maps. Planar maps are the easiest to understand and paint since they are simple straight-on projects. The trouble comes when applying them to rounded objects, and our apatosaurus is certainly round. Map

stretching will become most obvious as the map tries to wrap past the flat areas of the model. However, by taking advantage of UV editing capabilities, we will be able to greatly alleviate the stretching. As you will see, every aspect of our model will be combined into one UV map, thus reducing the number of image map files needed.

Model Construction

As with all our models, it's best to start with a reference image. In this case, a profile of the apatosaurus will work just fine. Have you done your research? If so, then you should have a profile drawing. After you are finished, import your sketch into a modeling view port so that the head is facing down the Z-axis. (See Figure 4.1.)

At this point, we are going to draw an outline along the back of the dinosaur. Depending on your modeling software, this might be line segments or a whole polygon. The one in this example used approximately thirty-three segments (eleven for the head). (See Figure 4.2.) Don't worry if the end points don't meet exactly at the center, but don't let them cross it.

You don't want to create too many segments or sides initially, since the extra geometry will make manipulating the mesh more difficult than necessary at this point. Remember, more faces will be cut in later.

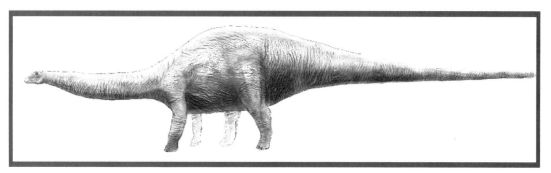

FIGURE 4.1 Import the sketch into the modeling view port.

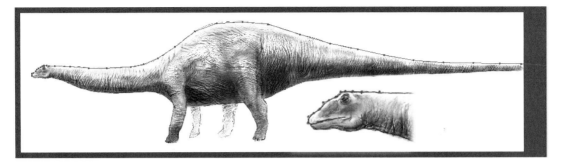

FIGURE 4.2 Draw a profile for the lathe operation. The inset shows a close-up of the head segments.

Now we're ready for the lathe. Perform a lathe on the Z-axis with fourteen sides as shown in Figure 4.3.

Whoa! That doesn't look so hot. Don't worry; it actually won't take too much manipulation to add shape to a dinosaur body. But first, give this object the surface name "Apato_body" or something similar. Remember to name surfaces and groups of polygons as you go for easy identification later.

To expedite modeling, cut the model in half down the middle (along the X-axis) or if you have a symmetry feature, turn that on now. All our geometry, even the legs are going to be modeled just on one side. If you are working with half a model, you'll mirror it at the end or periodically to check progress.

Working in the profile first and with the design sketch visible (usually accomplished by turning on wire frame mode), start moving the lower points and polygons of the belly up to conform

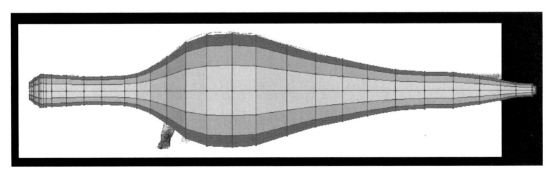

FIGURE 4.3 Lathe the profile with fourteen sides.

to the shape of the drawing as shown in Figure 4.4. This is accomplished easiest with a magnet operation, but can also be done by moving individual vertices if your program doesn't support magnet moves. This is why you don't want to have too much geometry at this stage.

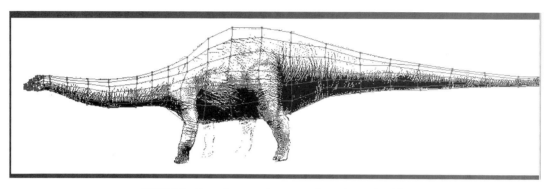

FIGURE 4.4 Move lower polygons to form the underside.

FIGURE 4.5 Shape the body from different angles. Taper the neck and tail.

Once you are happy with the profile, turn your attention to the other angles. Give the neck and tail a nice taper, and indicate some anatomical detail such as the neck and spine vertebrae. (See Figure 4.5.)

If your model has a hole at the tail tip, or a bunch of triangle polygons, it's time to fix that. If there are triangles, delete them to create a hole as shown in Figure 4.6. We'll fill this hole by building new polygons.

Connect the vertices of the tail to make three new polygons. (See Figure 4.7.) Next, cut those three new faces in half as shown in Figure 4.8. Lastly, to seal this up for good, weld or join the two points at the edge. (See Figure 4.9.)

We're going to add a little more geometry to the body. Start by cutting or dividing new faces around the hip area as shown in Figure 4.10. Next, cut two more rows horizontally across the whole body (Figure 4.11).

Now, we're going to turn our attention to the creation of the legs. This is going to be accomplished in the same manner as the body, with the lathe tool, only this time along the Y-axis.

FIGURE 4.6 A close-up of the hole in the tail.

FIGURE 4.7 Build three new polygons to close the hole in the tail.

FIGURE 4.8 Cut the new polygons in half.

FIGURE 4.9 Weld or join the two points to close the hole.

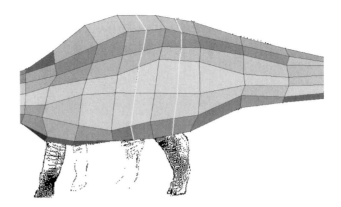

FIGURE 4.10 Cut two more rows of polygons around the hips.

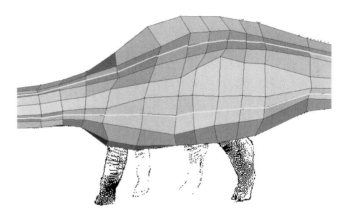

FIGURE 4.11 Cut two additional rows along the body horizontally.

As with the body, draw a segmented profile shape of the rear leg as shown in Figure 4.12. Then lathe the leg segment along the Y-axis with ten sides. (See Figure 4.13.) Name this group of faces "Apato_Leg_rear." They don't need to have a different surface name from the body, but it does help to be able to single them out if necessary.

Again, this is going to look more like a goblet than a leg. As with the body, in the profile, adjust the back to look more like a leg. (See Figure 4.14.)

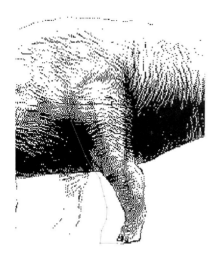

FIGURE 4.12 Draw a profile segment for the back leg.

FIGURE 4.13 Lathe the leg segment with ten sides.

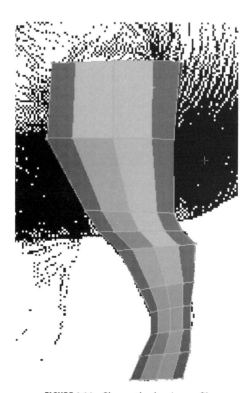

FIGURE 4.14 Shape the leg in profile.

Don't forget the other angles! In the front view, flatten the leg with a stretch tool, and position it close to the body as shown in Figure 4.15.

Hide the leg geometry to make the next operations easier. Delete six polygons to make a hole for the leg attachment. (See Figure 4.16.) View the leg geometry again. Begin to make this creature whole by welding or joining outer leg points to the body. The number of points joined should match up if you've followed this example. You should have something that looks like Figure 4.17.

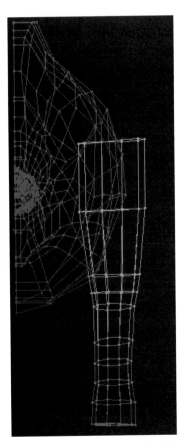

FIGURE 4.15 From the front view, stretch the leg flat and move it into position.

FIGURE 4.16 Delete six polygons to allow for the leg attachment.

FIGURE 4.17 Weld or join outer leg points to the body.

Let's work on the front leg now. The procedure will be much like that of the back leg. First, cut a new row of faces around the shoulder area. (See Figure 4.18.)

For the front leg, we can draw a segmented outline and perform a lathe, or as an alternative approach, try this: Create a cylinder with ten sides and seven segments. Delete the top polygons.

(See Figure 4.19.) We've quickly created a form that will work nicely for a leg. As with the rear, shape the leg to conform to the background sketch. Also cut out polygons from the body for the front leg as shown in Figure 4.20.

Position the shaped front leg by the hole (Figure 4.21). And finally, weld or join the points of the leg to the body. (See Figure 4.22.)

We're going to move on to the head now. As with the tail, you'll either have a hole at the tip, or several triangle faces. If the latter, delete them so it resembles Figure 4.23.

Create four new polygons to fill the hole as shown in Figure 4.24. Split the new polygons in half (Figure 4.25), and seal it off by joining the two corner points (Figure 4.26).

Let's shape the head some more. Move the vertices around while thinking about where major landmarks, such as the eyes and mouth, will be. It's always a good idea to be thinking a few steps ahead. By setting up the geometry as you go for the next few steps, you'll ultimately make everything easier, and your model

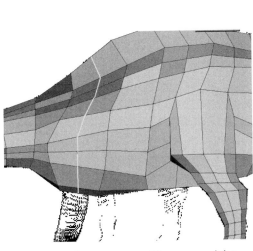

FIGURE 4.18 Cut a new row of faces around the shoulder area.

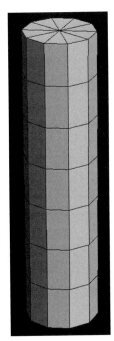

FIGURE 4.19 Create a cylinder with ten sides and seven segments. Delete the top polygons.

FIGURE 4.20 Cut out polygons for the front leg.

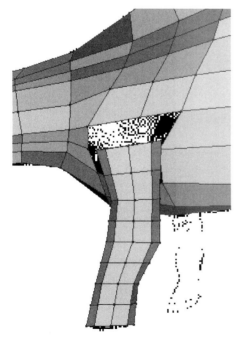

FIGURE 4.21 Position the front leg by the hole in the body.

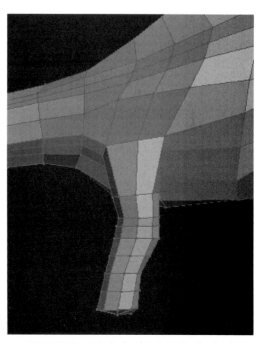

FIGURE 4.22 Attach the front leg to the body.

FIGURE 4.23 The hole at the front of the head.

FIGURE 4.24 Create four new polygons to fill the hole at the front of the head.

FIGURE 4.25 Split the new polygons in half.

FIGURE 4.26 Weld the two corner points to close the hole.

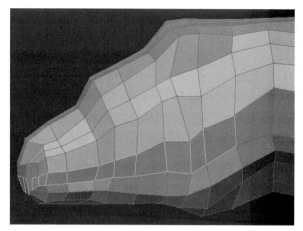

FIGURE 4.27 The basic head shape with the mouth faces highlighted.

will require less editing later when the mesh is more detail-heavy. Much of this type of modeling is akin to chiseling out of stone. You first define the broad forms, then go in to refine and add details. Don't forget to work the model from all angles.

Now we're going to add more faces for detail. Starting with the mouth, select the row of faces near the mouth area (Figure 4.27) and inset them slightly by extruding the selected row, then scaling the newly created faces. (See Figure 4.28.)

Now, move up to the four faces that will be the eye area and extrude and scale them slightly as shown in Figure 4.29. Then cut a new row of faces into the eye socket area (Figure 4.30). Extrude and scale the inner polygons back into the head again. (See Figure 4.31.)

We're getting close to finishing the eye. Cut two more rows of faces into the second circle of faces just as Figure 4.32 shows. Lastly, select the four innermost faces again and extrude them straight back a couple of times, keeping the first close to the edge and the second farther into the head. (See Figure 4.33.) This is where the eye will sit.

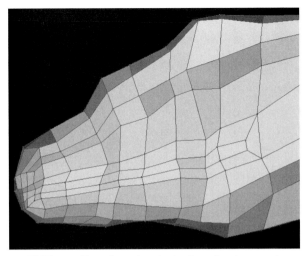

FIGURE 4.28 Extrude and scale the faces for the mouth.

FIGURE 4.29 Extrude and scale faces for the eye socket.

Why all this geometry? It may seem like a lot for an area as simple as an eye, but we need it to create sharper edges and define forms. Remember, we will be performing a subdivide routine on these faces, and if there isn't enough there, the final result will appear soft and undefined.

FIGURE 4.30 Cut a new row of faces into the eye socket.

FIGURE 4.31 Extrude and scale the eye socket again.

Next, let's add some more definition to the skull by indicating one of the large cavities. Select the six faces just beyond the eye and extrude them in as shown in Figure 4.34. To help with some definition, cut another row of faces into the cavity. (See Figure 4.35.)

FIGURE 4.32 Cut two more rows of faces into the eye area.

FIGURE 4.33 Extrude and scale the eye faces two more times.

FIGURE 4.34 Select the six faces just beyond the eye and extrude them in.

If you haven't already, perform a smoothing operation on your mesh to check the results. Figure 4.36 shows a smoothed mesh, and we can start to see the apatosaurus coming to life out of the formerly blocky polygons.

Moving down to the mouth again, flatten the inner row of faces all the way back to the centerline of the model as shown in

FIGURE 4.35 Cut another row of faces into the cavity for definition.

FIGURE 4.36 Check the smooth, shaded view for progress.

Figure 4.37. Don't be overly concerned with the neatness, as we are going to delete them anyway. (See Figure 4.38.)

To make the next steps easier, hide the unnecessary faces of the head and body, leaving only the inside of the mouth. These are the stretched faces from when the mouth faces were pulled to the centerline. We'll want to make some new faces inside the mouth. Cut two new rows of faces as shown in Figure 4.39. Make sure you include the palate as well when you cut.

For easy selection later, name the inner mouth faces. Then pull the lower jaw section straight down (along the Y-axis) into the

FIGURE 4.37 Flatten the mouth faces to the centerline of the model.

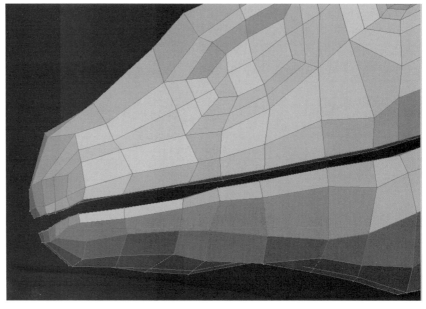

FIGURE 4.38 Delete the inner mouth faces.

FIGURE 4.39 Viewing only those faces that are necessary, cut two new rows of faces for the inner mouth.

jaw, and push the top up to give some depth in the mouth. (See Figure 4.40.)

Collect the two faces at the back of the throat and extrude them a couple of times for some depth there as well. (See Figure 4.41.)

FIGURE 4.40 Give the inner mouth faces a new surface name and push them deeper into the skull.

FIGURE 4.41 Extrude faces for the throat.

Great! That'll do it for the inside of the mouth. Let's get out of here. Show the hidden geometry and zoom in on the outside of the mouth. Cut a new row of faces around the lips (Figure 4.42).

Step back, smooth or subdivide the model and admire the apatosaurus so far. He should look something like Figure 4.43.

Looking pretty good? We can really see him coming together now. But there's still more work to be done. Let's start by giving him some definition in the legs. Start with the back legs. We're going to need to add some more geometry to work with, so cut some new faces; once where the leg joins the body and twice around the knees as shown in Figure 4.44.

FIGURE 4.42 Cut a new row of faces around the mouth.

FIGURE 4.43 The apatosaurus so far.

Pull vertices to add some definition to the upper leg so it's not so much of a cylinder. Think about the underlying muscles. Since an apatosaurus is a pretty massive animal, there should be some weight to the anatomy. You might indicate a bit of this heavy skin and muscle by adding some overhanging skin around the knee area such as that in Figure 4.45. Having a sense of the scale of the model you are recreating and paying attention to details such as

FIGURE 4.44 Cut new geometry in the back legs.

FIGURE 4.45 Pull geometry around knees and shape legs further.

this will go a long way to the effectiveness without adding much extra geometry.

Move around the leg, and select eighteen faces at the rear of the thigh as shown in Figure 4.46. Extrude and scale that selection of faces. Scale them narrower than the thigh. This will create some hamstring-type definition. Clean up the area to make a smooth transition. (See Figure 4.47.)

Move down to the foot. Select the ten faces at the front of the foot and extrude them forward. Scale them down on the Y-axis, but keep the lower edge parallel with the bottom of the foot. (See Figure 4.48.) For some nice crease definition, cut a new row of faces around the ankle as shown in Figure 4.49. If you have a hole in the bottom of the foot from the lathe operation, then seal it in the same manner you used with the end of the tail and the head. Again, to help with muscle definition, add a new row of faces down the outside middle of the leg as shown in Figure 4.50.

FIGURE 4.46 Select eighteen faces at the rear of the thigh.

FIGURE 4.47 Extrude and scale the faces for muscle definition.

FIGURE 4.48 Extrude out ten faces at the base of the foot.

FIGURE 4.49 Cut a new row of faces around the ankle.

Check your progress on the back leg by subdividing or smoothing. Are there any harsh lines or shadows? Does the modeling feel natural or mechanical? Make adjustments to correct any problems that catch your eye. (See Figure 4.51.) Are you happy with your results so far? Don't rush it. Be critical. Remember, it's easier to make changes at this stage than when even more detail is added.

Great, let's move on to the toes. This is straightforward. Select five faces at the tip of the foot and extrude or bevel them out *individually*. You want separation here. They don't need to extend very far. See Figure 4.52 for a view of this.

Move forward to the front leg and cut some new faces up toward the body and at the knee joint much like the back leg. (See Figure 4.53.) We're going to do something now that we didn't do on the rear leg. Select the three rows of faces starting at the base of the foot and ending below the joint, and give them a *slight* rotation. Depending on your software, this will either be along the heading or Y-axis. Then deselect the top row and give it another slight rotation. Perform this once again until the geometry looks something like Figure 4.54.

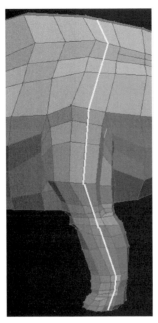

FIGURE 4.50 A new row of faces is added to the leg.

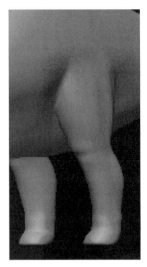

FIGURE 4.51 Subdivided, shaded leg so far.

FIGURE 4.52 Bevel out five toes.

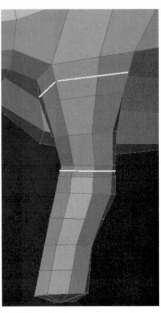

FIGURE 4.53 Cut new faces into the front leg.

Why on earth did we do this? By giving the lower limb or forearm a subtle twist, we are preparing the polygons to flow in a direction and take the shape that the muscles of that area conform to. And those muscle configurations are ultimately dictated by the underlying bones, which in this case are the ulna and radius. Later, when we add more faces for muscle definition, it will be easier to model them in the correct direction. This is a subtle, but worthwhile effort.

Let's add some more detail by cutting two new rows of faces around the foot (Figure 4.55). And, as with the rear leg, extrude out the faces for the foot. Scale them and keep the bottom edge flush with the bottom of the leg. (See Figure 4.56.)

Cut three new columns of faces, two on the leg and one just behind it on the body. This will give us some more geometry with which to play. Continue these cuts all the way around the body. (See Figure 4.57.) Now that we have these extra points to pull around, let's make something of them. As always, think about the underlying anatomy. Give an indication of the scapula. Bulge out the deltoids a little more. (See Figure 4.58.) The last thing to do

FIGURE 4.54 Give the lower leg geometry a slight twist.

FIGURE 4.55 Cut new faces around the foot.

FIGURE 4.56 Extrude out faces for the foot.

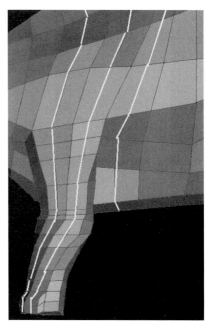

FIGURE 4.57 New rows of detail are added on and around the front leg.

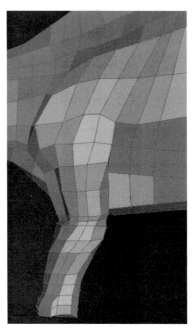

FIGURE 4.58 The geometry is pulled and shaped to accentuate underlying anatomy.

with the front leg is to extrude out toes. It's the same procedure as used with the back leg.

We're going to return to the head. Zip down the neck and cut three new columns of faces at the base of the skull. Pull the middle column down to make a nice wrinkle of bunched skin as shown in Figure 4.59. Pull up the vertices under the jaw to define and sharpen it as shown in Figure 4.60.

The apatosaurus's nostrils aren't where you'd normally expect them; they are on the top of the head, just over the eyes. As strange as this may seem, it's actually quite easy to model. Extrude or inset the face just above and in front of the eye, but don't push it in or out. (See Figure 4.61.) Next, simply extrude that face into the head as shown in Figure 4.62. Lastly, cut a new group of faces around the outside edge of the nostril. This will give a nice little lip. (See Figure 4.63.)

Let's not forget about the eyes. First, simply create a low-resolution sphere with the surface name "Apato_eye"; size and position it in the socket. Then adjust the lid geometry so it closely hugs the eye sphere. It's best to check the model in subdivided form to

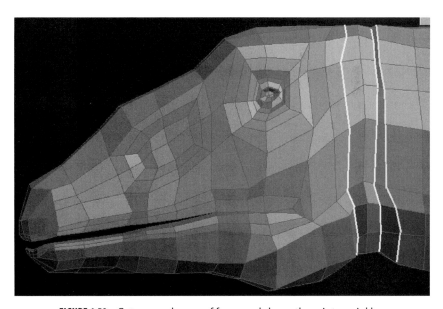

FIGURE 4.59 Cut new columns of faces and shape them into wrinkles.

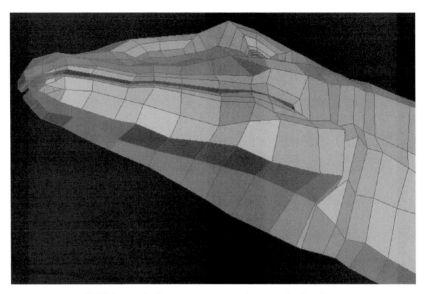

FIGURE 4.60 Pull up geometry to sharpen the jaw line.

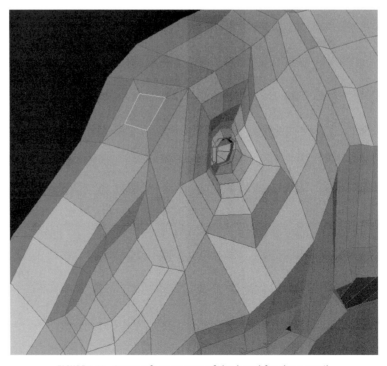

FIGURE 4.61 Inset a face on top of the head for the nostril.

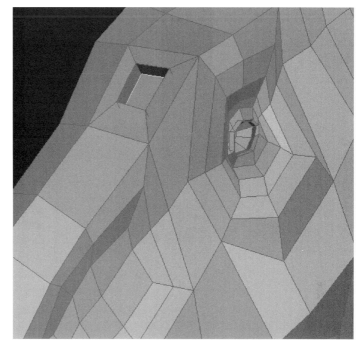

FIGURE 4.62 Extrude the face into the head.

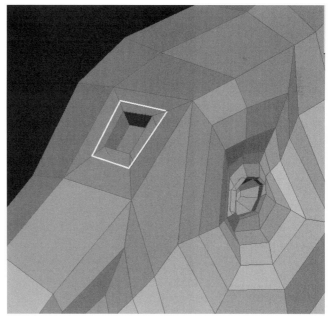

FIGURE 4.63 Cut new faces around the nostril.

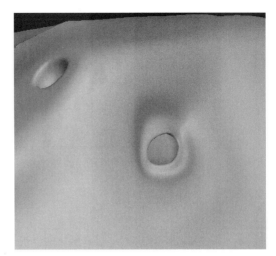

FIGURE 4.64 Position a sphere in the head and conform the lids to it.

gauge how accurately the lids are fitting. See Figure 4.64 for a sample.

Guess what? We're almost done with the main geometry! The last part is easy. Cut a couple more columns at the base of the tail (Figure 4.65).

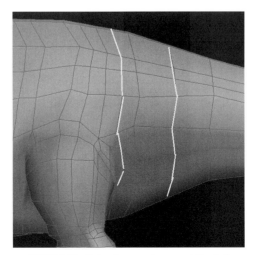

FIGURE 4.65 Extra faces cut around the tail.

Check your model again in the subdivided form. How does the light play across the surface? Are there any unusually wavy areas? If so, smooth them by either hand-pulling vertices or using a smooth function (not one that adds geometry but one that just evens it out).

Modeling the Apatosaurus—Extra Bits

Did I say we were done? Well, not completely. You certainly could stop here, but there are a few more details and bits that can add even more to our model. We are going to give him some toenails and teeth, gums and a tongue. All of these items will be modeled as separate objects and stuck into place on the model. In many cases, this method works fine.

We'll begin with the toenails. Create a cube and give it the surface name "Apato_nails." (See Figure 4.66.) Next, subdivide the cube once. This will give us a rounded form to start (Figure 4.67). Flatten the lower vertices so they are flush with the middle edge of the nail as shown in Figure 4.68.

Cut new faces into the nail (Figure 4.69). Make sure the extra horizontal faces are close to the bottom edge of the nail. If you remember the principles of subdividing polygons, you know that

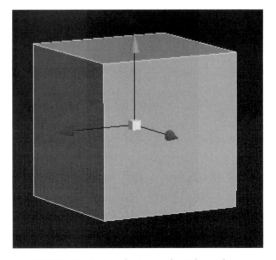

FIGURE 4.66 Begin the toenails with a cube.

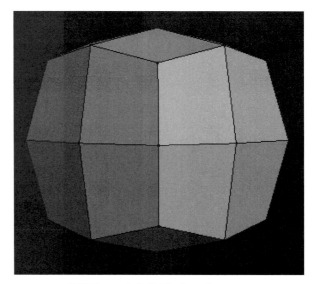

FIGURE 4.67 Subdivide the cube once.

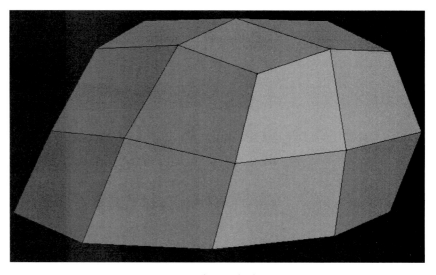

FIGURE 4.68 Flatten the bottom.

two edges close together will make a harder edge. In this case, that is exactly what we want. And since we won't really be needing them, delete the back polygons shown in Figure 4.70. Don't be concerned about the hole there. It will be buried in the toes.

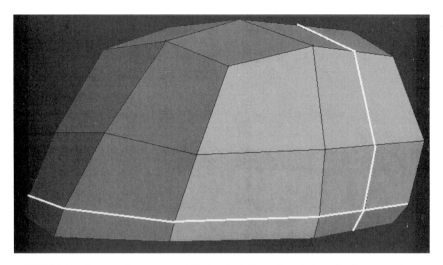

FIGURE 4.69 Cut new faces toward the back of the nail and along the bottom edge.

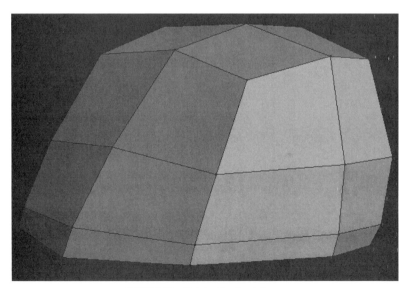

FIGURE 4.70 Delete the back faces.

There is fossilized evidence that the apatosaurus, in addition to the blunt nails, had larger pointed claws on its legs; the first toe on the front leg and possibly the first and second toes on the rear leg. To make the claw, create a duplicate of the nails you just made,

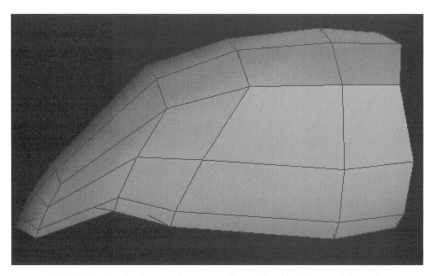

FIGURE 4.71 For the longer claw, extrude out the front faces of the nails.

and extrude out and scale the four end faces to a pointed tip as shown in Figure 4.71. Make more duplicates of the nails and rotate, scale, and place them at the ends of the toes. Adjust the toe geometry if necessary. After you're done, you should have something that looks like Figure 4.72.

FIGURE 4.72 Duplicate and position the nails on the foot.

The final bits of detail will be inside the mouth. Even though the apatosaurus doesn't have prominent teeth, it would be nice to see some if you decide to open the mouth in an animation. Beginning with the gums, create a cylinder with ten sides and five segments and align it along the Z-axis. Name it "Apato_gums." (See Figure 4.73.)

Next, cut the cylinder in half as shown in Figure 4.74. Working over the wire frame of the head, stretch and bend the cylinder to the inside of the mouth. Curve the end and make sure the edge vertices are at 0 on the X-axis. (See Figure 4.75.) The final fitting is best done with just the inner mouth faces visible. Raise or lower the gums and vertices so they conform to the inside of the mouth as shown in Figure 4.76. Do the same for the upper gums.

 You might get most of the way toward completing the upper gums if you just copy and flip the lower gums.

Let's make some teeth to stick in those gums. The apatosaurus's teeth were thin and peg-like, best suited for stripping foliage off branches. The construct of a tooth starts out as a divided cube with two segments on the X axis, two on the Y and three on the Z. Make it thin and tapered at the base as it is in Figure 4.77.

FIGURE 4.73 The gums begin as a cylinder ten sides by five segments.

FIGURE 4.74 Cut the cylinder in half.

FIGURE 4.75 Stretch and bend the cylinder to the inside of the mouth.

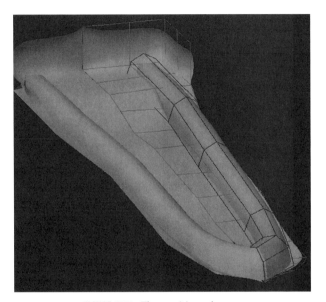

FIGURE 4.76 The positioned gums.

The next steps are just simple, manual labor. Make numerous copies of the tooth, then scale, rotate, and position them in the gums. (See Figure 4.78.)

Try not to make the teeth all even or the same size to avoid a mechanical feel.

To go the extra yard, let's make a tongue. Begin with a divided cube. Move the middle points close to the center as shown in Figure 4.79. Next, taper the tip and pull the middle points down a bit to create a slight depression (Figure 4.80). Give a slight bend to the tongue so it's not stiff like a board, and view the subdivided version. (See Figure 4.81.)

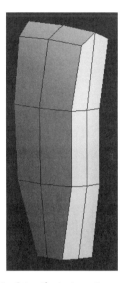

FIGURE 4.77 A tooth starts out as a segmented cube.

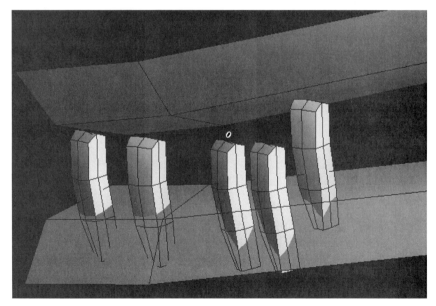

FIGURE 4.78 Make numerous copies of the tooth, then scale, rotate, and position them in the gums.

Position the tongue appropriately in the head and guess what? We're done! Mirror the other side if you were working on just one half of the model. Zoom out and view your subdivided masterpiece. (See Figure 4.82.)

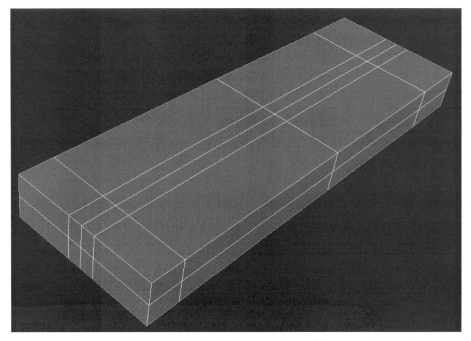

FIGURE 4.79 The tongue begins as a divided cube. Move the middle points close to the center.

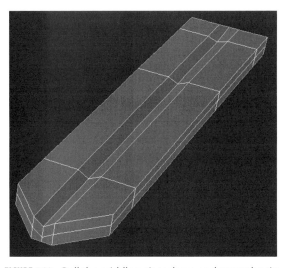

FIGURE 4.80 Pull the middle points down and taper the tip.

FIGURE 4.81 The subdivided tongue.

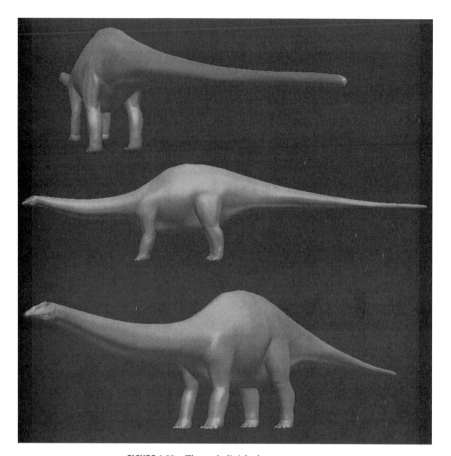

FIGURE 4.82 The subdivided apatosaurus.

You may have noticed while going through this tutorial that we didn't take any one part of the model to completion until the end. That is, we didn't model all the back leg's details right away, then move on to the front legs, then the head, etc. The method this tutorial emphasizes is working in a circular fashion on the model; keeping the whole model at equal stages of development throughout. The advantage of this way of working is that it helps not to focus on or become caught up in one area of the model for too long or too early in the process. Always keep an eye on the "big picture," and we're talking big when dealing with dinosaurs.

To come clean, the truth is we're not totally done. Sorry. We are just done with the modeling stage. Admire your work, take a break and gear up for the next stage—texturing.

Texturing the Apatosaurus

We are now entering a part of model creation that can make or break all the work you've done so far. While good texturing won't make a poorly modeled creation great, it certainly will be the crowning aspect of a well-done model.

This is not mentioned to be intimidating. You may be a little insecure if you haven't done much texturing or don't feel you have good painting or drawing skills. Don't fret. The techniques described in this section require very little in terms of actual free-hand drawing abilities. As mentioned in a previous chapter, strong observation skills are a major factor in being an effective artist, especially in the digital realm.

The bulk of the apatosaurus bump maps (the little wrinkles and folds) will be accomplished by cutting, sizing, and cloning actual images of elephant skin, an animal comparable to the apatosaurus. But before we do that, we need to do some technical work to prep the model for these textures

Setting Up the UV Maps

Virtually all the surfaces on the apatosaurus will be covered in one UV planar map. As hinted at earlier in the chapter, there are going to be inherent texture-stretching problems in attempting to planar map an obviously rounded form such as our dinosaur. But as you'll soon see, we can overcome much of the stretching by properly setting up and adjusting the UV maps while retaining the ease of painting on a planar map template. Enough talk, let's get started.

Go to the UV editing module of your program, or use a stand alone application such as UVMapper. Load the apatosaurus model and make sure all the parts are visible. Now, assign a planar map along the X-axis and call it "Apato_body" (if your program has the ability to name UV maps). You should end up with something similar to Figure 4.83.

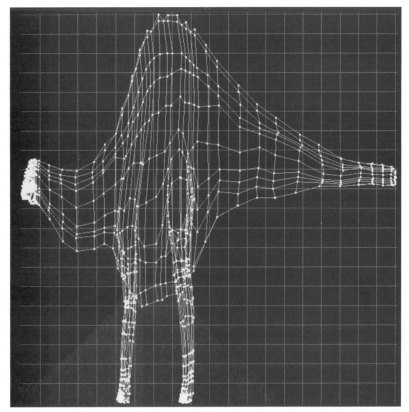

FIGURE 4.83 The whole model planar mapped in the UV window.

There! We're done, right? Wrong. There are a few problems in this UV map. The first we'll cover is the actual proportions of the map. Although it does look like our dinosaur from the side, you can easily see that he's quite compact, and doesn't have the same length ratio as the actual model. This will become a problem if we attempt to paint using these UV coordinates. Aside from the actual difficulty in envisioning and painting over a template whose proportions don't accurately match those of the model, there will most likely be pixel stretching on the maps when applied due to the distorted ratio. Remember, UV maps are square and will not take on the actual dimensions of the model. One solution is to size the UV map faces. Select all the geometry (while in the UV module) and scale or stretch them until they look in correct proportion

to the actual model as seen from the side. This eases the proportion ratio problem but creates another. Take a look at all the space around the geometry in the UV map. This is quite a bit of wasted space. (See Figure 4.84.)

So, who cares if there's a little bit of blank space in our texture maps? The biggest problem is that since the actual geometry is such a little portion of the map, to get decent detail (that is, the smallest pixels you can draw), the map will have to be extremely large. Not good. Just about every aspect of our lives benefits from saving space, and this is even more important in our digital world. Wasted space leads to unnecessary memory usage and hard drive storage. Even if you have a fast computer, plenty of memory and

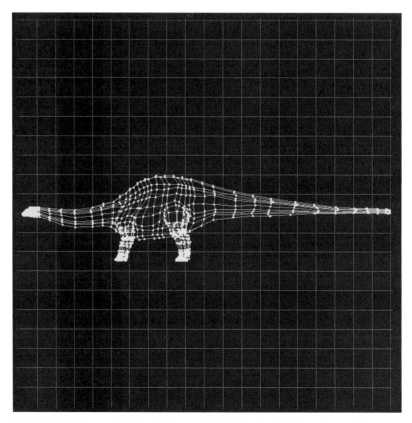

FIGURE 4.84 The aspect ratio of the model is better, but with much wasted space in the map.

hard disk space, you'll do well to get into good habits with image maps, too.

The last problem with this mapping method is that the legs are overlapping the body, which means that texture painted onto the legs will project through to the body underneath.

So, how can we effectively fit this long, rectangular form into the square requirements of the UV map? We're going to cut our apatosaurus into pieces! Don't worry; it won't hurt him.

Think about the aspect ratio of all this dinosaur's parts. It's easiest to visualize while looking at an orthographic side view with a grid feature turned on. Is the length of the head and neck equal to that of the body? The tail is probably at least the length of the body and neck combined. Don't forget about the legs either.

To begin, we should start moving the various parts around to find a good way to lay them out. Starting with the first UV example of this model, select the head and neck and move it to the upper-left-hand corner. Separate the tail from the body and move it down to the right. For now, slide the legs over to the upper right. (See Figure 4.85.)

However, we still have those proportion problems. The idea here is to keep all the parts in correct proportion while utilizing the UV map space and doing this in such a manner that all the pieces fit. It is like a puzzle, but with only a few pieces.

The head/neck piece and the body are easy to position, but the tail is another story. If left in one piece, it still would be rather squashed. The solution is to cut the tail in two and reposition those pieces. When you are done, you should have something similar to Figure 4.86.

Why have the different pieces in proportion to one another? It's not absolutely necessary, but it certainly will make painting easier. If the UV coordinate size of one body part differs from that of a neighboring, or one of a contiguous surface such as we have in the apatosaurus, then brush strokes will vary in size when applied to the model even though you painted them with the same width brush in your paint package. You could compensate while painting by varying the size of the brush, but this is an awful lot of extra work.

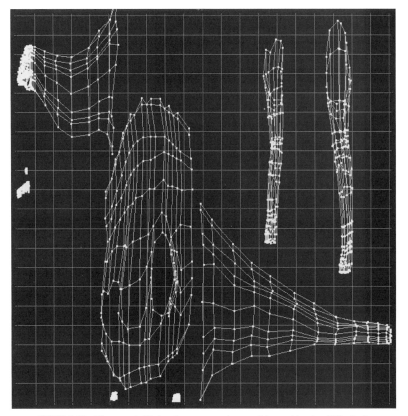

FIGURE 4.85 The model is broken up and repositioned in the UV window.

Painting the seams where the parts have been separated is an issue you want to deal with now. Fixing it isn't really a big deal, especially when using clone tools in the paint program to match separate seams.

You might have noticed that there are a few extra little bits of geometry left over. These are items such as the eyes, teeth, inner mouth, tongue, and nails. While we're in the UV mapping mood, we can catch them as well. The good news is that we still have some room on our main UV map to fit these items. Figure 4.87 shows how the extra bits were fitted into the UV map. With these items, we don't have to make them in proportion to the rest of the body since they are separate and not part of the contiguous skin surface. In fact, that tactic will work to our benefit, as the large

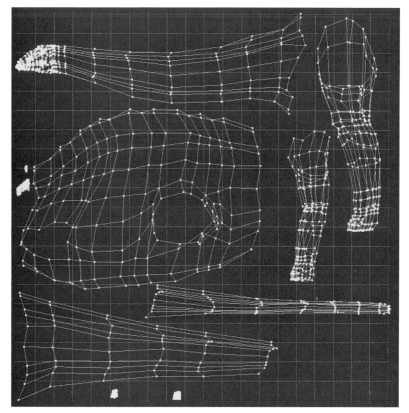

FIGURE 4.86 The individual pieces are brought into correct proportions.

scale will help with detail. We can also map them on a different axis to suit their geometry. The eye and teeth can be on the X-axis and the nails, tongue, and inner mouth can be on the Y-axis.

Good job. But let's check our UV handiwork with a simple image map. Grids or checker patterns work well for this; you can easily see if the texture lines up or stretches. Make a checker pattern at least 1024 × 1024 and apply it to your apatosaurus' skin surface with the Apato_body UV mapping. Check where the seams connect and see that the checker squares have the same size. If they have a noticeable difference, then adjust the geometry in the UV map to correct this, usually by sizing or stretching. It doesn't have to be absolutely perfect, just not noticeably different. Figure 4.88 shows the checker pattern applied to the model.

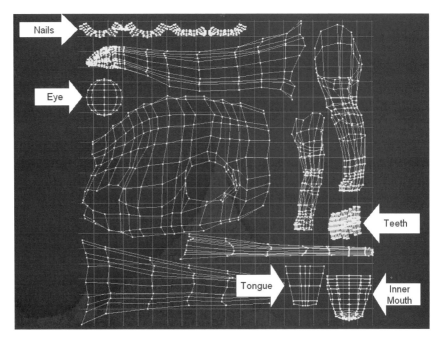

FIGURE 4.87 The extra geometry included in the UV map.

If you're happy with the checker proportions on the model, it's time to zoom in to check for and fix texture stretching. This will be most pronounced on areas such as the legs and the top and underside of the body.

Here's an example of how we can alleviate texture stretching. Zoom in on the rear leg. Rotate it around so you see it from a three-quarter view. Notice how our nice checker pattern becomes stripes as it attempts to wrap around the outside of the leg? Figure

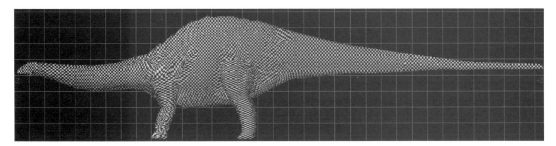

FIGURE 4.88 Checkerboard pattern applied to the model to check for proper proportions in UV maps.

4.89 shows the textured leg in the left window and its UV map in the right.

It's time to start pulling vertices in the UV window. Start at the midline, and stretch those points outward. It's very helpful if you can see the texture update at the same time on your model. If your program doesn't support this work method, then be sure to load up the model in your rendering package to check progress. You also might need to pull various surrounding vertices to keep the texture ratio evenly spaced. When you are done, you might end up with something similar to Figure 4.90.

The next example illustrates the same process in the case of the head. Notice the texture stretching toward the top of the head in Figure 4.91. Now compare it and the adjusted UV map in Figure

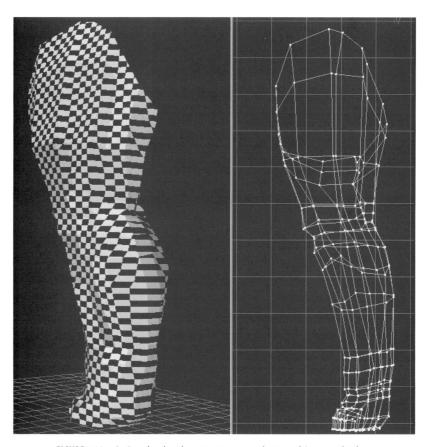

FIGURE 4.89 A simple checker texture reveals stretching on the leg.

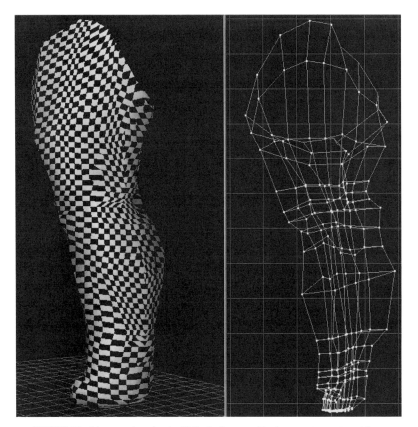

FIGURE 4.90 Move points in the UV window to alleviate texture stretching.

4.92. Notice how we were able to fix some of the stretching through a little UV manipulation. This method will never be without some texture distortion, but it certainly goes a long way without having to break our model up into too many separate pieces. And in many cases, this will do just fine.

You should perform this UV manipulation all along the body where you see texture distortion. When you are pleased with the results, it's time to get into the actual texture painting.

Texture Painting

You can always go back and make some more UV adjustments after you've applied the actual texture, but it's a good idea to set them up

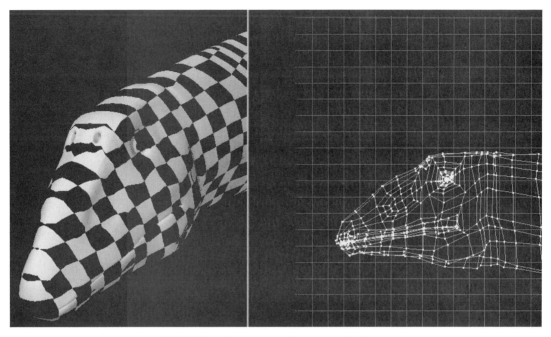

FIGURE 4.91 Texture stretching along the head.

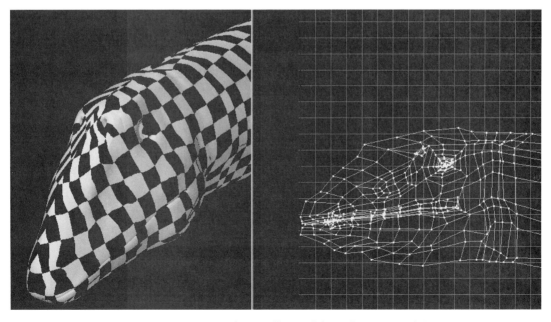

FIGURE 4.92 Texture stretching is alleviated through UV manipulation.

as much as you can beforehand since you are going to use the UV map as a background painting template for the textures.

If your software supports the exporting of the UV map in a user-defined size, then save it as "Apato_paint_template." If not, perform a screen capture of the UV window and paste that into your paint program. The example here was created at a 2560 × 2560 resolution. This will yield a decent resolution for fine detail.

ON THE CD

Earlier it was mentioned that we would be using real-world images for the texture maps. Here's an example of using some quite straightforwardly. Figure 4.93 shows three images from an elephant: one full-body and two close-up. These images will be used for the bump map, so their colors aren't important since bump maps are usually grayscale images. But notice the one thing that these different images share is fairly neutral lighting. This is important for utilizing real-world images as textures. If there

FIGURE 4.93 Three separate images to be used for texture creation.

are too many shadows or hot spots, painting them out will be difficult. The full-body elephant has a few shadow areas, but they can be manually fixed without trouble.

It is easy to locate images such as these either through books or photo CD-ROM collections, or you can make your own during a trip to the zoo. Once you have acquired similar images, load them and the Apato_paint_template. Either pull out all the color saturation through the color adjustments, or change the image from RGB to grayscale. This example starts with placing a full-body elephant image over the painting template. The elephant layer transparency is reduced so you can see the template underneath, and resized so that its legs approximately line up with the "leg holes" on the apatosaurus mesh underneath.

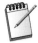 *You may notice that the elephant is facing in the opposite direction from our dinosaur. This doesn't matter at all since we aren't trying to literally fit the elephant onto the apatosaurus. In fact, we are going to take advantage of some of those nice wrinkles near the elephant's front legs. See Figure 4.94.*

FIGURE 4.94 The full-body image is copied into the painting template and resized.

Obviously there is a lot of unneeded image still in the elephant layer that needs to be erased. See Figure 4.95.

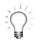 *An alternative to actually erasing the texture image is to mask it so portions don't show. Then you have the advantage of being able to use portions of the texture again since the data isn't gone, just temporarily covered up.*

Next, a close-up image of elephant skin is placed into a layer, moved below the first layer, and resized. See Figure 4.96. This is for the belly. It will help you identify the layers if you name them.

Now begins a little creative cloning. Select your paint program's clone or stamp tool, sample an area on the belly, and paint in the remaining underside. Be on alert for repeating patterns as the result of cloning the same spot over and over. Sample often from different spots to avoid this telltale sign of stamping a texture around. (See Figure 4.97.) Later, you can go over certain spots with some hand tooling to create more variation. A second close-up texture is used on the back for added variation. You can also

FIGURE 4.95 Unwanted portions of the texture image are erased.

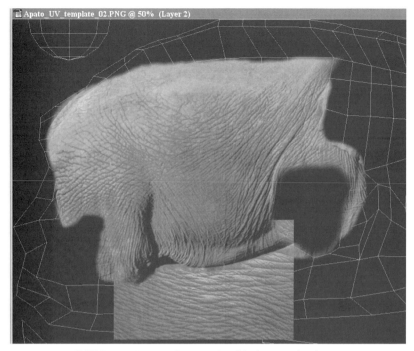

FIGURE 4.96 A second texture is added on another layer.

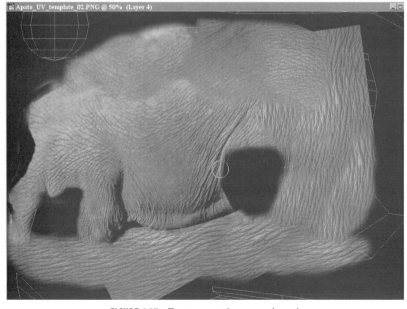

FIGURE 4.97 Texture sections are cloned.

FIGURE 4.98 Beginnings of neck texture with rotated close-up image.

use that same close-up texture and rotate it to cover other areas such as the tail and neck as shown in Figure 4.98.

Complete the rest of the bump map in this manner—cloning, rotating, and sizing the three different real-world elephant textures. Figure 4.99 shows the front leg bump map.

FIGURE 4.99 Front leg bump map.

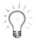 *Don't forget to perform numerous test renderings to check on how the map is actually appearing. (See Figures 4.100 and 4.101.)*

You may find that due to the neutral gray nature of the bump texture it may need to be "punched up" a little after viewing the

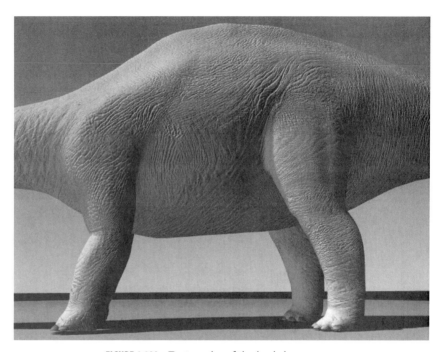

FIGURE 4.100 Test render of the body bump map.

FIGURE 4.101 Test render of the head and neck bump map.

test rendering. That is, you'll want to add more contrast—more blacks and whites. This can be accomplished in several ways. The quickest is to adjust the contrast of the whole map. That may work for some areas, but for more control you'll need to go in by hand. This isn't difficult either, especially if you use the Burn and Dodge tools of your paint software. You can easily selectively paint lights and darks. Just be sure to use a small enough brush, but you don't need to be too careful as all the detail is already in the map, you're just bringing out certain values. (See Figure 4.102.)

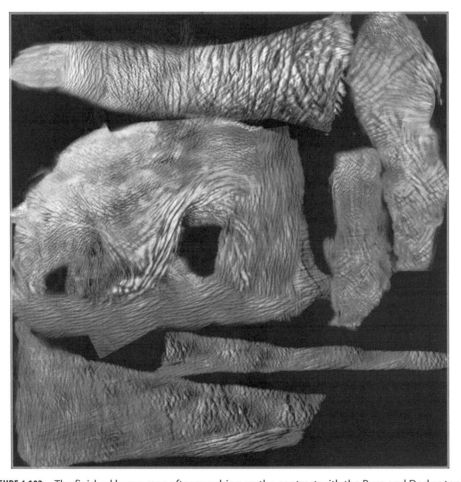

FIGURE 4.102 The finished bump map after punching up the contrast with the Burn and Dodge tools.

Continue with this back-and-forth painting and test rendering until you are happy. Pay attention to the seam areas, and use the clone tool to copy over any adjoining spots. Copy out the bump layer into a new image and save it as "Apato_bump."

That's it for the bump map. You'll be surprised how much mileage you can get from just a few source textures. The real trick is placing them where they make sense. Let's move on to the color map now.

The color map will be handled a little differently than the bump. We will be painting over the mesh template again, so keep that handy. You can even use the file with the template and the bump map layer, but convert it back to RGB if it is in grayscale. Then, hide the bump layer and make a new one for the color.

We're first going to fill the color layer with a solid color. Taking our cues from elephants, make this a brown-gray. (See Figure 4.103.)

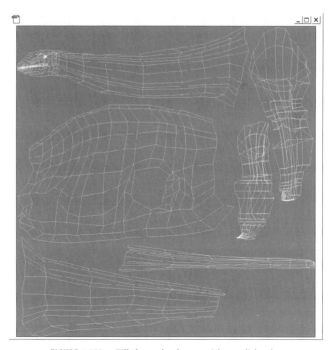

FIGURE 4.103 Fill the color layer with a solid color.

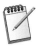 *It's doubtful that an animal this big would have bright colors or camouflage, but you can certainly try that scheme if you like.*

Next, we're going to paint in some rough, broad strokes of different colors. This can easily be done by drawing a lasso selection around an area and filling it with color. Put a lighter color on the underside and a darker on the back as shown in Figure 4.104. Don't be concerned about the harsh edges of colors, since this next step will fix that. Perform a heavy blur operation to soften the whole image. (See Figure 4.105.)

We don't want the apatosaurus to look like a toy, so more color breakup is needed especially on a creature this large. A quick way to get this breakup is to apply a noise filter to the whole image. In this example, which was done in Photoshop, Gaussian Noise with a monochromatic 41-pixel range was used. (See Figure 4.106.)

FIGURE 4.104 Rough out different color variations. See color version on CD-ROM.

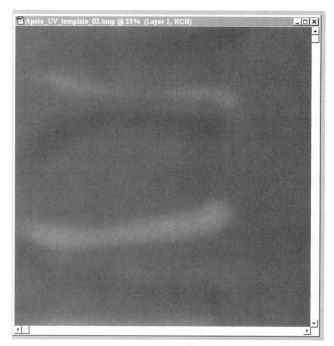

FIGURE 4.105 Blur the image.

FIGURE 4.106 Add Gaussian, monochromatic noise to the image.

That helps, but the noise is too sharp and defined. Once again, we'll call upon our friend the blur. Add a Gaussian Blur with a 4.4-pixel radius to the whole image. This softens the noise nicely, and leaves the splotchy quality we are looking for (Figure 4.107).

We're getting close, but now is a good time to do some hand painting. (You didn't think you'd get out of it, did you?) Again, this can be done mostly with the Burn and Dodge tools. Since we've created this nice splotchy pattern over the map with the noise, it's easy to go in and darken or lighten certain patterns of color. You can pick out stripes or large spots, or just subtly add contrast to certain areas. Figure 4.108 shows the result of some burn and dodge work on the color map.

Let's not forget about the extra bits of geometry that need painting on this map. Zoom in on the eye and give it an off-white color as shown in Figure 4.109. Finish it off with an iris and pupil. This is easiest to do with a Sphere-Selection tool to help paint a clean circle. Figure 4.110 shows the finished eye texture.

FIGURE 4.107 Apply another Gaussian blur to the image.

FIGURE 4.108 Use the Burn and Dodge tools to create more color variation.
See color version on CD-ROM.

FIGURE 4.109 Paint the eye by starting with an off-white color.

FIGURE 4.110 Add pupil and lighter variation within the iris.

FIGURE 4.111 The teeth are given some color variation. See color version on CD-ROM.

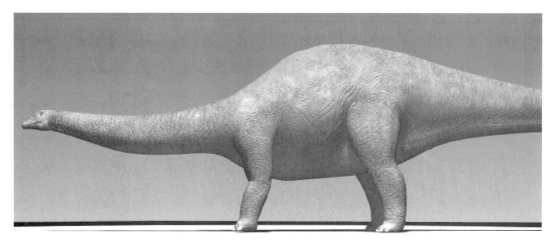

FIGURE 4.112 The finished apatosaurus.

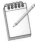 *You may wonder why, since the eye is a sphere, that we didn't apply a spherical map to the eye. In many cases, this isn't necessary, as you'll never see the whole eye (unless you have some gory plans for the eye to be ripped out). Additionally, it's easier to paint on a flat template and the most texture stretching will occur around the sides to the back.*

The teeth can be dealt with in a similar manner. Paint a yellowish-tan color across the teeth area and add some darks towards the base. (See Figure 4.111.) In your modeling package, turn up the specular settings for inside the mouth a little, since those areas will most likely be "wet." Paint the tongue and gums an appropriate color and the apatosaurus is done!

SUMMARY

You have just completed the first model of the book (see Figures 4.112 and 4.113)! How did it go? This model is a good example of how to make a dinosaur from the simplest of modeling operations. If you are feeling good about your results, move on to the next chapter where we will get into a more complex model.

FIGURE 4.113 The apatosaurus out for a stroll.

5 DIMETRODON

IN THIS CHAPTER

- Using Spline Guides to Aid in Form Construction
- Modeling to Facilitate Texture Mapping
- Using Different Mapping Types on One Model

The fantastical-looking dimetrodon ("two long teeth") isn't technically considered a dinosaur, but a pelycosaur ("sail reptile") that existed in the Permian and early Triassic age. The main difference in their construction as compared with the traditional dinosaur is the sprawling posture of the legs—much like today's lizards. The traditional dinosaur's legs would extend straight down from the hips. Comparison of the skulls shows that the dimetrodon's contains far fewer openings or cavities. Aside from the eye (orbit) socket and the naris, there's only one (right behind the eye).

But, of course, the most spectacular feature of the dimetrodon is the huge sail spanning the length of its torso. Made up of spines, most likely covered by skin, it has been the subject of speculation as to its function. The theories have ranged from the literal (it was literally a sail used to aid swimming) to the more realistic and practical (it was used to regulate body temperature).

CONSTRUCTION OVERVIEW

The dimetrodon presents us with a couple of distinctive modeling challenges. The most obvious is the spine sail on its back. How can we effectively and easily model almost thirty spine shapes covered by a thin skin? The second major challenge is the legs. Their natural bent state makes for some tricky texture mapping later on. Here, you'll learn why it's important to be thinking about all aspects of model construction, such as texturing, as early as possible.

With the apatosaurus we used the lathe feature to block out the main body shapes, but for the dimetrodon we will use spline extrusion, or lofting, for added control of the initial forms.

A spline is a curve that can be represented quite smoothly by few control points. (See Figure 5.1.) Splines come in several varieties, which include Cardinal, Bézier, B-spline, and NURBS (non-rational uniform b-splines), and your modeling package might support one or all of these. For our purposes, it is not important to have one type over the other, just as long as you know how to create the desired curve.

FIGURE 5.1 A spline curve.

As mentioned, we will be using splines as a guide to extrude or loft a polygon cross section or outline to create the main bulk and form of the model and parts. Here is the basic theory in practice:

1. Figure 5.2 shows a flat polygon disk and a spline curve.
2. The disk is then extruded along the spline path to create more polygonal geometry. (See Figure 5.3.)

As you can see, forms can be quickly and easily created this way. But it doesn't have to stop with one spline curve. Multiple curves can be used to further define the resulting shape. Figure 5.4 shows the disk with two spline paths and Figure 5.5 shows the result of the extrusion.

With the addition of one more spline curve, a much more complex shape has been created. More splines can add to the diversity of the resulting form. Figure 5.6 shows the same disk that followed four spline paths.

Four is a good number since it allows you to define the top, bottom, and sides of a body. You can conceivably add more splines, but that could be unnecessarily complex. The greater the number of segments extruded, the better they will conform to the true shape of the splines, but keep in mind that the geometry still needs to be manageable and will be subdivided later, so don't make it too dense.

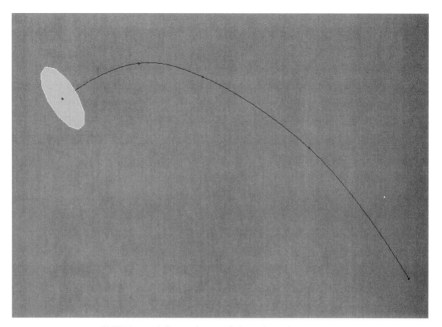

FIGURE 5.2 A flat polygon disk and a spline curve.

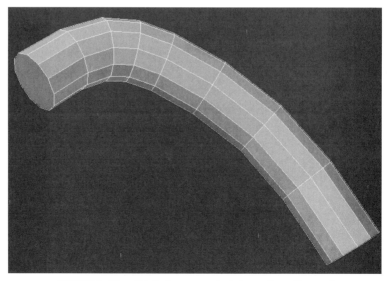

FIGURE 5.3 The disk is then extruded along the spline path.

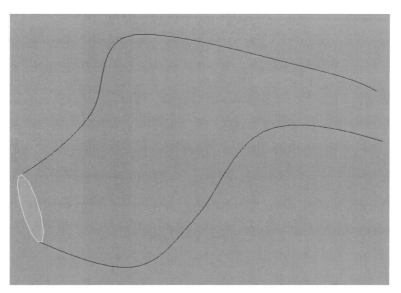

FIGURE 5.4 The disk with two spline paths.

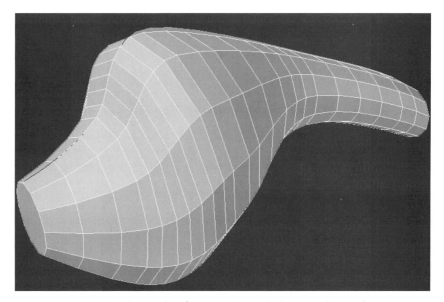

FIGURE 5.5 The results of an extrusion with the two spline paths.

The nice thing about spline extrusion paths is that they allow for easy "drawing" and editing of the contours. With that basic knowledge under our belts, let's tackle building the dimetrodon.

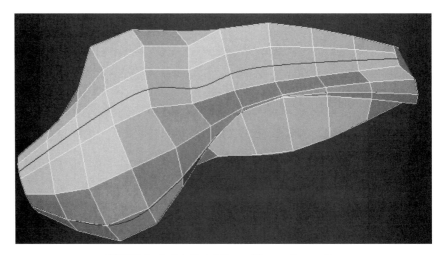

FIGURE 5.6 A disk that followed four spline paths.

Model Construction

More than ever, a design sketch will aid greatly in the construction, especially since we will be drawing spline contours. It's easy to just trace over a drawing. First create, then load your dimetrodon sketch into the side view of a modeler window. (See Figure 5.7.) If you've done a drawing from another angle, such as the top, this will help as well.

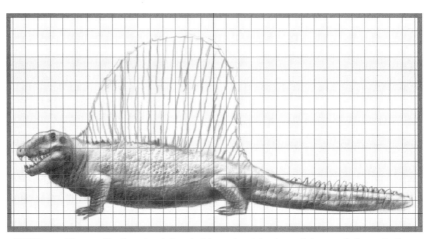

FIGURE 5.7 The profile drawing is loaded into the side view of the modeling window.

Using spline curves, create the top and bottom contours stopping where the head meets the neck as shown in Figure 5.8.

 This example used a spline with eleven control points each for the top and bottom. Having an equal number of points on both splines isn't necessary. As with everything in model construction, have just enough information to define the shape you are creating.

You might have noticed that the head is going to be handled separately. Often while modeling (or tackling any kind of project) it is helpful to break the different major pieces down into separate parts. That way, you can think about what shapes are needed for each section and how they will connect as opposed to trying to tackle a larger chunk. Later in this section, you'll be presented with an alternative spline construction body where the head is included as part of the extrusion. Study and try them both to see which way you prefer.

Let's get back to the modeling. We'll want to make a polygonal shape, which will represent a cross section of the body, to extrude along these splines. A disklike shape is usually good for a body, but how many sides should it have? This is where you'll have to envision the shapes you are trying to create and how much geometry you'll need. Too much geometry will make editing unwieldy, and too little will make defining certain forms difficult. Better to err toward too little as you can always cut in more faces later. Trial and error and some experience will make the decision easier.

FIGURE 5.8 The top and bottom spline curves.

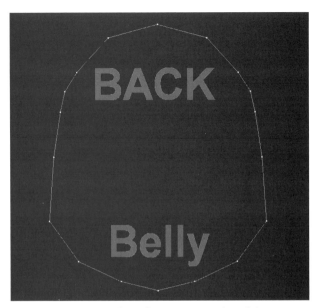

FIGURE 5.9 The polygon cross section disk.

If you are following along with this example, the guesswork can be removed by making a polygon with eighteen sides and shaping it similar to the one shown in Figure 5.9.

Next, this disk is divided up evenly, splitting it vertically down the middle and connecting the vertices horizontally across the body. (See Figure 5.10.) This division will help us in a few of the following steps. First, we are going to bend the polygon to conform better to the background splines. Select the bottom vertices and bend them at the middle until you have something like what appears in Figure 5.11. Line them up with the beginning points of the splines as best you can.

Time to see some volume here. Extrude or loft the cross section with twenty-two sections, favoring the bias toward the points of the splines as opposed to evenly along them. You should end up with something similar to Figure 5.12.

Now, we are going to set up the splines for the head. Rather than treat the head as a whole, we'll break it down further into top and bottom (the lower jaw). This will enable us to draw splines to suit the individual needs of each part of the anatomy. With the

FIGURE 5.10 The disk is split up into smaller polygons.

FIGURE 5.11 The cross section is bent and lined up with the body splines.

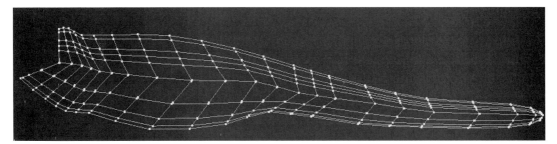

FIGURE 5.12 The cross section is extruded along the spline paths.

background image still visible, create two splines—one representing the top contour of the head and the other the upper lip line—both starting where the neck geometry stops. (See Figure 5.13.)

We are going to need another spline to help define the final shape. This step just involves duplicating the lower lip spline, and moving the two out to approximate the thickness. Have them angle in toward the nose as shown in Figure 5.14.

Now select the upper six polygons of the neck-end cross section (Figure 5.15) and extrude them along the three spline curves with eleven segments. You should get results similar to Figure 5.16.

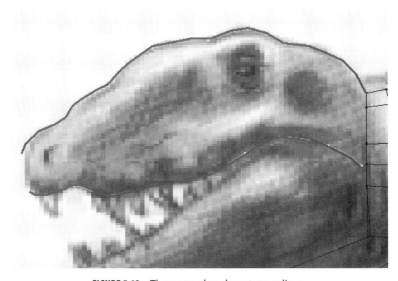

FIGURE 5.13 The upper-head contour splines.

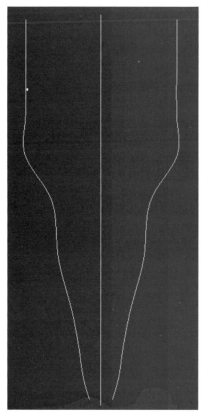

FIGURE 5.14 Top view: The lower lip spline is duplicated and both are moved to approximate the thickness of the head.

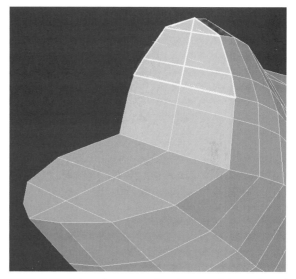

FIGURE 5.15 Select the upper six polygons of the neck-end cross section.

Don't be concerned if the head isn't totally the perfect shape right now. The low amount of geometry will make it easy to alter. But as you can see, the splines helped get the shape blocked out quickly.

Now move on to the lower jaw and create two spline curves that represent the lip and jawline contours according to your drawing. (See Figure 5.17.) Select the four faces shown in Figure 5.18. Be sure to skip the row of faces just under the upper jaw.

Using the jaw splines as a guide, extrude the four selected faces with nine segments. Narrow the tip if necessary and make sure the whole jaw is thinner than the top of the head. You should have something similar to Figure 5.19.

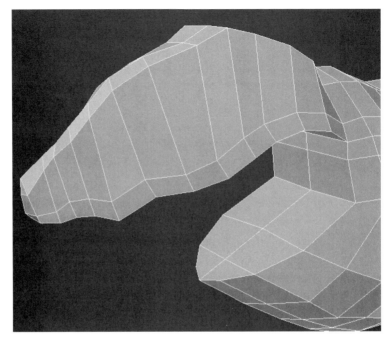

FIGURE 5.16 The upper head extruded.

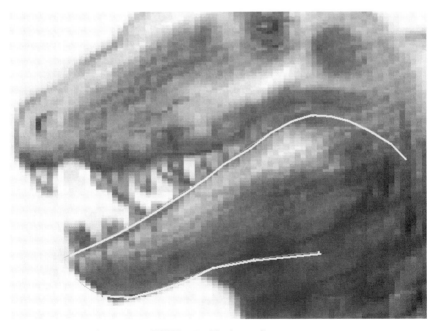

FIGURE 5.17 The jaw splines.

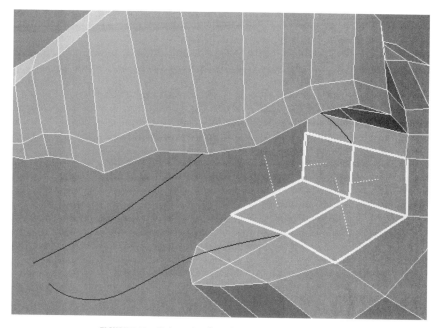

FIGURE 5.18 Select the four faces for the lower jaw.

FIGURE 5.19 Extrude and scale the lower jaw faces.

FIGURE 5.20 Delete eight faces, four under the lower jaw and four on the neck.

 Depending on the modeling package, you might need to delete the originally selected faces that remain inside the model.

Next, delete the eight faces, four under the lower jaw and four on the neck, shown in Figure 5.20, and create new faces to close the hole (Figure 5.21).

We have more deleting to do. Move up to the juncture of the lower jaw and upper head. Delete the fourteen inner faces (six on the lower jaw, six on the upper head, and two on the neck) shown in Figure 5.22.

 A note to avoid confusion: if you are working with the model cut in half, then divide the number of faces mentioned in half.

Now we're going to partially fill this gap. Create three new faces connecting the upper head and lower jaw as shown in Figure 5.23. These faces and the separation of upper skull and lower jaw will later make room for the meaty jaw muscle that is visible when animals such as lizards or alligators open their mouth.

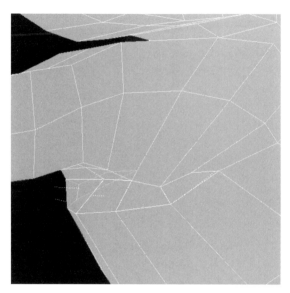

FIGURE 5.21 Create new faces to close the hole in the neck.

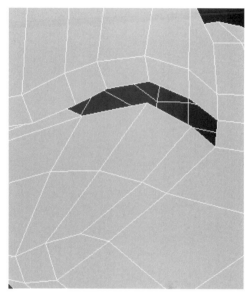

FIGURE 5.22 Delete the inner faces of the upper head and lower jaw.

Now we will fill in the inner mouth or throat faces to close the hole. Create two new faces. (See Figure 5.24.) This is the last bit of work we'll do on the head for the moment.

FIGURE 5.23 Create three new faces connecting the upper head and lower jaw.

Alternate Head- and Body-Construction Approach

This section is here to present to you a slightly different approach. The rest of this chapter will follow the original steps and pick up where we left off, so keep that in mind if you decide to try this method. The main variation in this is including the head in the main spline extrusion. There are fewer splines to make, but there is more manual positioning of individual vertices. Try it out and see which method you prefer.

Starting with our profile curves, create two splines much like the first step in this chapter, however, in this case include the head. Be sure to use your background drawing as reference. (See Figure 5.25.)

Next, create a divided-disk polygon (Figure 5.10), but this time, scale it smaller and place it at the tip of the nose as shown in Figure 5.26. The next step involves extruding it along the splines with thirty-three segments. (See Figure 5.27.)

FIGURE 5.24 Create two new faces to fill in the hole in the throat.

FIGURE 5.25 The two profile splines that include the head.

FIGURE 5.26 The scaled disk, placed at the tip of
the nose

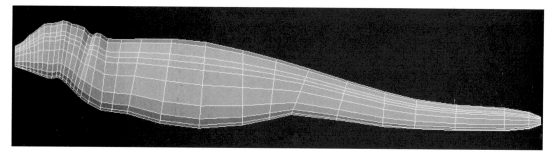

FIGURE 5.27 Extrude the disk along the splines with thirty-three segments.

Using the background design as a guide, move vertices around to define major features such as the upper and lower lip shape. (See Figure 5.28.) Don't worry about stretching those middle polygons, as they will be deleted. We don't need the mouth area faces,

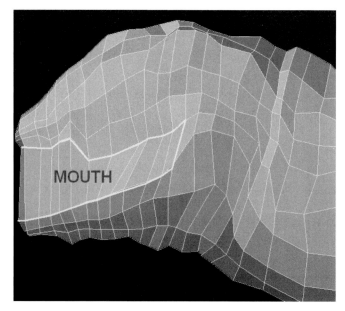

FIGURE 5.28 Move vertices to match features of the head.

so delete them as shown in Figure 5.29. Next, add faces to seal the lower jaw and upper head (Figure 5.30).

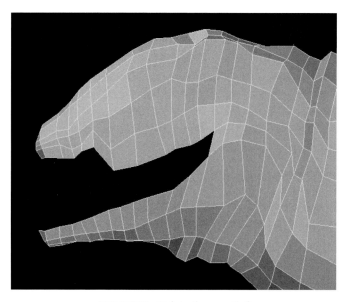

FIGURE 5.29 Delete the mouth faces.

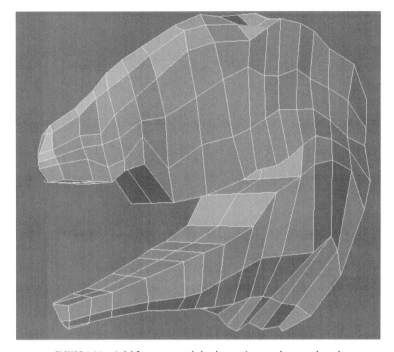

FIGURE 5.30 Add faces to seal the lower jaw and upper head.

That brings us up to the step shown in Figure 5.24 with only a few more head faces. Those can certainly be put to good use.

Back to the Body

Let's return to the procedure where we left off at Figure 5.24. We're going to turn our attention to the body—namely, adding some limbs so this guy can walk around. The legs do pose a few challenges for us to consider before modeling. If you look at the natural leg position for a dimetrodon based on the skeleton, you'll notice that they are quite bent and at odd angles (angles that don't lend themselves to easy modeling or texturing). Let's just jump into a time machine and take a look at the front leg of the finished model in a natural position. (See Figure 5.31.)

While modeling the leg in this position might not be too tough, figuring out how to texture it is. The angles don't lend themselves naturally to any one mapping method. Several would have to be

used. After breaking the leg up into numerous mapping surfaces, that would make the process needlessly complicated. Instead of going to all that trouble, we are going to model the legs sticking straight out as shown in Figure 5.32.

This splayed pose will make the dimetrodon look as if he's ready for filleting, but it will make texturing much easier as you'll see. To get him into a natural pose you have two options.

- Bones are perhaps the most obvious choice for posing models. A skeleton is inserted into the mesh, and then bent, or animated, into whatever position you want.
- Posing the model in your modeling package. If you don't have software that supports bones, or if you just want to make a static posed model without the bone setup, you can bend the limbs into place, but *only* after setting up your UV mapping coordinates. The newly positioned model can be saved out, or the

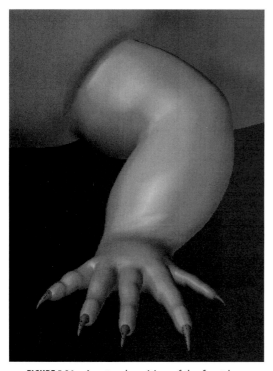

FIGURE 5.31 A natural position of the front leg.

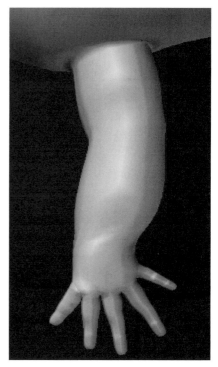

FIGURE 5.32 The leg will be modeled straight out.

original, splayed version can be morphed into the posed one. If you choose the latter, then be sure to not change the point count (usually done through deleting) while altering the original or the morph won't work.

This is why you need to be thinking many steps ahead in all aspects of the model-creation process. Heading off these problem areas early will make your life much calmer down the road.

Having said that, let's get back to those legs. Start with the front leg by gathering four polygons on the body and giving them a slightly rounder outline. (See Figure 5.33.) With those faces still selected, create new ones with an inset or extrude command, but keep them on the same plane as the originals (Figure 5.34).

Let's return to making some splines. Switch to the top view, and create two splines for the shape of the outer and inner edge of the leg that extend down to the foot. Be sure they line up with the edges of the selected faces from the previous step. (See Figure

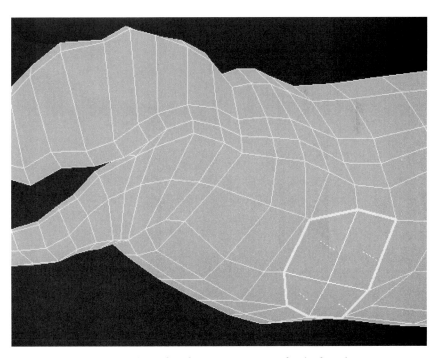

FIGURE 5.33 Shape four faces in preparation for the front leg.

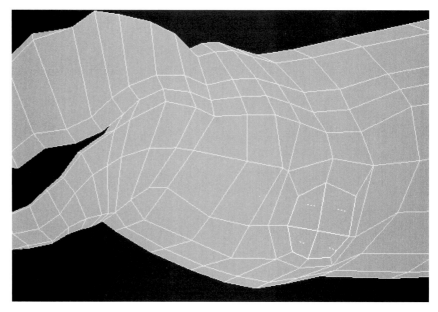

FIGURE 5.34 Create and inset new faces.

5.35.) Extrude the four faces we had selected on the body along the splines with ten segments as shown in Figure 5.36.

Figure 5.37 shows the rear leg splines. In this case, four were used to define the shape. Since there are very few extruded faces, the amount of control in the shape will be limited, but the extra splines can help give you a little more control over the initial

FIGURE 5.35 Create two splines for the shape of the leg.

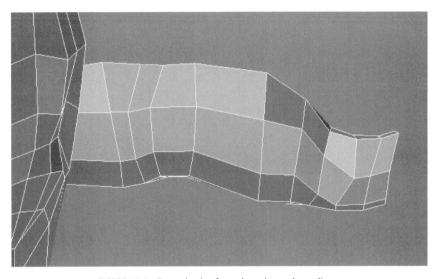

FIGURE 5.36 Extrude the front leg along the splines.

FIGURE 5.37 The four control splines for the rear leg.

FIGURE 5.38 Shape, inset, and scale the four faces to be extruded into the rear leg.

shape. Try a leg with one, two, or four control splines and see which appeals to you.

Shape, inset, and scale the four faces to be extruded into the rear leg just as you did for the front. (See Figure 5.38.) And finally, extrude those faces along the splines with twelve segments as shown in Figure 5.39.

Both legs will still need a little manual refinement. You should use tools such as taper, stretch, and plain old vertex pulling. But we are pretty close. Let's make some toes and claws.

First we need to do a little work to the foot area to accommodate toes. Look at the end of the back leg. You should have ended up with something similar to Figure 5.40. The three faces make a nice base to connect some toes. If you choose to be a little more accurate to the actual animal, they had four toes in the rear and five in front, much like today's alligator.

Here's how we can add geometry for that extra toe to the rear foot. The same procedure can be applied to the front. After shaping and evening out the foot geometry, select the five faces along the outside edge of the foot and extrude them out. Angle the faces so they taper into the shin area and keep the toe area roughly equal in size to the rest of the foot as shown in Figure 5.41. That's all there is to it. Now on to the toes.

In keeping with the theme of this chapter, we will be using splines to shape the basic forms we are creating. Create two splines

FIGURE 5.39 Extrude the rear leg faces along the splines.

FIGURE 5.40 The back leg and foot area.

FIGURE 5.41 Extrude and shape faces to accommodate another toe.

FIGURE 5.42 Create two splines representing the top and bottom of the toe.

representing the top and bottom of the toe and align them with a face of the foot (it doesn't matter which). (See Figure 5.42.) With one face of the foot selected, extrude it along the splines with ten segments. Pull a few vertices to accent the joints and you should have something like Figure 5.43.

That was easy. Only eighteen more to go! No, actually you don't have to create any more splines or toes. You can just duplicate this toe, then position and attach them around the feet. Be

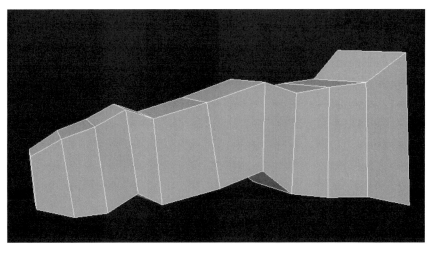

FIGURE 5.43 The finished toe.

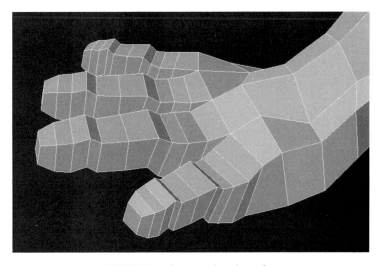

FIGURE 5.44 The completed rear foot.

sure to delete the inner polygons of the area where you are attaching the toe. Figure 5.44 shows the completed rear foot with attached toes. Repeat the same procedure for the front foot and toes.

We're ready to tackle the second major challenge of this model—the large dorsal fin. Although seemingly simple in appearance, this bit of the dimetrodon's anatomy does require some thought and breakdown of its individual forms just like all aspects of a model. The more you think about, understand, and break down all the individual forms you are attempting to recreate, the easier the modeling will go and the better the model will be. The dorsal fin can be broken down into two key parts: the spines and the skin spanning them. A spine can be represented by a simple rectangular box. But we also want to have the skin geometry attached to the spine, so we need to take that into account. It's also important to have enough faces to hold the shape as it subdivides.

Start building a spine by making a segmented box (three segments on the X-axis, two on the Y-axis, and one on the Z-axis) as shown in Figure 5.45. Pull the top to a slight point. We can take this spine, duplicate and resize it for the rest of the spines. But there are approximately thirty that need to be made and that's just a little too tedious. There is a better way! We'll call on our old friends the splines to do the work.

FIGURE 5.45 The spine geometry.

Using your background drawing as a guide, draw two splines, one for the top of the sail and one that follows the back of the body. (See Figure 5.46.) Next, scale and position the spine geometry at the tip of the spine splines (say that five times fast) near the neck. Use the splines as a guide to clone the spine geometry thirty times. This is different from an extrusion, as the rail clone will make copies of the geometry along the splines. Figure 5.47 shows the result of the rail clone. With the help of the splines, that operation just took a few seconds. If the spines are looking a bit too evenly spaced, go in and manually introduce some subtle variation to their angle and spacing.

To create the spanning skin, select the two facing faces between two spines, and use a modeling command such as bridge or connect to make the new geometry between them. If your modeling package doesn't have a command like that, then you'll need to go in and manually connect all the faces to make the skin geometry. But even

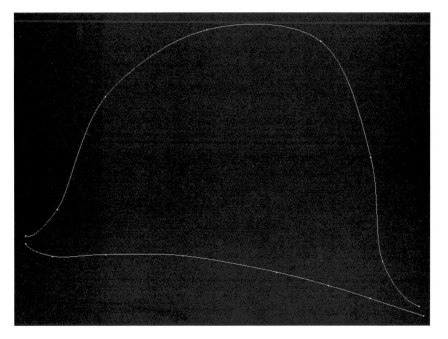

FIGURE 5.46 The spine splines.

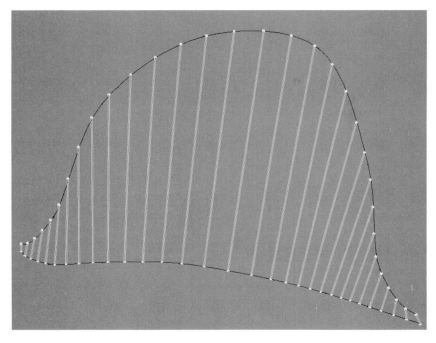

FIGURE 5.47 The rail-cloned spines.

that shouldn't be too difficult. (See Figure 5.48.) The sail with all skin membranes attached is shown in Figure 5.49.

We aren't quite done yet even though the form is all there. The problem will come when we subdivide it. The expanse of the sail from top to bottom is one polygon in length. That's a large area to subdivide without getting some shading problems on the surface. Find out for yourself by subdividing it once or twice. It would help to add a few more rows of faces horizontally and vertically to help "hold" the geometry in place as it subdivides. Cut four rows horizontally, keeping the top and bottom two close to the edges. Then, cut new faces on the skin surface between each spine. This is easy with a knife or split-polygon tool. The points at the top between each spine can be pulled down to give little dips in the membrane. (See Figure 5.50.) We should also cut a new row of faces down the sail's middle. This will help it keep a nice, sharp edge when it subdivides. Zoom in toward the middle geometry of the sail since it is probably pretty thin and cut a new row of faces as shown in Figure 5.51.

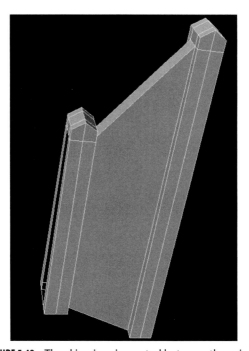

FIGURE 5.48 The skin piece is created between the spines.

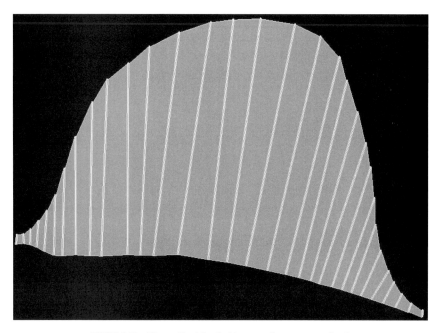

FIGURE 5.49 The sail with all skin membranes attached.

FIGURE 5.50 Extra geometry is cut into the sail.

FIGURE 5.51 Cut a new row of faces along the edge of the sail.

Lastly, we should widen the base just a bit to have it join up more naturally with the body. Select the bottom row of points and stretch them out in both directions as shown in Figure 5.52. Check to see how the sail meets up with the body and make any necessary adjustments so the two fit as smoothly as possible. (See Figure 5.53.)

By now you can really see the dimetrodon coming together. If you are happy with all the forms at this point, it's time to go in and add details.

The head still is a smooth shell, so let's get on that and add features. First, we're going to give it just a little more thickness and at the same time add detail that will help us. Start by selecting the two rows of faces that wrap around the lower jaw and extrude them out just a little. This adds definition to the jawline and a thickness for the inner mouth. (See Figure 5.54.) Do the same

FIGURE 5.52 Select the bottom row of points and stretch them out in both directions.

FIGURE 5.53 Check to see how the sail meets up with the body.

thing for the upper head. Be sure not to select the faces between the upper head and lower jaw or the top of the head (Figure 5.55). Shape any vertices if needed to smooth out the shape or get rid of any harsh edges. Be sure not to make the head too thick, as the dimetrodon's head is rather narrow.

FIGURE 5.54 Select and extrude the lower jaw faces.

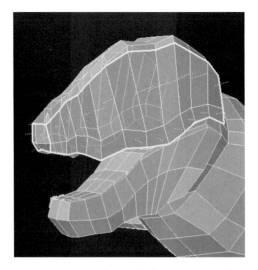

FIGURE 5.55 Select and extrude the upper head faces.

We'll define the eyes now. Select the two faces shown in Figure 5.56 and extrude and scale them in just a bit. Don't move them in too much. We want to add more rows of faces for the eye area. You can do this with a series of extrusions or circular cuts into the existing geometry. Make five of these additions being

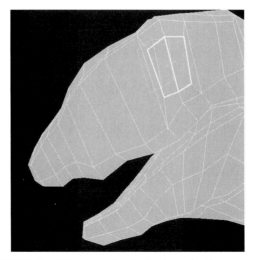

FIGURE 5.56 Extrude and scale the faces for the eye area.

careful not to go too deep into the head. The last extrusions should be straight back into the head for the eye socket. (See Figure 5.57.)

The creations of the other cavities in the head, such as the one behind the eye and the nasal, are done in the same way as the eyes. They won't need as many cuts as the eyes. See Figure 5.58 for an example of the cuts.

FIGURE 5.57 Cut new faces into the eye area and extrude the eye socket into the head.

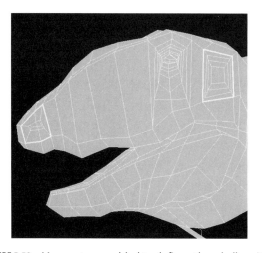

FIGURE 5.58 More cuts are added to define other skull cavities.

We still need to cut some more faces into the head, otherwise it will become a little too soft-looking when subdividing. Begin by cutting horizontally across the face from the nose, through the eye to the back of the skull as shown in Figure 5.59. Now cut new faces across the base of the skull, and then weld or join the two vertices to get rid of that odd-sided polygon (Figure 5.60).

Again, to help define and hold areas on the head, make four more cuts across the geometry as indicated in Figure 5.61.

Don't forget about the inside of the mouth. Surface or name the faces appropriately (such as "Dimetro_inner_mouth"). Pull the middle down on the lower jaw and up on the palate, then extrude the throat back a couple of times. (See Figure 5.62.) Notice that the mouth was modeled in the open position. This was done to give easy access to all areas inside the mouth and the lips. You may choose to close it at any point in the modeling, or do that through facial morph targets or bones. However, it is a good idea to see how the lower jaw closes and fits in the head. Select the lower jaw faces, which is easier if you've named them, and rotate the jaw closed. You can undo that step and make adjustments, then test it again.

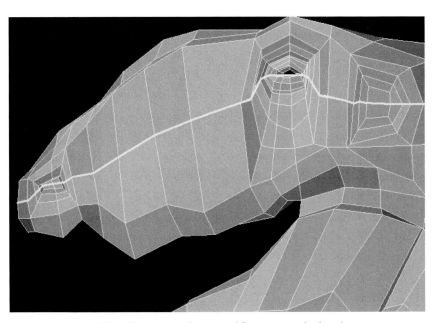

FIGURE 5.59 Cut new horizontal faces across the head.

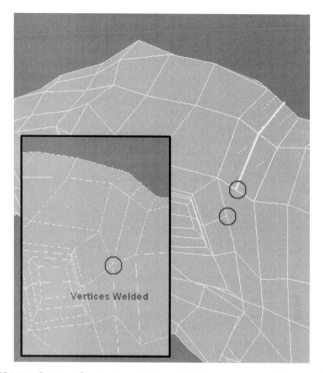

FIGURE 5.60 Cut new faces across the back of the head and weld the vertices.

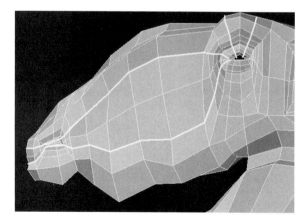

FIGURE 5.61 Make four more cuts across the head and eye areas.

Be sure to make a couple of spheres for the eyes, position them, and adjust the eyelid geometry if needed. Smooth or subdivide the model to check your progress. (See Figure 5.63.)

FIGURE 5.62 Shape the inside of the mouth.

FIGURE 5.63 The subdivided head.

He has a nice crocodile smile going, huh? To make that smile a bit more formidable, we should give him teeth since he was a carnivore. The teeth and nails can be created in the same manner. In fact, you can just create one tooth or nail, and use it for both the nails and the teeth. To make a tooth, create two contour splines and a six-sided disk, then extrude the disk along the splines with five segments. Be sure to name the surface for easy selection later. (See Figure 5.64.)

Now begins a little manual positioning of these small items. For the teeth, study the skull of the dimetrodon to look at the variation and placement. You can make half of the teeth, and mirror the rest, but be sure to make one side slightly different from the other to avoid a too-uniform look. Check to see if the mouth closes with satisfactory results with the teeth included. You don't want them passing through the lips or intersecting each other. (See Figure 5.65.)

One last bit of detail, should you choose to include it, is some small tail fins. These are made from a simple, segmented box, then

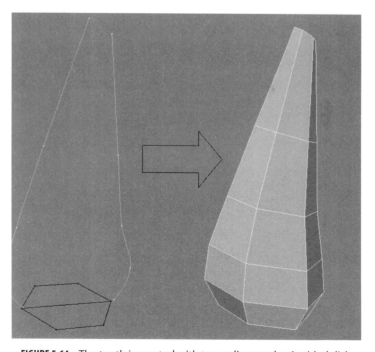

FIGURE 5.64 The tooth is created with two splines and a six-sided disk.

FIGURE 5.65 The teeth are positioned and the mouth checked for proper closure.

FIGURE 5.66 The tail fins are made from a simple box and positioned.

copied, sized, and positioned on the tail as shown in Figure 5.66. You can continue to add more fins or scales this way, but since we have limited space here, we will move on. Check out your dimetrodon one more time to make sure you are happy with it before moving on to texturing. Figure 5.67 shows the finished model in a subdivided state.

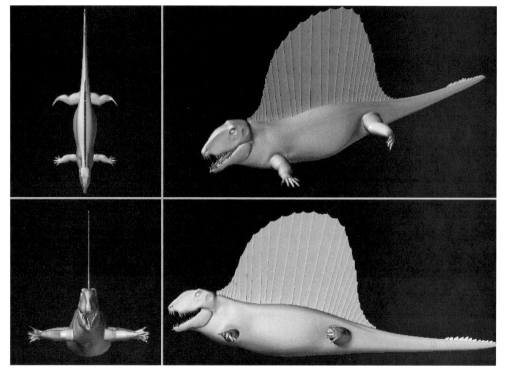

FIGURE 5.67 The finished, subdivided model.

DIMETRODON TEXTURING

Setting Up the UV map

If you're ready, we'll tackle texturing this beast. The first step is to set up and define the UV coordinates. As with the modeling, it helps to break the surfaces down into basic shapes that work with mapping methods such as cylindrical or planar. For instance, a logical choice for a planar UV map is the sail. That's pretty straightforward. But what should we do

about the body? In the apatosaurus chapter, we mapped the body with planar maps. Manipulation of the UV coordinates helped alleviate stretching that occurred, but there was a limit to what we could do there. It would be nice not to have to worry about texture stretching on areas such as the belly or back so we can put in some nice scales and wrinkles. Take another look at the body. Doesn't it resemble a bottle on its side? A cylindrical map would be a good choice to map a bottle, and that would work here, too.

However, cylindrical maps have problem areas at their caps, and this would cause the most trouble on the head. The viewers' eyes will go there first, so we want to have as few problems to hide as possible. But take another look at the head. If you've followed along with this tutorial, you'll see that it has easily defined sides and a top. A planar map would work here.

As you'll recall, we modeled the legs sticking straight out from the body in an unnaturally splayed position. This is where you'll be happy you did so. The legs can each be textured with cylindrical maps since they are in a very cylindrical position right now.

There are a few bits left over at this point. Although we could leave the toes as part of the cylindrical leg maps, cleaner results can be achieved through giving them planar maps. You could get wild here and even give each toe a cylindrical map, but we won't for this tutorial. The eye can be planar mapped, as well as the inside of the mouth, toenails, and teeth.

So let's recap how we'll break this model down:

- Planar mapped: sail, head (sides and top), toes, inner mouth, eyes, teeth, and nails
- Cylindrical mapped: body, front and back legs

Now we have our attack plan. The next challenge is fitting all these disparate parts together efficiently in one UV map. This will be like making a puzzle.

If you've been naming surfaces or parts as you've been modeling, that's wonderful. If not, it's still not too late. Now that you know how you are going to break down your surfacing, you can name those parts accordingly. It will make reselecting them easier.

If you've been working with your model cut in half, mirror it whole again. We are going to start with the body and assign it a

cylindrical map along the Z-axis. The body geometry will be every-thing from the tail to where the head meets the neck. The first thing you want to check for is that there is a nice centerline pass-ing through the body. If there isn't, the map will come out off cen-ter, and the texture will be affected. Figure 5.68 shows the right and wrong centerline alignment. Remember, we need to think of the body as a cylinder. Use the grid feature to check this. If your body wasn't modeled in the perfect position, reposition it, even ad-just some geometry, assign the UV map, and move it back into the original shape if you preferred it that way. Some software allows you to rotate or move the map, or a visual representation of that map, to adjust its positioning. This is also an option. Assign the cylindrical UV map to the body. You should get something similar to Figure 5.69.

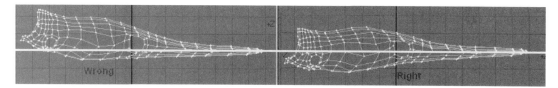

FIGURE 5.68 Make sure the centerline of the cylindrical map passes through the center of the model.

Now we're going to do something that is usually undesirable; we are going to cut the model in half, then mirror it whole again. This will also cut the UV coordinates in half and mirror them, and the results will be textures that are perfectly symmetrical on both sides of the model. This would be very obvious on a model such as a human head, and thus avoided. But in the dimetrodon's case, we rarely will see both sides of the body at once, thus cutting down the risk of seeing the symmetrical textures. The main advantage is that it will buy us some UV map real estate. With half the geome-try represented in the UV window, we'll be able to have it take up more space and fit the rest of the geometry. So, go ahead and cut away. Once you've done that, rotate the body's UV coordinates so they mimic the way the model is built. That is, the belly coordi-nates will be toward the bottom of the window. This isn't crucial,

but will just make for better visualization when painting the textures. (See Figure 5.70.)

While we're in a cylindrical mapping mode, let's tackle the legs. Cut the model in half again, and select the front or back leg. This geometry will start where the leg meets the body and extend to include the foot, but not the toes. Like the body, make sure the leg geometry has a clean centerline through it before assigning the map. Make a cylindrical UV map through the X-axis for one leg at a time. You should end up with some something like Figure 5.71. Then, mirror back the body half. We now have two sets of mapping coordinates that will cover four legs. Again, we are saving space. For now, scale and move them away to make room for the other maps to come. After all maps are assigned, we will resize and fit them better.

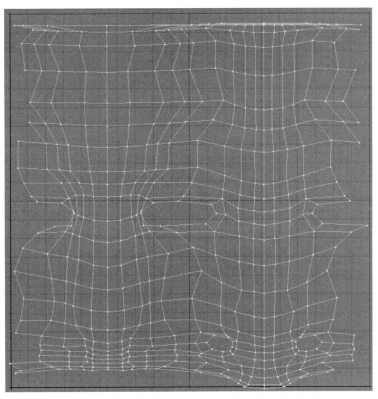

FIGURE 5.69 The cylindrical UV map assigned to the body.

FIGURE 5.70 The body is cut in half and mirrored back, then the UV coordinates are rotated.

The cylindrical maps are the toughest to figure out. Now we just have planar maps to do. Based on the surface breakdown list mentioned earlier, assign the UV planar maps to those parts. Don't worry about proportion in the UV window yet. Just get everything up there. (See Figure 5.72.) It's also a good time to bring back our friend the checker or grid texture and apply it to the surfaces with the UV coordinates we've just made. Check for stretching and other oddities. Most areas should look pretty good, but check out what happens as the tail gets thinner. Notice the way the texture pattern becomes more compressed as compared to the body? (See Figure 5.73.) This is because, in the UV map, the tail geometry takes up the same width as the body, yet in the 3D reality, the geometry becomes thinner. This could lead to the textures you paint becoming compressed in undesirable ways. You could adjust

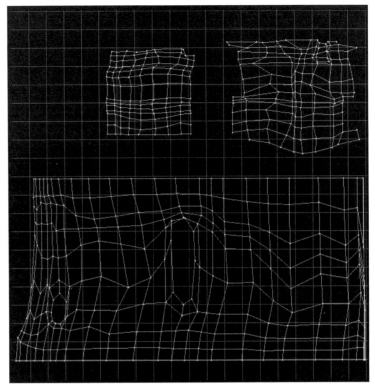

FIGURE 5.71 The legs are cylindrically mapped along the X-axis.

how you paint them, but that's hard to predict. Or, you can adjust the UV map now and avoid that hassle.

Select the tail geometry in the UV window and scale or taper it. Observe the checker or grid texture on the geometry. Notice how it becomes more in proportion with the rest of the body. This doesn't have to be perfectly measured, just eyeball it until it looks good. (See Figure 5.74.)

That part is over, but now begins a little bit of UV room redecorating. As mentioned in the apatosaurus chapter, you'll want to keep all contiguous surfaces that might share a similar texture in relative proportion to each other and the original geometry. However, if you plan to have distinctly different textures on each of the various parts, you can relax that practice a little. You can even take advantage of it. For instance, you can make a surface, such as the

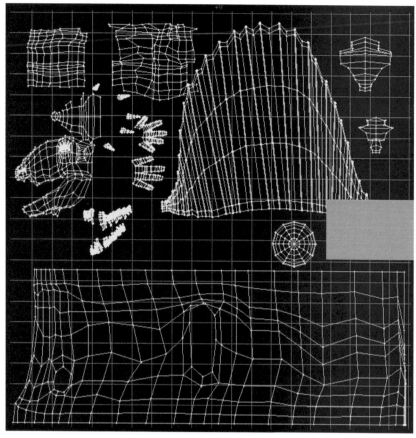

FIGURE 5.72 All the parts with their UV map assignments.

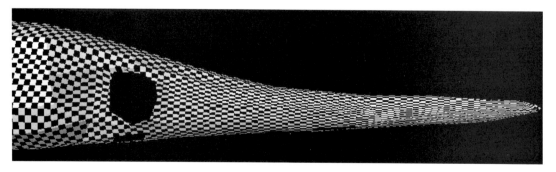

FIGURE 5.73 The texture pattern on the tail becomes more compressed as compared to the body.

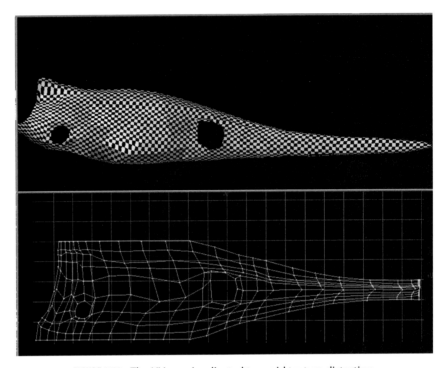

FIGURE 5.74 The UV map is adjusted to avoid texture distortion.

head, bigger in relation to other geometry so you can use a larger portion of the image map, thus affording more detail than less-important areas.

Figure 5.75 shows the completed UV map layout. Notice that the tail was cut off from the body and moved. This was done to allow greater texture resolution on those areas without distorting the proportions. The head top was not cut in half to avoid symmetry issues. This was the only area on the model done this way.

Painting the Maps

You've spent the time setting up the UV map properly, now let's give our dimetrodon some texture. As with all texturing issues, find a real-world counterpart to be the base. In the dimetrodon's case, he resembles a modern day alligator or crocodile. It doesn't hurt our cause that those creatures have been around for millions

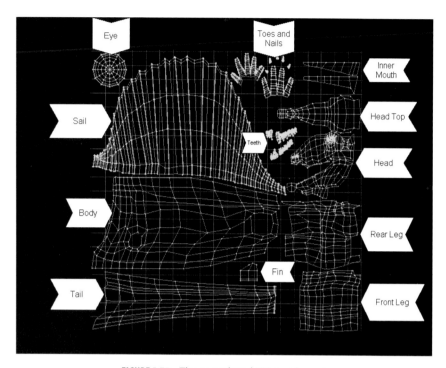

FIGURE 5.75 The completed UV map layout.

of years in some form. And they sure have plenty of cool texture from which to pick. Through books or the Internet, find images of alligators or crocodiles and study them (Figure 5.76). Notice that there are different scale patterns on the back than on the belly or head. Gather as much information as you can.

You don't have to literally copy a crocodile texture, but it can serve as inspiration. It can also help to decide how many different textures you'll want. Just like with modeling, it's good to break down into parts the shapes and textures you are trying to create. You'll want the finished model to feel like a cohesive whole, but the better you understand the surface you're trying to recreate, the easier it will be to do so.

Painting something like this with so many scales would be very tedious to do by hand. You can try it if you like, but leave a good, long weekend to do so. It would be best to make a few texture stamps to clone around the model. Chapter 3 talks about

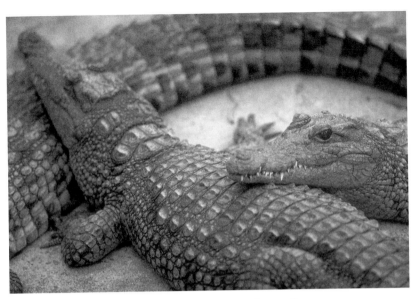

FIGURE 5.76 Reference image of crocodiles.

methods to capture and make a tile or stamp. You can also hand-paint small textures if you can't sample a real-world image. For instance, to recreate the plate-like shingles, first roughly draw a grid pattern on a new 256 or 512 pixel image. Don't make them too even. In fact, make an effort to make it uneven. Make sure that the image tiles. (See Figure 5.77.) Then, just paint in simple shading of white, black, and gray. This does not need to be super-detailed (Figure 5.78).

In your paint program, it's helpful to keep textures such as different scale patterns on separate layers. This will allow you to change and blend with ease. Then, when you're happy, you can merge the layers and continue the blending. But enough talk, let's do.

Create a painting template of your UV mesh. You should know how to do this. If not, return to Chapter 3 to find out how. (See Figure 5.79.) The texture size of the one in this tutorial is 2560 to allow for sufficient detail. Add a new layer and paint, with a scale stamp, the scales that represent the middle pattern strip of the body (Figure 5.80). Add a new layer and duplicate the shingle

FIGURE 5.77 The beginnings of a scale shingle
texture.

FIGURE 5.78 The finished shingle scale pattern.

scale pattern for the belly. (See Figure 5.81.) Figure 5.82 shows yet
another layer and scale pattern added for the back of the creature.

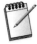 *Don't be concerned about the tonal differences of the patterns. You can adjust the
brightness/contrast and tonal control over each layer until they match up. Erase or
try different textures on layers; these are just some of the advantages of using them.*

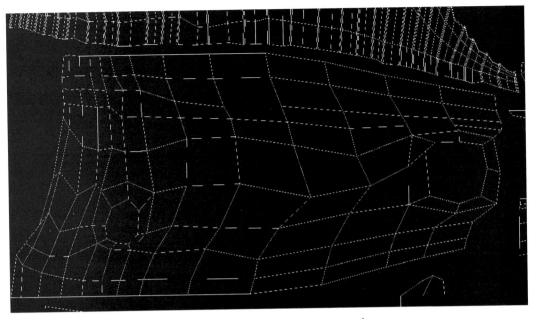

FIGURE 5.79 Close-up of the body area paint template.

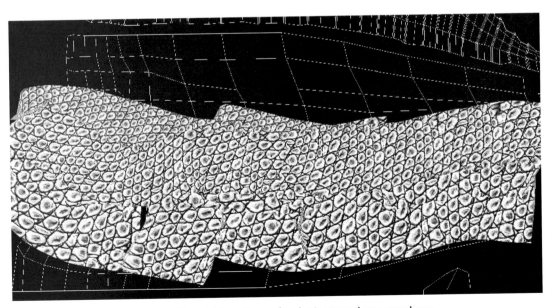

FIGURE 5.80 The middle pattern of scales is created on a new layer.

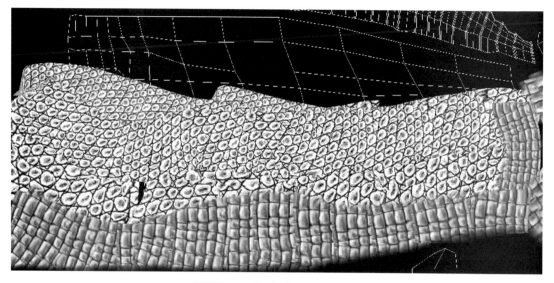

FIGURE 5.81 The belly scale pattern.

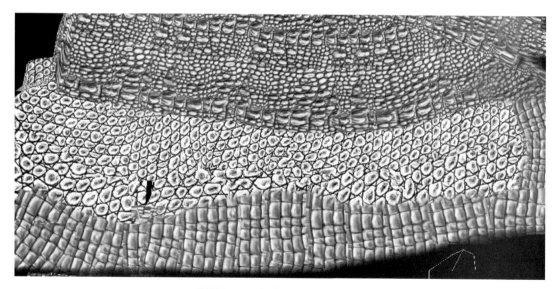

FIGURE 5.82 The back scale pattern.

When you are happy with this stage of bump map, flatten the layers and blend any harsh edges using a soft-edge clone tool and by hand-tooling so the lines and cracks meet up. Be sure to do plenty of test renders. Figure 5.83 shows a bump map rendering on the model and Figure 5.84 shows the finished bump map.

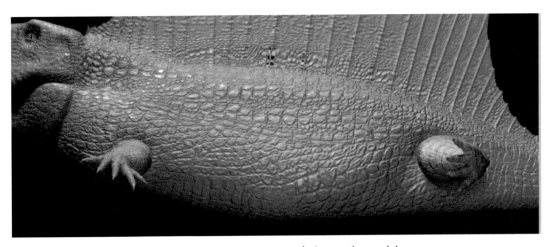

FIGURE 5.83 Bump map test rendering on the model.

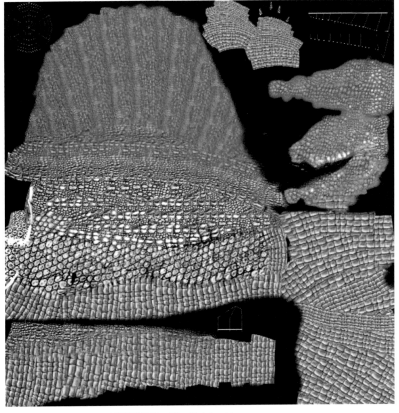

FIGURE 5.84 The finished bump map.

On to the color map. You can do this over the same UV painting template. Create a color layer and fill it with a yellowish tone (if you choose to follow this tutorial). Then, with a gray-bluish color, paint this darker tone over the back area. Make it somewhat splotchy to avoid an unnaturally even look. This can be done with a random-spatter-type brush or by adding noise as described in the texture section of Chapter 4. Add a lighter color on the underside as well. (See Figure 5.85.)

This looks pretty good, but we still want to add more detail. A common feature of scaly skin like an alligator's is darker colors in the cracks. We could paint those in by hand, but there's a better way. Let's bring back the bump map and put it on a layer above

FIGURE 5.85 The base color patterns. See color version on CD-ROM.

the color. Set the layer blend mode to multiply or overlay and by adjusting the opacity, you can quickly add those darks in the crevices. If needed, make different layers with blend mode types at various opacities to get the results that make you happy. Don't forget to paint the eye and other bits of anatomy on the map. (See Figure 5.86.)

We're almost done; hang in there. One map that we haven't touched upon is the specularity. Much like a bump map, the specularity map controls the shininess of the surface through the lights and darks of the map. In fact, the bump map can be used as a basis for the specularity map. On its own, it might be too bright, so alter

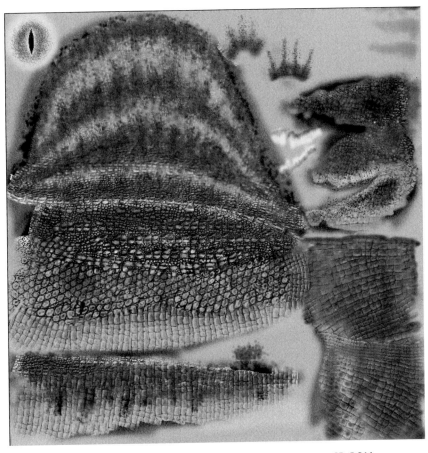

FIGURE 5.86 The finished color map. See color version on CD-ROM.

it using the image manipulation controls of your paint package. Figure 5.87 shows the specularity map for the dimetrodon. This should give him a nice sheen. If you want a wetter look, then brighten the image, dryer then darken. Be careful not to go too shiny as this can lead to that plastic look of computer models that we all want to avoid, unless of course, you are replicating a plastic model!

It's now time to put this all together. If you haven't already, apply all the image maps to the model and perform test renders (Figure 5.88).

When you are happy, set the dimetrodon loose in the swamp! (See Figure 5.89.)

FIGURE 5.87 The specularity map.

FIGURE 5.88 The finished dimetrodon. The legs are positioned using bones.

FIGURE 5.89 The dimetrodon in a habitat.

SUMMARY

Now we can see how splines can help quickly form out a model's basic shape. We also learned the importance of considering mapping early on in the modeling process. This is an extremely crucial skill to obtain, and we will be putting it to good use throughout the rest of this book.

6

PTERANODON

IN THIS CHAPTER

- Construction: Designing a Flat Mesh
- Setting Up UV Maps Early in the Construction Process
- Pteranodon Texturing

The pteranodon represents one of the largest animals to ever soar through the skies. A member of the pterosaur (winged reptile) family, they existed throughout the Triassic, Jurassic, and Cretaceous Periods. Pteranodon means "winged toothless flier." The wingspan reached more than twenty feet, but its construction was light and delicate to facilitate flying. The head, with its large, bony back fin, was nearly twice the length of the body. The head fin is speculated to be a counterweight to the long beak, or a stabilizer during flight. The beak was most likely suited for catching ocean fish, and they might even have had a pelican-like pouch underneath.

Looking at fossils of pteranodons, we can see that the wing resembles an arm, with three clawed fingers approximately halfway down. The fourth, extremely elongated finger actually comprises the rest of the support for the wing. Largely thought to stay aloft by gliding, more recent studies suggests that they were active fliers, flapping their wings much like today's modern birds. Their speculated land-based movements have ranged from clumsy and vulnerable, to the more controversial opinion of walking in a bipedal position.

CONSTRUCTION OVERVIEW

The pteranodon represents a unique modeling challenge due to its wings. How do we create wings that connect seamlessly with the body? The wing membrane could be built separately, and just "inserted" into the body, but sharp edges where the two meet will be visible (Figure 6.1). We don't have to settle for that. A different construction approach is in order.

For this model, we are going to design a flat polygonal template of the dinosaur before entering the modeling program. This can be done on tracing paper over a drawn design or in a paint program. The drawn template is then brought into the background-modeling window, and polygons are created using the template as a guide. This is still done in two dimensions. Then, the points are pulled to give the model volume.

The advantage of this technique is that you can take your time and lay out your polygonal configuration first in a medium that is easier to change (drawing). You can plot out as much detail as you want, and rearrange it until you are confident to start the actual modeling. Another plus is that you can assign planar UV map coordinates while the model is still flat, then add the volume. This helps alleviate any stretching that might occur if you mapped the

FIGURE 6.1 Sharp edges occur when the wing membrane is built as separate geometry.

model afterward. To see an example of this, make a flat plane with several subdivisions. (See Figure 6.2.) Assign a planar UV map and a texture such as a grid. Pull the middle points up and push some lower ones in. Notice how the texture still hugs the shape nicely. To illustrate the difference, make a copy of the modified plane and assign a new planar projection map with the same grid texture. Notice the texture stretching and distortion around the bent areas shown in Figure 6.3.

The challenge of this method comes in breathing volume into the flat mesh. It's a bit less intuitive than starting from simple

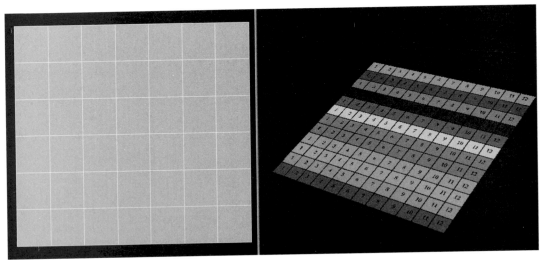

FIGURE 6.2 A simple grid texture is assigned to a subdivided plane.

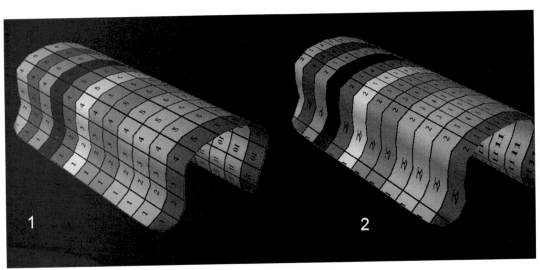

FIGURE 6.3 The difference between assigning UV and texture maps to a flat plane before altering the geometry (1) and after (2).

forms that already have the approximate shape. It also requires you to have some understanding of subdivision routines beforehand while designing the mesh. For our pteranodon, however, you'll find this technique lends itself quite nicely.

COLOR PLATE 4 Dimetrodon from Chapter 5.

COLOR PLATE 5 Pteranodon from Chapter 6.

COLOR PLATE 6 Stegosaurus.

COLOR PLATE 7 Tyrannosaurus Rex from Chapter 8.

Pre-Production

We will start with the drawn pteranodon design shown in Figure 6.4. You may choose to draw top and side views, but in this case the head was drawn turned to profile. It won't be modeled that way, as you'll later see. Either with tracing paper or in a paint program such as Photoshop begin plotting out the mesh. If using a paint program, make the document dimensions large enough that you'll be able to draw thin, single-pixel lines in detailed areas if needed (2000 pixels by 2000 pixels for this example). Create the mesh layout in a new layer. The line tool makes this process easy and is preferable to freehand airbrush drawing. (See Figure 6.5.)

FIGURE 6.4 The pteranodon design.

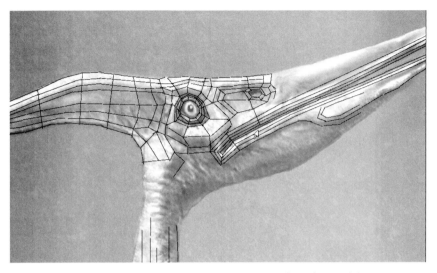

FIGURE 6.5 Use the line tool in a paint program to draw the mesh layout.

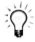 *It's not imperative that the lines meet perfectly, just as long as you can see what's going on. Change the color of the lines if necessary for better viewing against the underlying drawing. (See Figure 6.6.)*

Keep in mind the shapes you're trying to ultimately create and plot your lines accordingly. Don't just draw a square grid. Think about the "flow" of the polygons. Will they help define the forms? Will they be easy to differentiate and edit? Will they lend themselves to being bent or displaced by bones? Remember some of the rules of subdivision, such as polygons that are closer together will create a tighter edge or crease. You can opt to add the finer details, such as adding more rows of polygons, later in the modeling stage to keep the drawn mesh less cluttered.

There will be places where you paint yourself into a corner, polygonwise. Or you might be unsure of what to do with certain rows where many polygons converge. One such example of this case is in the pteranodon's wings. If we just carried the rows of polygons off the body and down to the end, by the end there would be quite a few colliding at the tip. Not only would this be an unnecessary number of polygons to define that area, it would also cause some shading problems, as there would be many hard

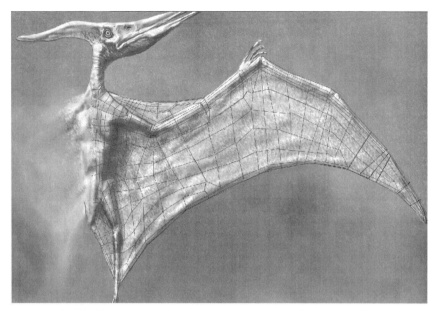

FIGURE 6.6 Design the mesh over the sketch and change the color, if desired, for better viewing.

creases. It would also be difficult to edit. But notice the mesh layout of the wings of this example. There are a few key points where the polygon count is "terminated" to prevent unwanted clutter in small areas. This can be done by ending a row in a triangle, but it is even better to end them in quads. (See Figure 6.7.) Near the tip of the wings there are only three rows, whereas near the body there are thirteen! These diamond-shaped quads are a good way to terminate or add detail.

Plotting out the mesh is much like creating a jigsaw puzzle, but one that has some function as opposed to random shapes. The head is handled in much the same way as the body, with the beak presenting the same problem as the wing tips. Keep the eye and mouth area a radial configuration. Since this angle is meant to represent the profile of the head, the neck polygons aren't the same count and don't line up with the body. This is because the body will be mirrored for the front and back, or top and bottom of the creature. So, the neck connection on the body will have double the polygons drawn here. When you are satisfied with your

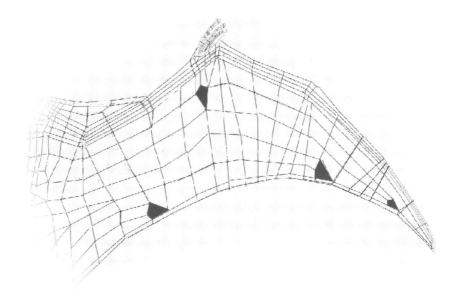

FIGURE 6.7 An example of how polygonal detail is terminated.

drawn-mesh layout (Figure 6.8), cut and paste the layer into another document and save it as "Ptero_template."

Modeling

By now, you are probably itching to get into the modeling, so let's not waste any time. Start up your modeling program, and load the Ptero_template in the top view. (See Figure 6.9.) The pteranodon wingspan is about twenty feet; so since this template represents half the creature, size it to around ten feet in the modeling window. It's time to play connect-the-dots. This will go quickly since you've laid down the map already. Aren't you glad you took the time to do that now? Start anywhere and create polygons over your template drawing. Creating them in rows is a good idea, as you can still see the underlying drawing. (See Figure 6.10.) Then, fill in the gaps. Again, don't worry about any other view than the top. Work your way all around and finally down to the fingers (Figure 6.11). When you are done, you should have half the body as shown in Figure 6.12.

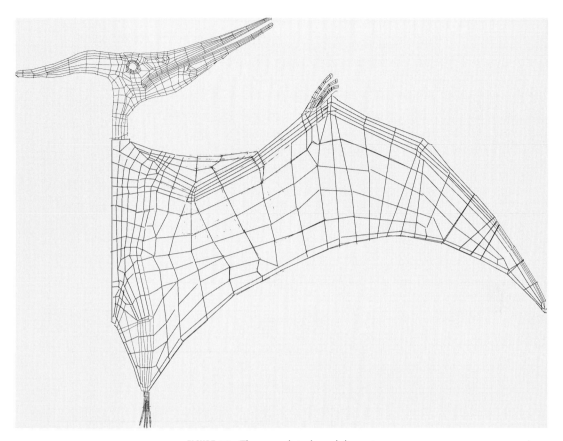

FIGURE 6.8 The completed mesh layout.

FIGURE 6.9 The template is loaded into the top view of the modeling program.

FIGURE 6.10 Build polygons over the template guide.

FIGURE 6.11 The finger configuration.

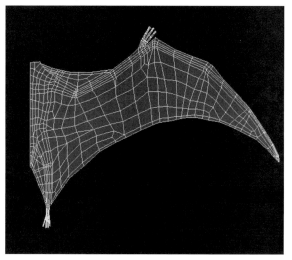

FIGURE 6.12 The completed body half flat mesh.

It's time to mirror this to create the other half. First, select the middle row of points and set their coordinates to 0 on the X-axis. (See Figure 6.13.) This will insure that no points overlap when you mirror. And speaking of mirroring, do that now. See Figure 6.14 for an example of the completed body.

Before we go any further, let's name our surface "Ptero_skin." It doesn't matter what color you give it at this point since it will be covered up by the texture maps. Make a copy of this object and flip

FIGURE 6.13 Select the center row of points and set them to 0 on the X-axis.

the polygons so they are facing the opposite direction. This copy will be for the front or underside of the bird. If your program supports labeling parts, then label each "Ptero_front" and "Ptero_back." This will allow for easy selection later if need be. Separating the two will help later when assigning the UV coordinates.

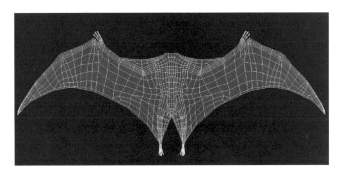

FIGURE 6.14 The completed flat body mesh.

Also, with the front geometry, add four more polygons in the front of the neck and terminate them with triangles. This extra geometry will allow the number of polygons in the head to connect cleanly with the body. (See Figure 6.15.)

FIGURE 6.15 Extra polygons are added to the front.

If you haven't done so already, create the head template in the same manner as the body (Figures 6.16 and 6.17). Label the polygon parts "Ptero_head," but give it the same surface as the body.

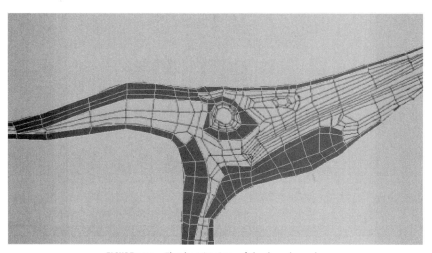

FIGURE 6.16 The beginning of the head mesh.

FIGURE 6.17 The completed head mesh.

Except for a few smaller sections, this model will be made up of one surface. The part labeling is for easy selection. When the head is completed, rotate it –90 degrees on the Z-axis. (See Figure 6.18.) This will put it on the X-axis. Move the head close to the body and you will start to see the pteranodon a little more dimensionally, although it still looks like a paper cutout as shown in Figure 6.19.

FIGURE 6.18 The head is rotated on the Z-axis.

FIGURE 6.19 The flat mesh as seen in the perspective view.

UV Maps

We are going to assign our UV maps now. Although it might seem a bit premature to be thinking of mapping, it will serve us well if we do. As mentioned earlier, if we make the maps now, as the model takes shape, the texture will still conform nicely to the forms you make. This is because the UV maps are assigned while the model is in the simplest mapping form—planar. There's no stretching with a planar map on a perfectly flat plane. When we assign a planar UV map to a perfectly flat model, it "remembers" those coordinates no matter what shape the model takes later. The problems inherent in planar mapping on a non-planar surface will be greatly reduced and easier to combat if encountered.

The main disadvantage to assigning the maps at this stage is that you should try to avoid cutting the body in half and mirroring it again, which is a standard practice for modeling to reduce working on both sides at once. Cutting and mirroring will do the same to the UV map coordinates, and whatever texture map is made will be repeated or mirrored on the left and right sides. This could potentially create a telltale symmetry that can destroy the illusion of

something natural. To fix this, you will have to select the faces that make up the new half of the body, and then move and mirror the UV coordinates. Not a huge hassle, but a few extra steps. If your program has a symmetry feature, then this cut and mirror operation isn't going to be needed.

The following steps all take place in the UV editor. Select the front and back body geometry. Since they are lying on the same plane, they won't be distinguishable from each other. It's time to assign the UV map. Create a new planar UV map along the Y-axis, since that's the direction it's facing, and call it "Ptero_skin_UV" (if your program supports naming of UV maps). In the UV edit window, you should see the body template looking much the same as we first made it. (See Figure 6.20.) You can also flip the underside

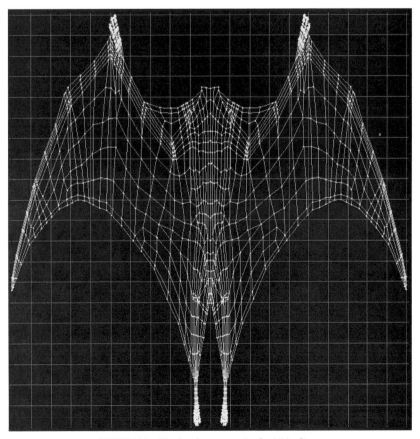

FIGURE 6.20 The body as seen in the UV editor.

faces in the UV window along the U coordinates. You will not notice a difference on the screen, but you will notice it later when painting, as the right and left sides of the geometry will be on the same side for both the top and bottom faces.

Now deselect the body, and select the head geometry. Remember, naming these parts will make this much easier. Reassign the Ptero_skin_UV planar map along the X-axis. You should see the head taking up the whole window along with the body. (See Figure 6.21.) What we want to do now is position the various sections to allow easy and proportional UV painting. Select the body halves and scale both body halves down vertically as shown in Figure 6.22. They can keep their horizontal scale. Next, select just the back of the body, and move it up above the front half (Figure

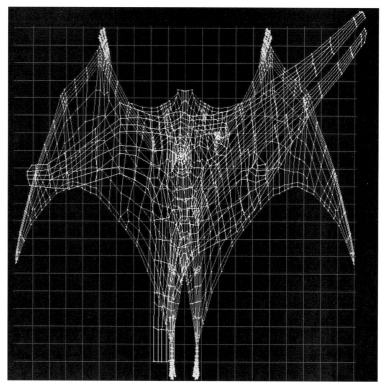

FIGURE 6.21 The head geometry is assigned UV coordinates which will overlap in the UV editor.

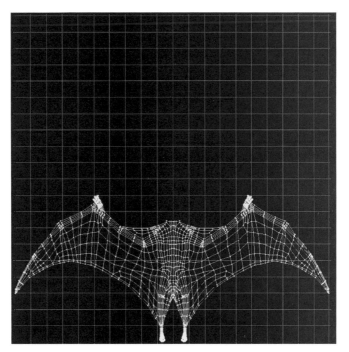

FIGURE 6.22 The body geometry is scaled down in the UV window.

6.23). Select the head and scale and stretch it until it's fairly proportional to the body. (See Figure 6.24.)

We want the head to be proportional so the texture map pixel ratio remains close to the body. Otherwise, your painting at that stage will be a bit more difficult. One way to test these proportions is with our good friend the grid texture.

Load in a grid image, and apply it to the Ptero_skin surface with the Ptero_skin_UV. You should see a grid paper pteranodon similar to the one in Figure 6.25. Zoom in close to where the head meets the body. Do the grid cells look the same size? They should be in the right ballpark, but you can further refine the ratio by using the grids of your modeling program. Just observe the head and body grid texture with the modeler's grid. Do they occupy the same space? If not, select the head geometry in the UV editor and scale them until the grids are proportional. (See Figure 6.26.)

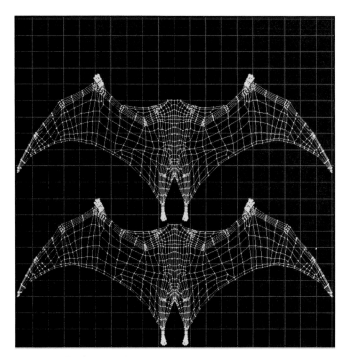

FIGURE 6.23 The back half of the body is moved up above the front half.

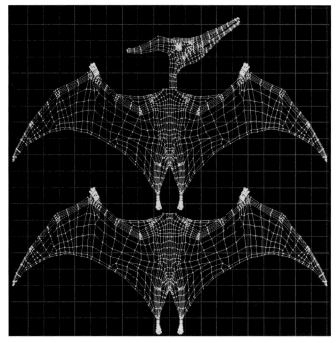

FIGURE 6.24 The head geometry is scaled to be proportional to the body.

FIGURE 6.25 A grid paper texture is applied to check the texture alignment.

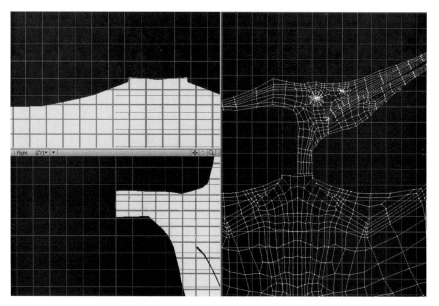

FIGURE 6.26 Use the grid in the modeling window to check the UV proportions of the head and body.

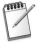

Why did we separate the front and back of the body, but not create two halves for the head? We could have just created one planar UV map that covered the front and back of the body, but then the texture would be the same for the front and back. This could work, but it would be better to be able to paint different texture variations for both halves. This isn't as crucial on the head, since you really won't see both left and right sides at the same time. The head is rather narrow, so the fact that the texture is the same on both sides will hardly be noticed. However, you can opt to create UV maps for the right and left sides of the head through the same procedure we used on the body.

Back to Modeling

We've set up the UV map coordinates, now it's time to get back to modeling and breathe some life into this flattened form. Start with the back of the body. Hide or make noneditable the other body parts such as the front and the head. On the back, select all the points except those of the outer edge. (See Figure 6.27.) These points must remain where they are, at 0 on the Y-axis, since they represent the horizontal midline of the body. They also need to meet with the points from the front half of the body. Move these points up on the Y-axis a small amount, about one-quarter to one-

FIGURE 6.27 The first selection of points for moving.

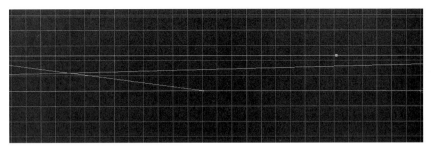

FIGURE 6.28 The first selection of points is moved up along the Y-axis.

half inch. We are creating the thickness of the wings, and remember that you will be doing the same to the front half, so don't make it too thick. (See Figure 6.28.)

Clear the point selection that comprises the wings, but keep the selection that makes up the middle section of the body, arms, legs, toes, and fingers. (See Figure 6.29.) Move these up, a little more than you did with the wings (Figure 6.30). Check your shaded view port to judge the thickness. (See Figure 6.31.)

FIGURE 6.29 The second selection of points.

FIGURE 6.30 The second selection of points is moved.

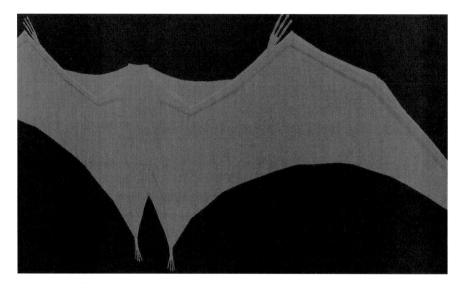

FIGURE 6.31 The results of point movement as seen in the shaded view.

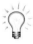 *If your software supports naming point parts, then you can use it to name these selections of points if you need to go back to edit them.*

Shrink the point selection again, this time deselecting the toes and fingers, keeping the midline of the arms and legs. (See Figure 6.32.) By now, you should see the pattern here. Move these points up some more, and view the results in the shaded view. (See Figure 6.33.)

Make another, smaller selection of points, mainly composing the back, and move those up yet again as shown in Figure 6.34. We won't do this procedure for every row of points, as we don't want to create a stair-step geometry. Pull up the middle row of points for

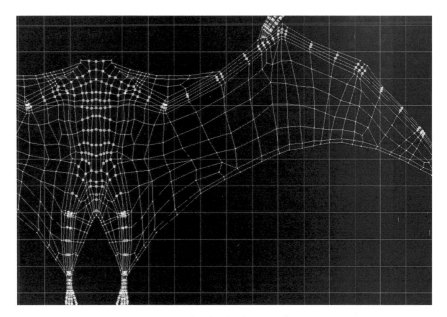

FIGURE 6.32 The third selection of points.

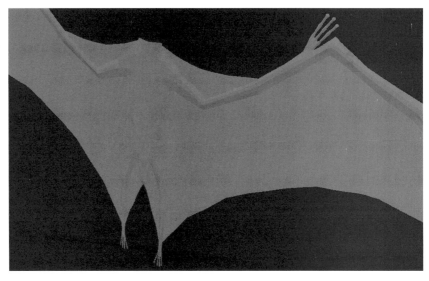

FIGURE 6.33 The results of the third point movement.

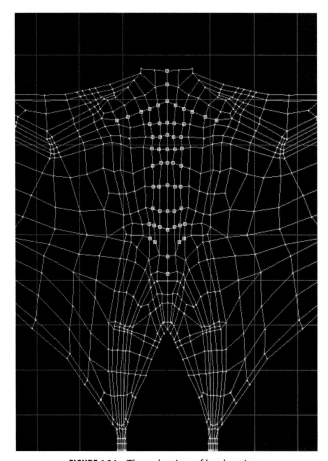

FIGURE 6.34 The selection of back points.

the spine and subdivide or smooth the model so far to view the re-
sults. You should have something similar to Figure 6.35.

 Don't be too concerned at this point about specific details or getting the back perfect. We need to work out the proportions of the rest of the model first.

Turn your attention to the front half of the body. Hide the
back's geometry and perform the same procedure of selecting
points, moving, shrinking the selection, moving. This time, bring
the chest out a bit more than the back. (See Figure 6.36.) Again,

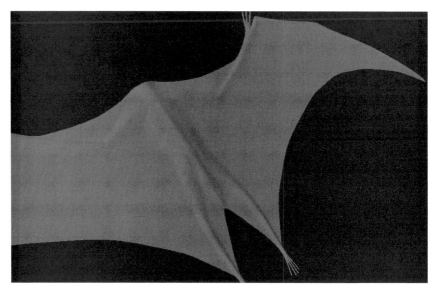

FIGURE 6.35 Smoothed view of the back.

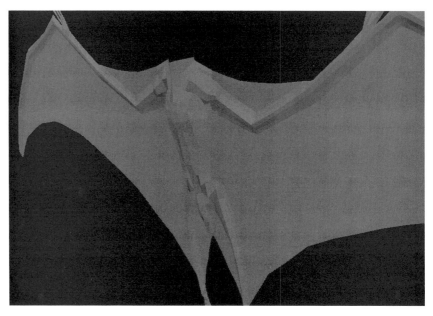

FIGURE 6.36 The front half shaped.

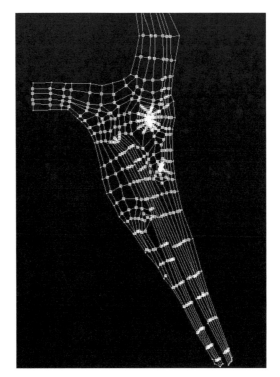

FIGURE 6.37 The first selection of points on the head.

don't be too concerned yet with any details; just develop a sense of the shapes that differentiate the front from the back half.

On to the head. As you've probably guessed, the procedure is again the same as with the body. Select the points except for the outer edge and the inner edge of the beak or mouth. (See Figure 6.37.) Move the selection out as shown in Figure 6.38. Shrink the selection, and move that out yet again. (See Figure 6.39.) Think about the underlying forms now. Don't just keep moving smaller and smaller rows of points out. (See Figure 6.40.)

At some point, you'll need to move points back into the head to form the eye area, fin, and other depressions. (See Figure 6.41.) Again, don't be concerned with the individual details yet such as making the eyelids just so. First, get a sense of the head as a whole by mirroring the half. (See Figure 6.42.) Remember that we want the UVs to be mirrored as well.

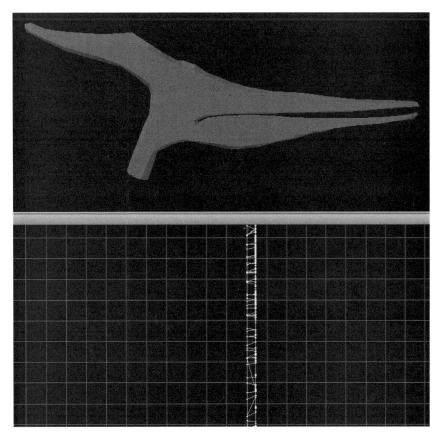

FIGURE 6.38 The first selection of head points are moved out.

Don't worry if the head still looks a little boxy or flat in places. It's time to take in the pteranodon as a whole and adjust the proportions further. The reason for not working any details at this point is that they might get ruined if you need to do any broader adjustments. Make the front and back half of the body visible, and view them together with the head. (See Figure 6.43.) Finally, we're seeing him start to come to life. Pretty cool!

Move the head closer into place. Spin the model around and study it from all angles. Try to envision it without the wing membrane; does the body still look too flat? If so, pull more points on either the front or back or both to add some more dimension. (See

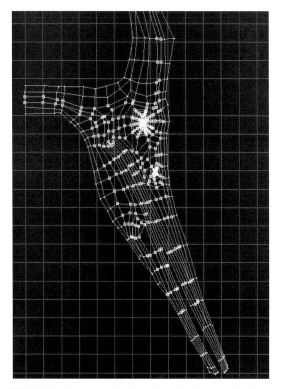

FIGURE 6.39 The second selection of points on the head.

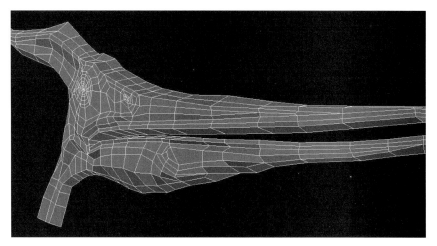

FIGURE 6.40 The result of the second point movement.

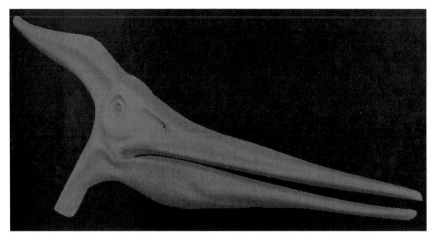

FIGURE 6.41 Move points back into the head for the eyes and other depressions.

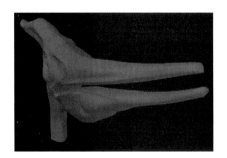

FIGURE 6.42 The head is mirrored to make a whole.

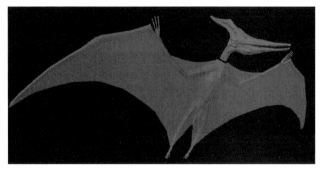

FIGURE 6.43 The model as a whole.

Figure 6.44.) Think about the underlying anatomy. Magnet operations are useful for making broad geometry changes.

Refinement

If you're happy with the rough forms, then it's time to refine the shapes even further. For instance, let's start with the chest. Pull out some points to define the breastbone that birds have. Push points to shape the armpits and chest muscles. (See Figure 6.45.)

Give more shape to the arms to keep them from looking like tubes and use some of the extra geometry we put at the joints to make creases as shown in Figure 6.46.

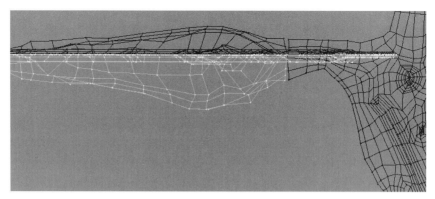

FIGURE 6.44 Adjust the body proportions if it still appears too flat.

FIGURE 6.45 The torso is further defined.

FIGURE 6.46 The arms are given more shape.

Pay the same attention to the legs and define them more. On the front, the small tail can be flattened down, letting most of the bulk be in the back (Figure 6.47).

On the back, sharpen the scapula and shape the arm muscles as well as the legs. (See Figure 6.48.)

Don't neglect the fingers and toes. Give them more form by pulling out the knuckles on the back half. (See Figure 6.49.)

Moving back to the head, let's insert some eyes and shape the lids closer to them. First, create a sphere with 12 by 12 divisions. Give it a surface name of "Pter_eye." Size and position it close to the lids as shown in Figure 6.50. Then, shape the geometry of the lids to closely hug the eye. (See Figure 6.51.) And here's an exam-

FIGURE 6.47 The legs are given more form and the tail is flattened in the front.

FIGURE 6.48 Define the anatomy of the back.

FIGURE 6.49 The fingers and toes are shaped.

ple of adding detail at this stage: Cut or knife a new row of polygons around the eye (Figure 6.52). This will help us give the lids a sharper delineation for the eye socket.

Moving down the head to the mouth, select the middle row of points inside the mouth and flatten them so they lie more flush with the edge of the beak. (See Figure 6.53.)

FIGURE 6.50 Eyes are created and put into place.

FIGURE 6.51 The lid geometry is shaped closer to the eye.

Since we're in the neighborhood, let's work on the inside of the mouth. The first step is to add another row of polygons to the inside edge of the beak as shown in Figure 6.54. Make sure you do this for the top and bottom. Next, select the inner row of polygons and give them a surface called "Ptero_mouth_inner." (See Figure 6.55.) Pull the lower jaw portion of the inner mouth down into

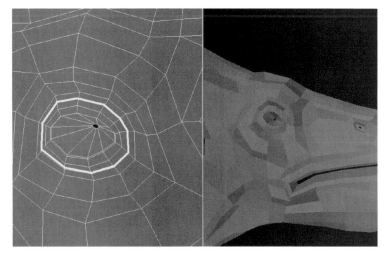

FIGURE 6.52 Extra geometry is added around the lid.

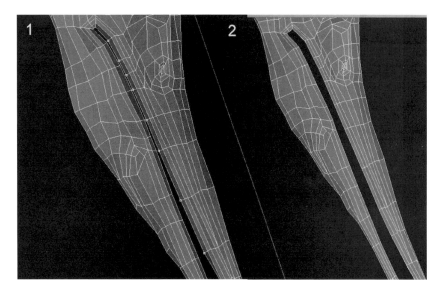

FIGURE 6.53 The points of the inner mouth are brought flush with the edge of the beak.

the beak and move the upper up. Now he has a nice cavity to catch fish. (See Figure 6.56.)

We should let him taste the fish by building a tongue. For ease while working, hide all the polygons except those in the lower inner mouth. Select two polygons toward the back of the throat,

FIGURE 6.54 Add an extra row of polygons to the inside of the mouth.

FIGURE 6.55 Surface the inner mouth.

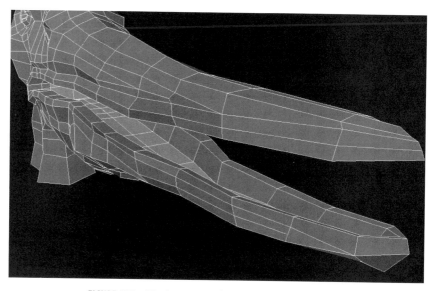

FIGURE 6.56 The inner mouth is pushed into the beak.

give them a surface name "Ptero_tongue," and extrude them up as shown in Figure 6.57. Next, select the two forward-facing polygons of this new geometry and extrude them far forward to the tip of the beak (Figure 6.58). Scale them down if necessary. The final steps are to cut the tongue into six sections, give it a natural shape, and lay it on the bottom of the inner mouth. (See Figure 6.59.) Finally, pull the middle row of points down to create a depression.

Lastly, let's give this guy room to swallow his food by creating a throat. This will also help if he opens his mouth during an animation. The throat is as simple as collecting the polygons in the

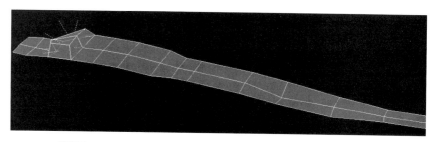

FIGURE 6.57 Extrude two polygons for the beginning of the tongue.

FIGURE 6.58 Extrude and scale the tongue polygons.

FIGURE 6.59 Cut the tongue into sections and shape it to the lower jaw.

back of the mouth, where the top and bottom meet, and extruding them back a couple of times. (See Figure 6.60.) Make sure they don't poke out of the side of the neck. If they do, just scale them down a bit.

The pteranodon doesn't have teeth, but it does have claws. We will make one claw and duplicate it on the fingers and toes. To make a claw, create a cube with two segments on the X-axis and five on the Y-axis (Figure 6.61, step 1). Taper this and pull up the points on the underside (Figure 6.61, steps 2 and 3). Bend the claw at the tip, and taper the top points (Figure 6.61, steps 4 and 5).

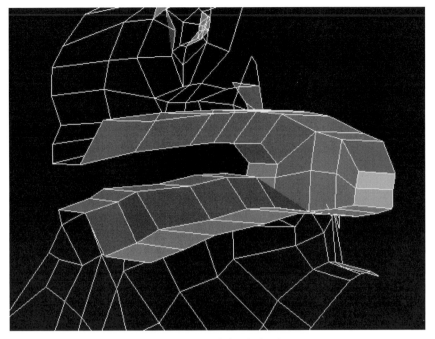

FIGURE 6.60 Extrude back the throat.

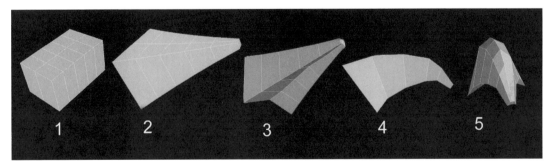

FIGURE 6.61 The steps in constructing a claw.

View your smoothed claw. Be sure to name the surface "Ptero_nail." Then, it's just a matter of scaling and positioning the nails in their respective digits. (See Figure 6.62.)

The pteranodon's head is still severed, so let's attach it. Line it up as close to the body as you can, and join or weld the points. They should line up fairly nicely. After the head is connected, you

FIGURE 6.62 Insert the claws into the tips of the fingers and toes.

can move points around to make the transition smooth and natural. (See Figure 6.63.)

We are going to construct the eyes a little differently than in previous examples. This technique is slightly more involved, but will yield more realistic results. To begin with, cut the eye sphere you had inserted into the head earlier in half, separating the front

FIGURE 6.63 Attach the head to the body.

from the back. Then, select the points from the front quarter of the eye. (See Figure 6.64.) This next step is best performed with a magnet tool with falloff. Move the center point back into the eye with a magnet move. If you've set the magnet falloff correctly, you should get a nice convex depression (Figure 6.65). This will represent the area for the iris. Name this surface "Ptero_inner_eye." Make another half sphere and size it slightly larger than the inner eye. Name this surface "Ptero_outer_eye." Give it a 99-percent transparency, a small refraction, and a high specularity. The eye color texture map will be applied to the inner eye surface. The outer geometry will give the eye a nice dimension that just mapping onto a sphere wouldn't. (See Figure 6.66.)

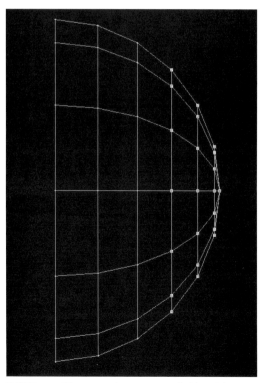

FIGURE 6.64 The eye sphere is cut in half and the front points are selected.

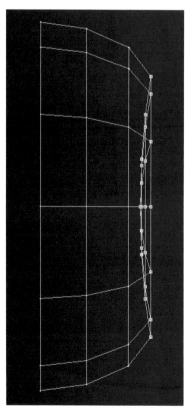

FIGURE 6.65 The points pulled back for the iris.

FIGURE 6.66 The outer eye geometry is sized
slightly larger than the inner eye.

Return to the UV

We're going to jump back to editing our UV coordinates again. After this, we should be set up with them. View the pteranodon with the grid texture visible. Notice how the grid lines on the body don't meet up and flow into the ones on the neck (Figure 6.67). This is because the neck and body polygons in the UV window aren't proportionate. If you recall, the head and neck were mapped on the X-axis, so we don't want to size the neck to meet the body. Only the first two polygons from the center should align with the polygons on the body. In the UV editor, stretch the lower rows of neck polygons wider until you see the grid texture line up on the body and neck (Figure 6.68). The grid lines should also be around the same thickness. You can set the grid image in the background of the UV window to help with this step. Some polygons on the left side of the body might need to be adjusted to align with the unseen mirrored head UVs. This work will prevent any unwanted pixel stretching when painting the maps and help with where the body and neck meet.

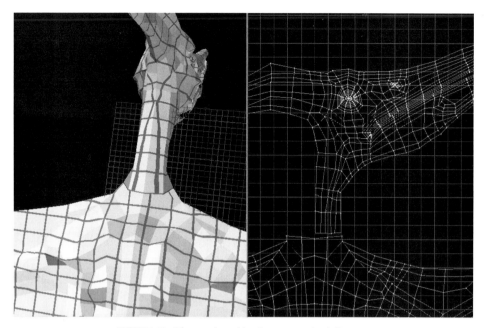

FIGURE 6.67 The neck and body texture don't line up.

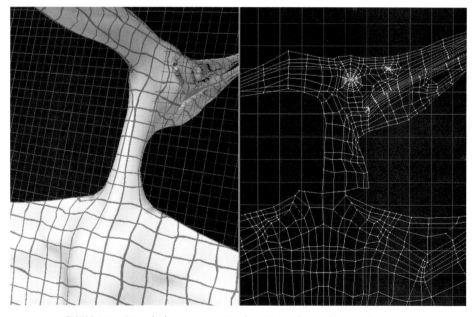

FIGURE 6.68 Stretch the geometry in the UV window to line up the maps.

Lastly, set up the inner mouth and tongue UV maps. Planar maps from the Y-axis should be good for our purposes. (See Figure 6.69.)

Modeling Final Touches

Our bird is almost ready to take to the skies. But right now he's rather stiff, like a board. Since he's an organic animal made up of flesh, we need to relax him a bit into a more natural position. Even if you plan to add bones to him later in your animation package, these changes are subtle and will even help in joint bending for animation.

FIGURE 6.69 The inner mouth UV map.

First, let's bend the fingers slightly. This is done by grabbing the vertices that make up one joint of one finger and bending them a small amount. Make sure you are performing the bend from where the joint is located in the finger. Next, expand the selection down to the next joint on the finger and bend that. Perform this on all the fingers. Figure 6.70 shows the result. This should be done with the toes as well. And while we're down there, we'll give the legs a slight bend. (See Figure 6.71.)

This may affect some wing geometry, but that's okay, we want to address that, too. Grab various vertices within the wing membranes and move them up or down a bit, enough to get some nice

FIGURE 6.70 The fingers are bent to a more natural position.

FIGURE 6.71 The toes and legs are bent.

ripples and a sense that this is a flexible, leathery skin. Rotate and observe the smoothed model from all angles and check it with some alternate lighting if you haven't already. (See Figure 6.72.)

Pteranodon Texturing

Actually, we can't send our pteranodon out into the world naked. He needs some textures to give him life and possibly attract a mate. Create a painting template as described in Chapter 3 (Figure 6.73), and name it "Ptero_paint_template."

To get sufficient resolution for detail work, make your map size 2048 by 2048. Start with the bump map. It will help us later in the coloring stages.

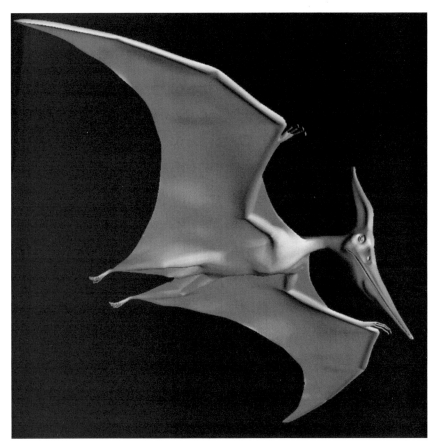

FIGURE 6.72 The wings are given some ripples.

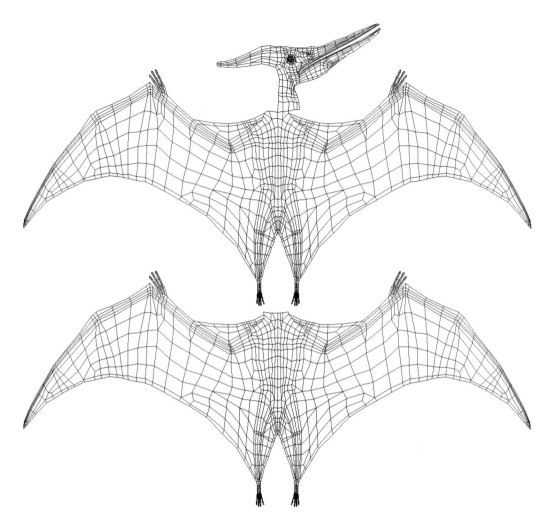

FIGURE 6.73 The painting template.

The main expanse of the wings will take advantage of a repeat-able tile that will be cloned over it. Creating a tile is described in Chapter 3. For a nice, leathery wing texture, find…well, some leather! Figure 6.74 shows a close-up digital photo taken of a port-folio case. 256 or 512 pixels is a good size to make the texture.

If you are using Photoshop to paint your textures, open the Ptero_paint_template and your leather tile texture. Select All, in the leather tile window, then Define Pattern under the Edit menu.

FIGURE 6.74 Leather texture taken from a portfolio case.

Create a new layer and name it "Bump." Using the Stamp tool, you can paint the texture around the wings. There is one problem, though. There is no size variation in the pattern. One way to combat this is to resize the leather texture image up or down, and define the pattern again. Or you can save out various sizes and click back and forth between them. (See Figure 6.75.)

Painter users have it a little easier. Load the painting template and the leather tile image. Capture the tile as a pattern. Create a new layer and name it "Bump." Then, using the clone tool, paint the tile around. But Painter has a convenient slider that allows you to quickly adjust the size of the pattern. Drawing tablet users can even set the pattern to change direction based on pen direction.

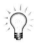 *Versions earlier than Painter 6 don't support layers in this way. One way around it is the tracing paper feature. Load the painting template, clone it, clear the clone, and set the clone source for the new image to be the template.*

Even with the size changes to the pattern you are painting, it's worthwhile to go back in and accentuate wrinkles by hand in random areas. The idea is to hide whatever patterns might have been made by the tile with a little random chaos. The Burn tool is an alternative to the airbrush tool for creating these extra lines. Vary

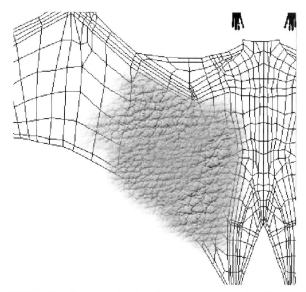

FIGURE 6.75 Clone the leather tile over the wings in different sizes.

the wrinkle patterns on other areas of the body such as the arms and neck. (See Figure 6.76.)

You can paint one half and mirror it to the other, but be sure to make some changes to eliminate the symmetry. Also, the texture can be copied and pasted to take care of the other half of the body.

Get into the practice of performing numerous test renderings with the maps. (See Figure 6.77.)

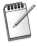 *Just because it looks good in the paint program, doesn't mean it will work the best on the model. It's helpful to also bring these renderings into your paint program to have them for easy reference.*

The color map is created in the same way. Create a new layer and name it "Color." Start out by filling the map with one predominant color. Now, just work in broad strokes; don't worry about painting in details. You can opt to make your pteranodon colorful like some male birds (Figure 6.78); the bright colors help attract mates. Continue roughing out the color scheme, and don't forget to do some test renders.

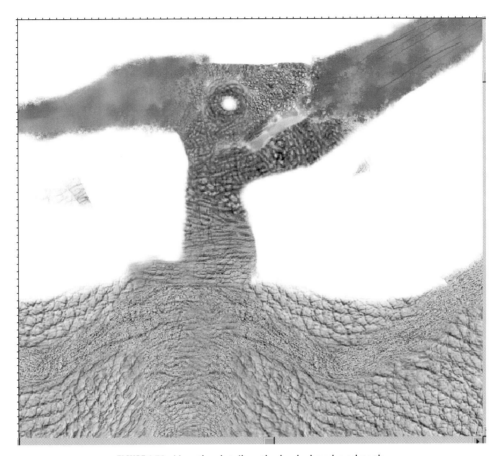

FIGURE 6.76 Vary the detail on the body, head, and neck.

When you are happy with the basic scheme, it's time to break up the smooth, airbrushed look a bit and add some randomness. This can be done in a variety of ways. Photoshop users can pick one of the irregular-shape brushes. Another method is to apply a noise filter to the image or sections of it, and then use the blur filter to soften the grainy look created by the noise. (See Figure 6.79.) Painter has numerous brushes and settings that throw random splotches of paint (Figure 6.80).

Observing the wings of bats, notice that there are lighter colors in the cracks or wrinkles. We can make the bump layer visible by reducing the opacity of the color layer and paint in a lighter color

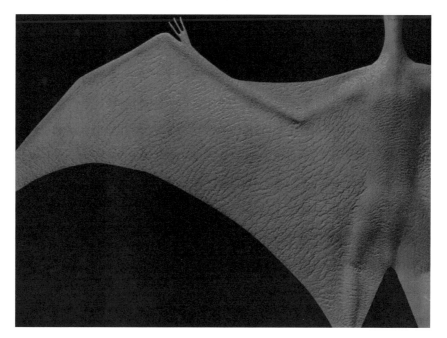

FIGURE 6.77 A test render of the bump map.

in the cracks. But that's arduous. There's an easier way! Make a copy of the bump layer and paste it above the color layer. Invert or make a negative of this new bump copy. Then set the blend mode to Soft Light and reduce the opacity to around 50 percent. (See Figure 6.81.) This quickly paints a lighter color in those wrinkles and adds more color detail as well!

Cut and paste one painted body half, (whichever one you did first) onto the other. Then add variations that differentiate the front and back such as painting the belly lighter. Adding a small amount of specularity to the beak would be a nice finishing touch in the body texture. We don't want it to be too shiny, so fill a new layer in with black, and paint a 7- to 10-percent gray over the beak area.

Separate out all the individual layers and save them with names like "Ptero_skin_Color" and "Ptero_skin_bump." To save texture memory, the bump and specularity maps can be converted to grayscale. Also, since the specularity map doesn't hold much detail information, the image size can be reduced greatly.

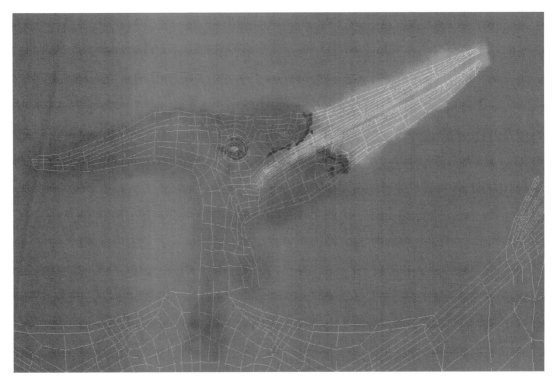

FIGURE 6.78 Rough out the color scheme. See color version on CD-ROM.

FIGURE 6.79 An example of blur applied to a noise filter to introduce variation.

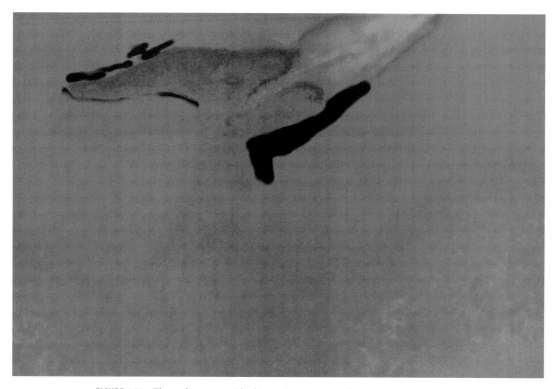

FIGURE 6.80 The color map with skin variation. See color version on CD-ROM.

Don't forget about the inner mouth and tongue. After making a paint template, sample the color from the edge of the beak on the main Color map, and Fill the inner mouth color map. Then you can add some warmer tones if necessary. Unless you plan to zoom right into the mouth in an animation, a bump map isn't necessary. Match the tongue colors to this palette, too.

Assembling It All

Finally we can apply all the maps to the model. Pay attention to where the different UV maps join, such as where the neck and body meet. If some colors don't line up, go back into the paint program and make the adjustments. This might take a few tries. Render the model from numerous angles and light setups to get a feel for it as a whole. Also, tune down the Diffuse on the skin so it's

FIGURE 6.81 The effect of the inverted bump map on the color map with the Soft Light composite method. See color version on CD-ROM.

around 85 percent, although you may want to experiment with your program's settings. Remember that it's best to have diffuse lower than 100 percent. When you are satisfied, let the pteranodon take to the skies and catch fish! (See Figure 6.82.)

SUMMARY

The pteranodon was a deceptively simple model in appearance, but actually presented us with several challenges in construction and texturing that the unique flat template method of modeling helped tackle. It allowed us to plan ahead for the mesh design and alleviate texture stretching by setting up the UV coordinates while the model was still flat. It's a powerful modeling method to keep in your arsenal.

FIGURE 6.82 The finished pteranodon.

7

TRICERATOPS

IN THIS CHAPTER

- The Box Modeling Method
- Localizing Detail
- Creating Model "Paint Model" to Aid in Texture Mapping
- Using Alpha Maps

Triceratops ("three-horned face") existed during the late Cretaceous period. This quadruped ceratopsian is distinguished by a solid (no window-like openings in the bone) neck frill, two large horns over the eyes, a short nose horn, and a length of up to thirty feet, with its head measuring more than six feet. It was initially proposed that the bony-rimmed neck frill was used as a defense, but more recent speculations indicate that it might have been used for display during mating, or even to regulate body temperature. An herbivore, its snout formed a parrot-like beak with the many small molar grinding teeth farther back in the jaw. The neck frill might have offered some defense, but the large brow horns were certainly a powerful deterrent and formidable weapon against predators.

MODELING OVERVIEW

This very popular dinosaur will be constructed with the box method of modeling. In this method, you literally start off with a box. (See Figure 7.1.) From these humble beginnings, a whole dinosaur will be built. But how? Box modeling is similar in theory to

FIGURE 7.1 Box modeling begins with—a box!

chiseling a sculpture out of a block of stone; first, the volume is defined, then the secondary forms, and lastly the detail. You can think of these as separate stages. You won't worry about detail, stage 3, until the first two stages are satisfactory. The advantage is that you'll block out form and proportion with a very light polygon model and gradually add more detail (polygons). The challenge comes in thinking ahead to allow for the following stages of modeling with minimal reconstruction or redoing of areas. But don't worry; polygons are much more flexible and forgiving than marble. We'll also learn about localizing detail on the model. This entails selectively and efficiently creating high-detail areas next to lower detail while maintaining a predominately quad surface. All this will become clear with examples, so let's dive in.

Model Construction

Regardless of the modeling method, it's always good to start with a design or drawing to help guide you. No exception here. Create at least a side view drawing as shown in Figure 7.2 or load this image into the side view of your modeling package. Keep any other reference material handy as well. Make sure that the length of the background illustration is approximately thirty feet in the modeling window, using the grid for guidance.

Start by making a box or cube similar to Figure 7.1. We'll want to make it the length of the dinosaur from the tip of the head to

FIGURE 7.2 The side view drawing.

the end tail with eleven segments similar to Figure 7.3. You have the option of either extruding the face of the single cube ten times or creating the long rectangle and cutting or knifing the segments in. If your software allows you to define the number of segments as you create the box, then that works too. While it is early in the game, name the surface "Tric_skin."

In the side view, move the vertices to match the profile of the illustration. Don't be concerned if there isn't enough geometry to match the shape exactly and don't include the neck frill. When you are happy with the side view, work from the top view to make the head and tail taper to be thinner than the body. Your results should be similar to Figure 7.4.

Now we can move on and add more geometry. Divide the model once along the X-axis and twice along the Y-axis. With the extra detail, shape the body and give it more dimension as shown in Figure 7.5.

Cut a new row of faces completely around the middle of the model. With the new vertices, give the body more roundness. Pay attention to the area that is now the head. Thin and taper the front in anticipation of the triceratops's beak. (See Figure 7.6.)

Are you happy with the results so far? If not, continue to edit the shape. Don't rush. Remember it will be more difficult to edit as the mesh gets heavier. If you are ready to move on, get out the knife, because we are going to do some major slicing. Knife or con-

FIGURE 7.3 The segmented cube.

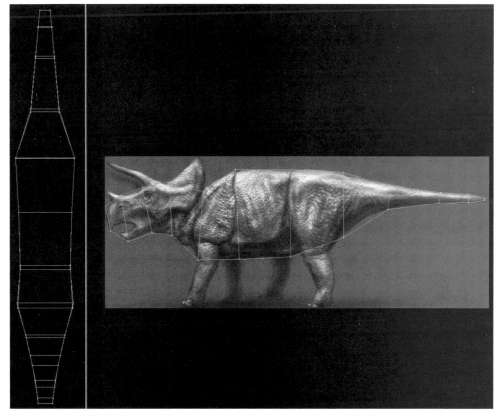

FIGURE 7.4 Move vertices in the side view to match the profile. Shape the top view.

nect the edges between all the columns down the length of the model. Also, divide it again down the middle as seen in the top view of Figure 7.7. With this new geometry, you can further edit the mesh to conform more closely to the profile of the background image. Don't forget about the other views as well.

The body is good for now, we're moving on to the legs. For the rear, select the four faces in the middle of the hip section (use the drawing as a guide) and extrude them out a small amount. (See Figure 7.8.) Select the two faces on the underside of these newly extruded faces and extrude them down three times. The segments should roughly form the upper leg, lower leg, and foot. Angle the geometry to match the position of the legs. Keep it this simple for now. (See Figure 7.9.)

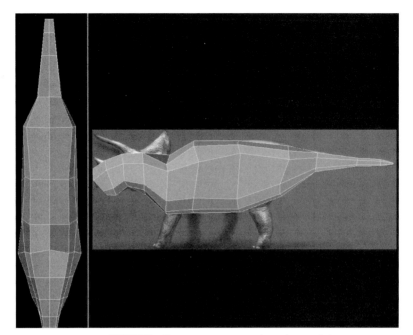

FIGURE 7.5 Cut more geometry into the model.

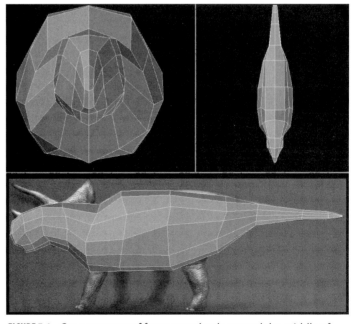

FIGURE 7.6 Cut a new row of faces completely around the middle of the model and continue to define the forms.

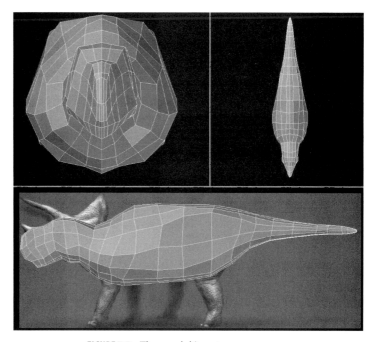

FIGURE 7.7 The model is cut up once more.

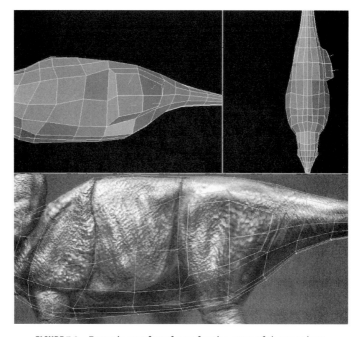

FIGURE 7.8 Extrude out four faces for the start of the rear legs.

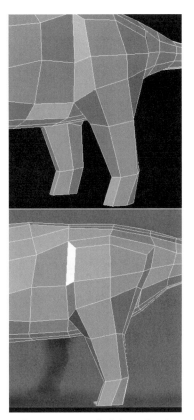

FIGURE 7.9 Faces are extruded down for the rear legs.

Move on to the front legs. This is the same procedure as the rear: Select the four faces, extrude out, then down three times as shown in Figure 7.10.

Leave the limbs for now and move back to the head. First, notice in Figure 7.11 how a line of faces roughly follows the bottom edge of the "cheek" bone that eventually flows up into the frill. Adjust yours so it matches this example, as it will make the next steps easier.

Perform a simple straight cut on the neck as shown in Figure 7.12. We are laying the groundwork for the neck frill and its smooth connection to the head. Now cut a new line of faces close to the edge of the beak and along the bony cheek ridge, but then

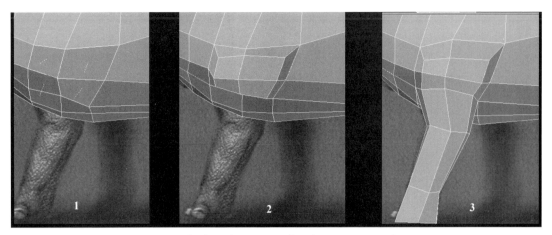

FIGURE 7.10 The front leg is created in the same way as the rear.

turn the cut upward and over to the back of the head as shown in Figure 7.13.

Before we continue, notice that we've created a three- and five-sided face next to each other where we "turned the corner" up to the back of the head. Let's clean this up a bit. Perform a cut from the bottom corner of the five-sided face up into the three-sided, which then turns that into a four-sided or quad. Pull the

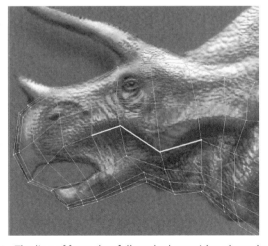

FIGURE 7.11 The line of faces that follow the bony ridge along the face.

FIGURE 7.12 Cut more faces into the neck.

FIGURE 7.13 A new line of faces is cut along the head.

bottom point of that face down a bit and round off the angles (Figure 7.14).

Select the strip of six faces that runs from the back of the head to under where the eye will be, cut it out (separate it from the mesh), move and align it with the edge of the frill in the drawing. Be sure to work from the front view, too. (See Figure 7.15.) Shape these frill faces so they form the edge thickness of the frill, then play connect-the-faces and create new faces from this frill section down to the head. It should be easy as you're basically connecting

FIGURE 7.14 Cut across the five-sided face to make cleaner quad faces.

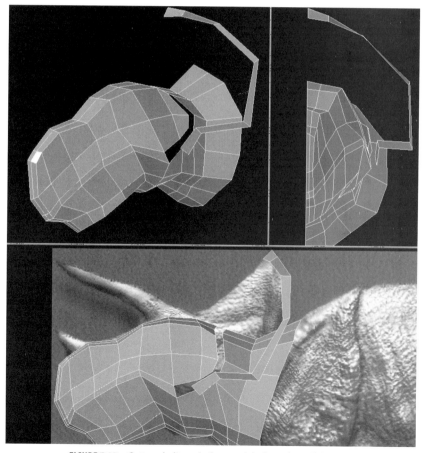

FIGURE 7.15 Cut and align six faces with the edge of the frill.

to the hole you cut out. Do this for the top and underside of the frill as shown in Figure 7.16.

That takes care of the volume of the frill, but we need some more geometry to model more form and help it hold its shape when it subdivides. To do this, add two new rows of faces around the frill, making sure to connect the edges on the underside as well. (See Figure 7.17.) Now cut two more columns of faces into the head as shown in Figure 7.18. Next, we'll cut a row of faces along the edge of the frill and upper beak, which you should see forming now. These will help hold a sharper edge on the frill. (See Figure 7.19.) Moving farther down on the head, cut a row of faces from the mouth to the back of the head in the same manner as you did earlier with the frill. This will give you the three- and five-sided faces that you'll turn into quads as you saw in Figure 7.14. End the new row at the upper mouth in a triangle (Figure 7.20).

FIGURE 7.16 New faces are created to make the frill.

FIGURE 7.17 More faces are added to the frill.

FIGURE 7.18 Cut two more columns of faces into the head.

Move to the mouth area. Cut a new line of faces from the upper corner of the triangle face around to the front of the jaw as shown in Figure 7.21. Remember to change the three- and five-sided faces that result in the corner of this cut as in previous examples. While we are getting rid of triangles, combine the two that are butting up against each other into a quad. (See Figure 7.22.)

To help with the flow of the faces around what is now becoming the mouth, rearrange the two faces in the corner to match Figure 7.23. This will help with the next step which is to cut new

FIGURE 7.19 Cut a row of faces along the edge of the frill and upper beak to help hold a sharper edge on the frill.

FIGURE 7.20 Cut more faces from the mouth to the back of the head.

faces from the top of the muzzle around to the front of the lower head as shown in Figure 7.24.

To open the mouth, delete the five polygons (if the model is cut in half, otherwise delete ten) shown in Figure 7.25. We are left with a hole and no inside of the mouth. Build the inside by first mirroring back the other half of the model, if need be, and creating new faces from one edge of the mouth to the other. Then, cut the inside mouth face down the middle (Figure 7.26).

FIGURE 7.21 Cut a new line of faces from the upper corner of the triangle face around to the front of the jaw.

FIGURE 7.22 Combine the two triangles into a quad.

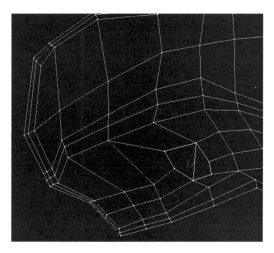

FIGURE 7.23 Rearrange the two faces in the corner of the mouth.

You'll now be able to cut the whole model in half for convenience if you like.

Perform two more knife or cut operations that cover both the upper and lower palates and end at the centerline. Don't forget to eliminate any three- and five-sided faces with the techniques discussed earlier. (See Figure 7.27.) Push the faces of the lower palate

FIGURE 7.24 Cut new faces from the top of the muzzle around to the front of the lower head.

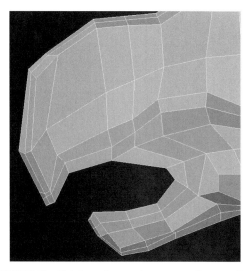

FIGURE 7.25 Delete polygons to open up the mouth.

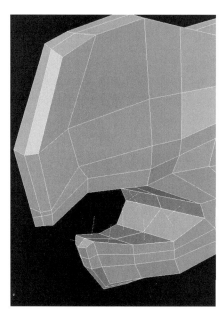

FIGURE 7.26 The inside of the mouth is formed.

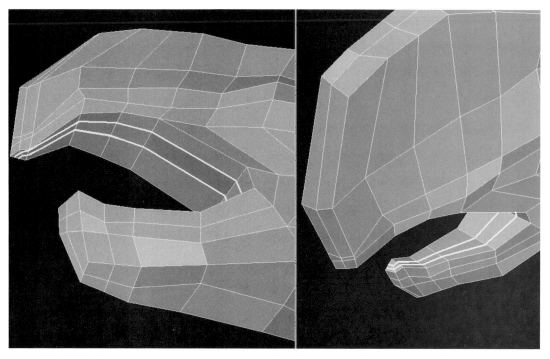

FIGURE 7.27 Perform two more knife or cut operations that cover both the upper and lower palates.

down into the jaw, the upper palate faces up into the skull, and the middle face back a bit for the throat (Figure 7.28).

 This also would be a good time to name the surface or part of these faces as "Tric_mouth_inner" or something similar. Remember, it is always easier to name parts as you go than it is to name them at the end.

On to the horns! The horns will demonstrate another example of setting up the UV map coordinates early to make texturing easier later. To begin with, select the two faces on the top of the head above where the eyes will go and extrude them straight up seven times. (See Figure 7.29.) Why straight up? We are going to apply a cylindrical UV map to the horn now, so make sure it is evenly shaped. When the horn geometry looks pretty clean and even, apply a UV cylindrical map to it on the Y-axis. This will eventually be a part of the entire body UV map, so name the map "Tric_skin_UV" or

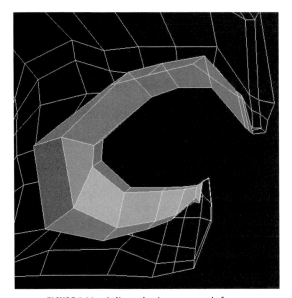

FIGURE 7.28 Adjust the inner mouth faces.

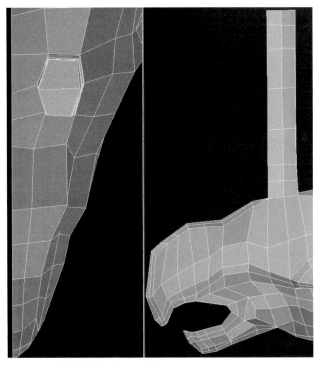

FIGURE 7.29 Extrude faces up for the horns.

something else distinguishable. We don't have an image map for this yet, but that's not a problem.

Now that the UV map is taken care of, we can focus on the proper shape of the horn. Taper it toward the tip as shown in Figure 7.30. Continue to model the horns with the proper curvature. If you are unsure, then study photos of the skull from your research or books. The horns do not shoot straight forward like cones jabbed in the head. Be sure to work them from all angles. (See Figure 7.31.)

While we are working on the horns, we might as well construct the smaller nose horn. The procedure is the same as for the big horn. Select the two center faces by the nose, extrude them straight up four times, assign the Y-axis UV map, and taper and shape the horn. See the result in Figure 7.32. To make selecting the horns easier if you need to later, give them surface or part names such as "Tric_Horns."

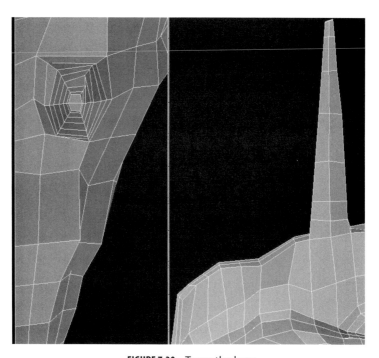

FIGURE 7.30 Taper the horn.

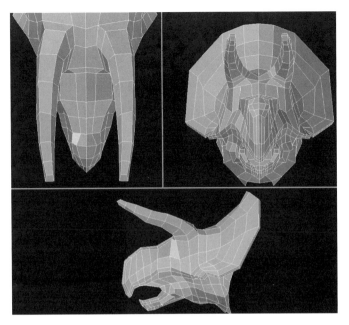

FIGURE 7.31 Continue to model the horns with the proper curvature.

FIGURE 7.32 The finished nose horn.

I'm sure you are dying to view a smooth version of the triceratops. If you have not done so already, perform a smooth or subdivide operation on the mesh (Figure 7.33). Whoa! It resembles a plush stuffed animal or cheap plastic toy. This is because we still do not have enough geometry to define and hold shapes during the subdividing routine.

Let us address this problem. The head is good for now. Move back to the body, specifically the rear leg. Cut a large loop of new faces vertically around the leg as shown in Figure 7.34. Add more geometry with horizontal cuts across the knee, calf, and foot. There is geometry to work with now, so take a moment to shape the leg indicating anatomy such as the calf. (See Figure 7.35.) Do not put that knife away. Cut a vertical strip all the way from the top of the back over the hip, down around under the leg to the other side on the belly as shown in Figure 7.36.

To define the calf and lower leg, cut a loop from under the knee around to the underside of the foot. Pull in some of the ver-

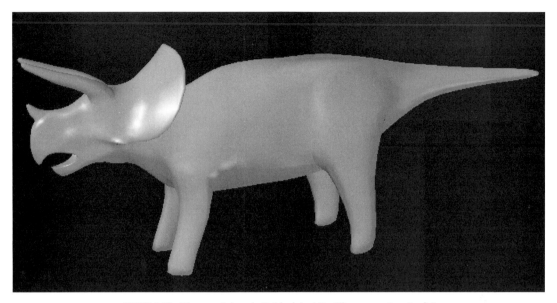

FIGURE 7.33 The mesh is subdivided, but it still appears too "soft."

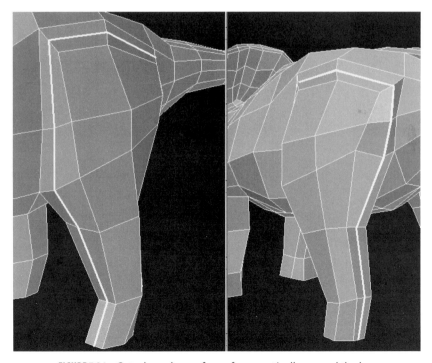

FIGURE 7.34 Cut a large loop of new faces vertically around the leg.

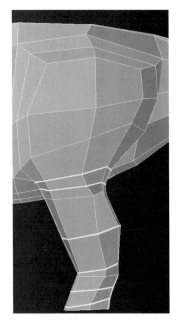

FIGURE 7.35 Cut new geometry and shape the leg.

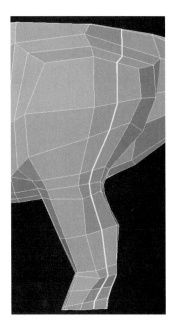

FIGURE 7.36 Cut a vertical strip around the leg.

tices to bring out the shape (Figure 7.37). Make five more horizontal cuts and one large vertical one. Use the extra geometry to further define and refine the leg as shown in Figure 7.38.

To continue with our refining, defining, and adding-detail process, we will move down to the foot. To begin with, cut new faces around the back of the foot and tighten them a bit. This can also be accomplished by extruding the twelve faces that are at the back of the foot, then shaping that geometry. (See Figure 7.39.) We are creating the pad of flesh that probably existed. An elephant's foot can be used as reference. As you work, try to visualize the underlying anatomy such as angle of the bones in the foot.

Move to the front of the foot to work on the toes. In the previous chapters, we extruded out the faces, such as the four selected in the top of Figure 7.40. For this model, we will do something a little different. There are a few more steps, but it will give a better separation between the toes. We are going to open up some space between each toe and build new geometry there. There are several ways to do this. One is to cut out the four vertical faces that make

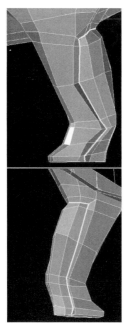

FIGURE 7.37 Define the calf and lower leg.

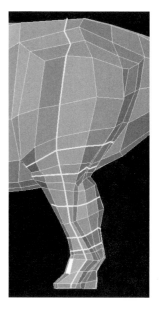

FIGURE 7.38 Make five more horizontal cuts and one large vertical one.

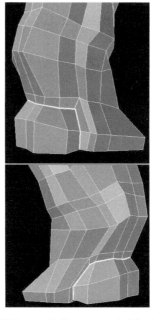

FIGURE 7.39 Define the pad of flesh at the back of the foot.

up each toe and paste them back without merging the points. They can also be placed on another layer. Then, separate the middle points. If your program allows you to simply separate or detach points, you can use that function to make the space between the points in each toe. You can also knife cut a new row of faces between each toe. The point-separation method used in this tutorial achieved the results shown in Figure 7.40.

Keep the size of each toe face roughly equal. Next, we will fill the gap with new faces. There will be two triangles in the new faces, but divide those faces with a cut or knife operation. This will give extra geometry to pull in between the toes and turn those triangles into quads. See Figure 7.41 for the results. To create the

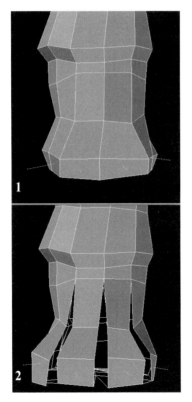

FIGURE 7.40 Space is opened up between each toe.

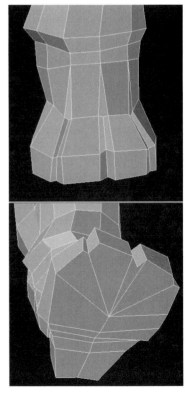

FIGURE 7.41 Extra geometry is built between the toes.

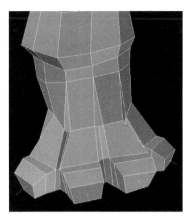

FIGURE 7.42 Extrude out the four faces
two times to create the toes.

toes, it is simply a matter of extruding out the four faces two times. (See Figure 7.42.)

Great! Things are moving along nicely. Time to leave the rear leg and head on up to the front. We are going to perform a number of knife or cut operations, six horizontal and one vertical, much like the rear leg. Refine the leg shape with the new geometry. (See Figure 7.43.)

Next, make a full loop cut vertically around the front half of the leg. (See Figure 7.44.) From here, you will build the leg pads and toes in the same fashion you used with the rear leg. The results will be similar to Figure 7.45.

We can add extra detail to the toes by creating a slight indentation where the nails will go. This will create a nice little lip of skin that looks better than just sticking the nails into the toe geometry. Simply cut a ring of new faces around the tip of the toe and inset and scale them in as seen in Figure 7.46.

In keeping with the circular method of working over the whole model, we are going to move back up to the head. To start with, cut a new row of faces down the second row of faces behind the horn and down the neck (Figure 7.47). Make sure the cut travels under the frill. To create a sharper notch in the frill under the eye, delete the four faces, top, bottom, and two sides. Rebuild this hole with six faces as shown in Figure 7.48.

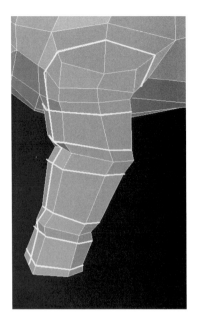

FIGURE 7.43 New geometry is cut into the front leg.

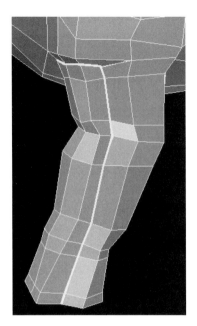

FIGURE 7.44 Make a full loop cut vertically around the front half of the leg.

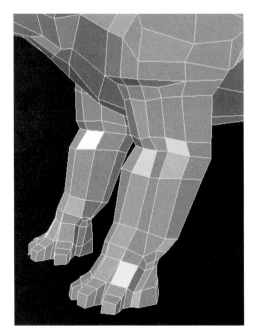

FIGURE 7.45 The front leg geometry so far.

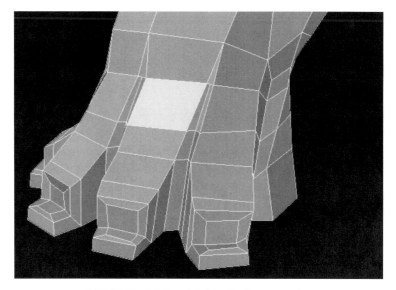

FIGURE 7.46 Adding detail to the toe geometry.

FIGURE 7.47 Cut a new row of faces down the second row of faces behind the horn.

Time to get down to the eyes. They will be formed starting with the two large faces just under and slightly forward of the horns, but first we need to add more geometry there. This can be done in several ways. You can perform an inset or extrusions. If you do ex-

FIGURE 7.48 Creating the notch in the frill.

trude, do not move the faces in or out. Extrude and then immediately scale them smaller. Do this four times. Now we can shape the eyes. You can pull the eyelid geometry into the head a bit . When you like the shape, extrude the center face back into the head and scale it small. Cut two more faces on the inside eye faces close to the lid. This will help hold a nice, sharp lid edge. (See Figure 7.49.)

We still need to add more geometry to the head. Make a large cut, starting from the tip of the nose, through the eye, up the frill

FIGURE 7.49 Creating the eye geometry.

and behind, and end it in a triangle where the neck meets the frill (Figure 7.50).

We are still not done adding geometry. Cut a large loop starting in front of the eyes, down under them, across the frill, and over to the midline again. This will leave you with two sets of the three- and five-sided faces. Be sure to eliminate them as described earlier. (See Figure 7.51.)

Now move down to the front of the head. We are going to give an indication of a naris or nasal cavity opening. This is quite large on the skull of a triceratops, so to make it, select the eight faces

FIGURE 7.50 Creating more geometry on the head.

FIGURE 7.51 Cut a new loop around the head.

toward the tip, right behind the beak, and perform an inset or extrusion two times. You do not need to go in too far. This will give a nice indentation in that spot. (See Figure 7.52.) To complete the nostril, perform a few more extrusions to make the flesh around it and push it in for depth (Figure 7.53).

Things are really coming together now. While we're in this neck of the woods, we will work on the beak. The profile shape is good, but it will look even better if we can create a "lip" of flesh to differentiate between the bone of the beak and the skin. This will be accomplished by cutting a couple of new rows of faces around the edge where the beak meets the skin. Thin the beak faces in just a little, and you are done. Be sure to do the same for the lower beak too. (See Figure 7.54.)

FIGURE 7.52 Making the nasal area.

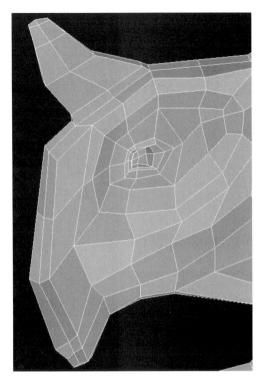

FIGURE 7.53 Building the nostrils.

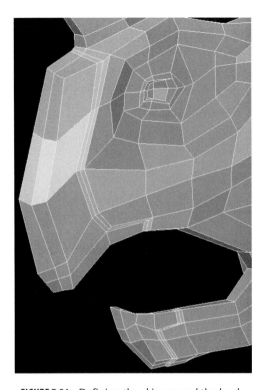

FIGURE 7.54 Defining the skin around the beak.

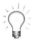 *You should always be on the alert for faces and areas of geometry that don't really help define any specific shape on the model. These faces aren't really trouble spots, but you can make your model more efficient by not being timid about rearranging or deleting them.*

Three faces back from the corner of the mouth is a face that isn't doing much for our model. It's not creating a skin fold or crease, and it's actually interrupting the flow of the jawbone. The left panel of Figure 7.55 shows this face. Delete that face; now there is a hole. Weld the two points to make a configuration that is similar to the middle panel of Figure 7.55. This is better, but it still leaves us with two awkward quads. Luckily, they can easily be merged together into one nice, clean quad as seen in the right panel of Figure 7.55.

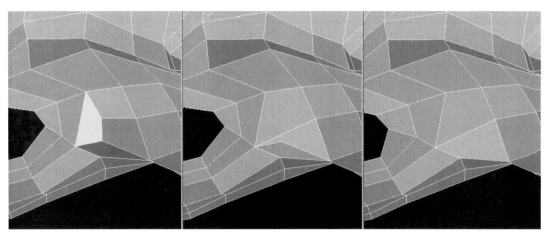

FIGURE 7.55 Rearranging some awkward faces.

That clears the path for more cutting and connecting. Figure 7.56 shows five more cuts that were made in the head. Two were made at the base of the horns to add delineation of where the horn meets the skull, much like the beak example. Another cut was made through the upper eye and across the brow to the midpoint. A tricky loop cut was made from the corner of the mouth, around, and under the jaw for a more defined jaw line. This one will leave three five- and three-sided face combinations, so get rid of them the way you did earlier. (See Figure 7.56.)

I'm sure you are anxious to view a smoothed version of the head so far. If you have not done so, smooth or subdivide the head (Figure 7.57). Are you pleased with the results? In the previous images, the body geometry was hidden for clarity in working. Unhide it if need be and view the whole model. It certainly looks good, a respectable dinosaur. But if you are up for it, we can add another level of detailed modeling that will really make it come alive.

There is still plenty of room to play around. That is, the mesh is not too dense and we have space to add more geometry for folds and wrinkles. Roll up your sleeves, and we'll get to it. To start off with, we will give the body four more straight vertical cuts, starting at the neck and ending right behind the rear leg as shown in Figure 7.58. This will give us more holding geometry.

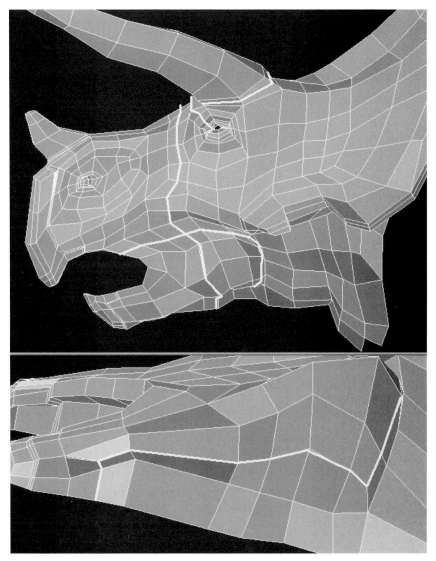

FIGURE 7.56 More cuts are made around the face.

The triceratops in this tutorial is going to take its detail inspiration cues from the modern-day rhinoceros. They have nice, thick skin folds on their backs. Cut a U-shaped line from in front of the rear legs, over the lower midsection, and up the neck to the midpoint as shown in Figure 7.59. Pull some of the vertices near the leg out to start the thick fold. Make another U-shaped cut to emphasize the shoulder area (Figure 7.60).

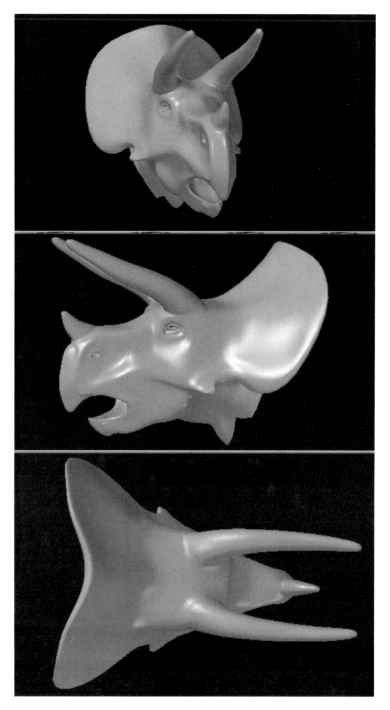

FIGURE 7.57 The subdivided head.

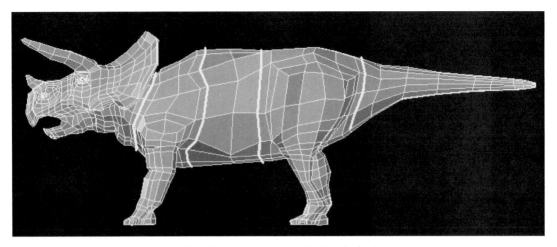

FIGURE 7.58 Four cuts are added to the body.

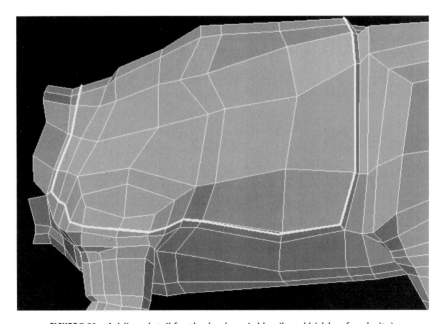

FIGURE 7.59 Adding detail for the body wrinkles (head hidden for clarity).

Localizing Detail

Since we are entering the realm of more-detailed meshes, this would be a good time to show a technique that will help keep a mesh manageable while still allowing for detail. In the past tutori-

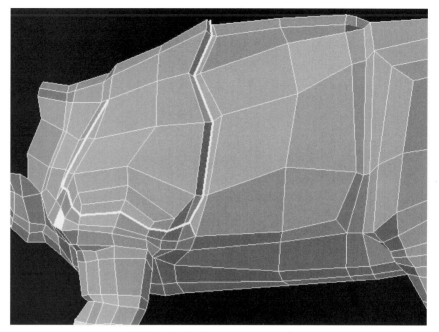

FIGURE 7.60 Adding another detail cut.

als, we generally added detail by just cutting a new band of faces all the way around the model. Figure 7.61 shows an example of this uniform adding of detail through a straight cut. This will keep

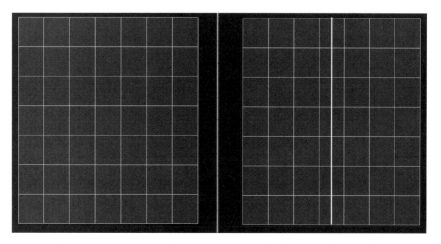

FIGURE 7.61 An example of cutting detail straight through a mesh.

all the faces as quads, but usually would give you geometry where you didn't need it. Perform too many of these cuts, and you will end up with areas of densely packed faces that are difficult to edit and cause unwanted creases. One of the nice features about working in polygons is that you can localize detail, that is, it doesn't need to travel completely around the mesh as with NURBS.

When you localize detail, you control the area of the cut, terminating the detail where you want. This allows some areas to have more detail than others. Figure 7.62 shows an example of creating localized detail. In the left panel, the points in the grid are opened up. The middle panel shows new faces built in the resulting hole. You can take it a step further by splitting those new faces, as shown in the right panel. This will give you even more geometry to make a crease or wrinkle, and it will also keep all of the faces as quads. Another method to achieve the same results would be to perform a couple of cut, connect, or knife operations and then merge the resulting triangles into quads. (See Figure 7.63.) Both yield the same results. It just depends on your preferences and what tools you have available in your modeling package.

Let us put this technique to practical use on our triceratops. Figure 7.64 shows three areas on the neck that have localized detail to create neck skin folds. The frill geometry was hidden for clarity. The right side of the figure shows the subdivided mesh.

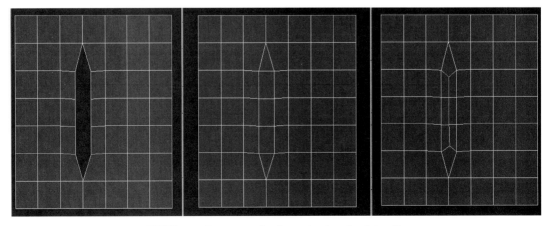

FIGURE 7.62 One example of creating localized detail.

FIGURE 7.63 Another method of creating localized detail.

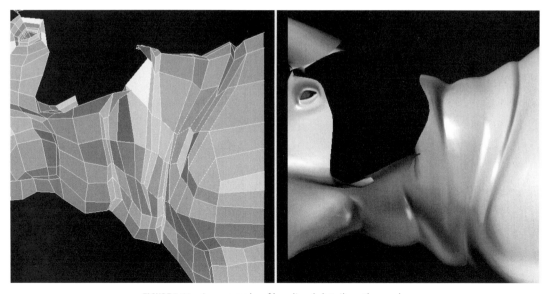

FIGURE 7.64 An example of localized detail on the neck.

This technique doesn't have to be confined to small areas with tight detail. For example, it would be nice to create a lip of skin running along the belly line of the creature. If we just cut one long, continuous loop, the extra geometry would go into already dense areas such as the tip of the tail where it would cause problems. We can "tie off" the extra geometry just beyond the rear leg and before the front with the techniques described here. (See Figure 7.65.) Figure 7.66 shows more vertical detail that's been added to the tail.

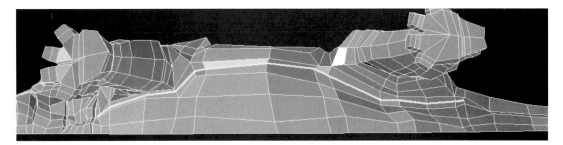

FIGURE 7.65 Localized detail is added to the underside.

FIGURE 7.66 More detail added to the tail.

Be sure to view the smoothed, subdivided version as you work. This is your best gauge of how the detail is looking and if you'll need any more. Sometimes, there is still too much space between faces to get any more form out of them. In those cases, you should cut more faces where needed. If you are unsure, view the model in smoothed form with and without the additional faces. If the extra geometry doesn't really add any noticeable help in shaping the mesh, then eliminate it. Figure 7.67 shows seven new cuts made on the body and legs.

Remember back to how simple this model was when it was started? Now look at it! Because we started with just a low-polygon model, carefully worked the forms and proportions, and then gradually cut in detail, adjustments made at these later stages will be easy. It is so much less overwhelming to begin with simple cages and build to a higher level of detail than trying to work, and think about, all that's to come at once.

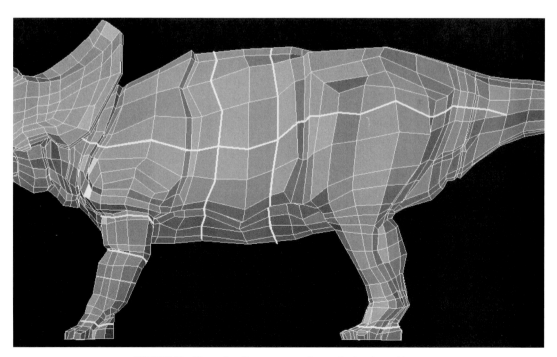

FIGURE 7.67 More detail cuts are made on the body and legs.

We are almost done with the modeling; only a few more tidbits to tackle. We should give our triceratops more of an inner mouth. Return to the head. If you had named the inner mouth surface, then this would be a good time to select it. Cut the model in half to make selection easier, too. Select the back face and extrude it back four times to make a throat. (See Figure 7.68.)

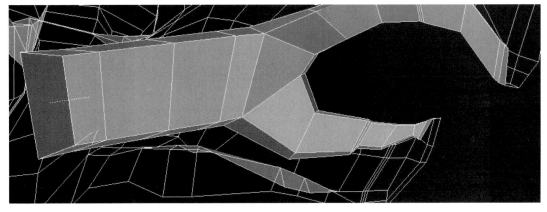

FIGURE 7.68 The inner mouth is created.

We will make the gums now. Instead of making separate gum geometry and placing it in the mouth, we will grow it right out of the existing faces. Select the four faces of the lower inner mouth, inset and extrude them once as shown in Figure 7.69. Do the same for the top gums as well. This is pretty simple, and it will give a good shape inside the mouth indicating gums. You can, of course, create more detail on the gums if you like, but they are set pretty far back in the mouth and might not been seen easily.

The tongue is simply two faces extruded five times from the floor of the lower mouth as shown in Figure 7.70. Pull down the middle row to give a little dip to the tongue.

Let us put teeth in the gums. One method to make the teeth is to make one tooth, then clone it for the rest. The triceratops had tightly packed, grinding molar-like teeth that were located fairly deep into the jaw. Unless you plan to feature these teeth in a close-up, we can simplify their construction. First, create a long,

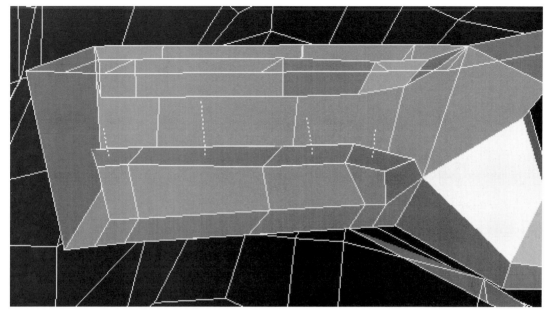

FIGURE 7.69 Extrude faces for the gums.

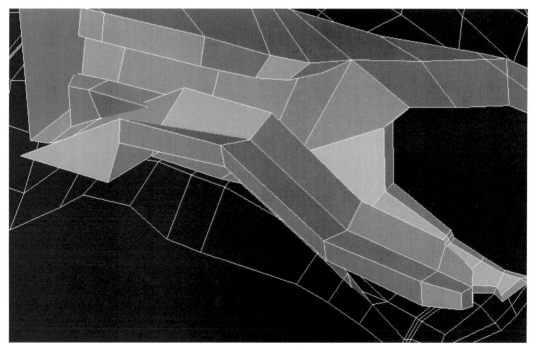

FIGURE 7.70 Creating the tongue.

twelve-segmented rectangle as shown in Figure 7.71. Next, bevel out the side faces slightly as shown in Figure 7.72. Finally, individually extrude each tooth's top three faces up a small amount. Create some variation in the teeth, too. (See Figure 7.73.) Now just place the teeth in the mouth, into the gum area. Mirror them along the Y-axis to make the upper set.

We are getting down to the smaller items. Triceratops had bony protrusions lining the rim of the frill. We are going to build those separately and put them in place individually. Begin by making a box with four segments on the X-axis, two on the Y-axis, and two on the Z-axis. Shape the geometry into a form resembling a wide arrowhead. Make new faces in the center of the

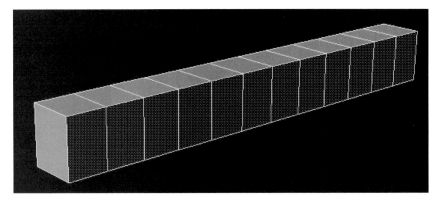

FIGURE 7.71 Beginning the teeth.

FIGURE 7.72 Bevel out the side faces.

FIGURE 7.73 Extrude up the top faces.

front by either a small extrusion and scaling or cutting. Delete the bottom faces. The bottom edge will be buried in the frill, and these extra faces will not be seen. When you consider that there will be approximately twenty of these bony horns around the frill, doing this will save a considerable amount of geometry in the end. (See Figure 7.74.)

Surface or name the part for easy selection. Make copies and position them around the edge of the neck frill. To avoid a too-uniform look, size each spike a little differently and even adjust the geometry to add further variation. Ten or eleven spikes is about right for one side. When the model is done, you should add some asymmetry to the spikes on the other side. (See Figure 7.75.)

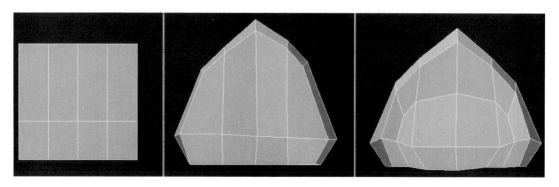

FIGURE 7.74 The bony frill protrusion.

FIGURE 7.75 The frill spikes in place.

While we are making bony protrusions, let us build the nails. They are quite simple. Make a box, subdivide it once, flatten the bottom, and delete the back faces, for they will be buried in the toes. The rationale for deleting these faces is the same as that for the frill spikes. Add another cut along the bottom edge to help hold a sharper edge and you are done with them (Figure 7.76).

If you haven't already, make a sphere for the eye and see how the lid geometry rests around it. Make any necessary adjustments. You can either choose to use this sphere as the eye geometry, or create one with inner and outer geometry as described in the pteranodon chapter. In either case, you can delete the back half of the eye unless you plan to animate the creature doing a major eye roll. Don't forget to label the surfaces, too. (See Figure 7.77.)

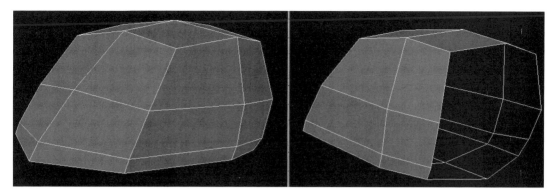

FIGURE 7.76 The toenail.

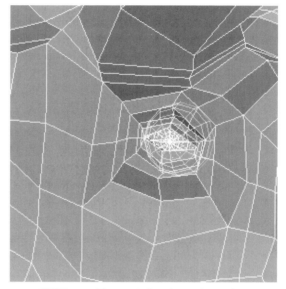

FIGURE 7.77 The eye is fitted into the socket.

Once again, you have completed the modeling portion of another dinosaur. Step back and view the beast in full (Figure 7.78). Rest up, for we have a bunch of texturing to do next.

Triceratops Texturing

Now that our modeling is complete, we can break it down into UV map coordinates. This comes from looking at the model and

FIGURE 7.78 The completed triceratops model.

determining what kind of map will be best suited for each part. Some areas of the model are easy to figure out, and some are head-scratchers. For instance, what would be a good method to map the head frill? The sloping shape doesn't lend itself to any one method of mapping. Ideally, we want to break up a model into as few pieces as possible to make painting the textures easier. We will go over a couple of techniques in this chapter for making UV mapping and texturing smoother.

Paint Models

In previous chapters, to combat texture stretching we had either adjusted the UV maps after they had been made, or applied the UV map early when the shapes were simple as we did with the triceratops's horns in this chapter. Now we are going to make a special

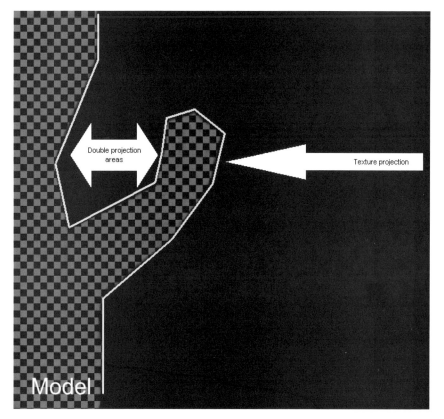

FIGURE 7.79 An example of a double-projection area.

version of the model to which the UV coordinates can be applied. This version will be reworked to accommodate the best UV map type for each area. For example, if we decide to use a cylindrical map on a leg, but it was modeled in a bent position, the leg would be repositioned and unbent to best resemble a cylindrical shape. If a planar map is going to be used on an area, that portion of the model will be rotated to best line up for the planar map. Areas that overlap or have undercuts can be adjusted in the paint model. Otherwise, these undercuts will cause double-projections of the texture map. Figure 7.79 shows an extreme example of a double-projection area. When creating a paint model, you should eliminate these areas. This can be a done through the standard modeling tools such as move, rotate, and magnet functions. A

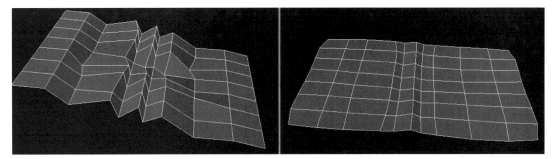

FIGURE 7.80 Problem areas in a paint model are fixed with the smooth command.

more automatic feature to fix these areas is a smooth or tighten function. This is not the subdivide function, where new faces are created, but one where the existing faces are smoothed out and made less jagged. (See Figure 7.80.)

The main challenge when making the paint model comes in maintaining face ratio and size. If a face changes size greatly when the model is restored to its original state, the texture will be distorted. The process of making the paint model, applying the UV map, returning the model to its original state, and checking the texture for stretching is a back-and-forth one. It may take several tries to fix problem areas. The resulting paint model will look quite odd in the end, but it only serves the purpose of helping the UV maps. There are two ways to return the paint model to its original state. One is to morph it back into place. The other is to make the paint model as a displacement state normally used for making different versions for facial animation and such. These versions are usually stored within the data of the model itself and can be called back up easily.

Let's get back to our triceratops. Before we make a paint model, we will determine how to map the various portions of the model. Take a look at Figure 7.81. For easy visualization, it has been colored to show the different surface breakdowns for mapping. You don't need to do this to your model; it is just an easy visual guide.

The breakdown is as follows:

- *Body.* Planar on the X-axis
- *Belly.* Planar on the Y-axis

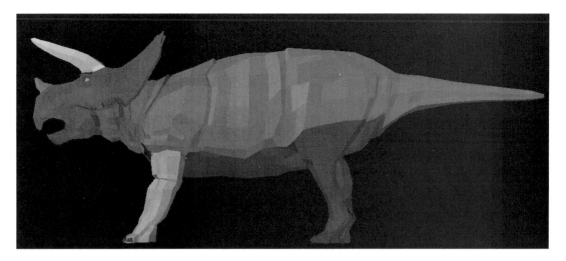

FIGURE 7.81 A colored example of the surface breakdown of the model.

- *Head.* Planar on the X-axis
- *Rear leg.* Cylindrical on the Y-axis
- *Front leg.* Cylindrical on the Y-axis
- *Under chin.* Planar on the X-axis
- *Large horn.* Cylindrical on the Y-axis (this was taken care of earlier in the chapter)
- *Small horn.* Cylindrical on the Y-axis (this was taken care of earlier in the chapter)
- *Toenails.* Planar on the Y-axis
- *Eye.* Planar on the X-axis
- *Inner mouth and tongue.* Planar on the Y-axis
- *Teeth.* Planar on the X-axis
- *Underside of frill.* Planar on the Y-axis

 Don't assign the UV maps to these areas yet. We will make the paint model first. Start by either saving out another version of this model with a different name such as "Tric_paint," or making a new morph target in your software. Remember, we don't want to change the original or add or remove any faces.

Figure 7.82 shows a comparison of the original model body and leg area to the paint versions. The portions of the legs that extend down from the body were straightened out for better

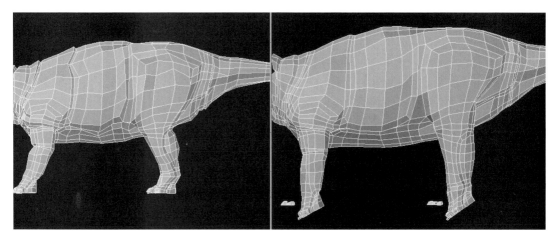

FIGURE 7.82 The original model and the paint model.

cylindrical mapping; many of the skin folds on the body were softened and flattened using a smooth command. Notice that the toenails were not moved with the legs. This is because they will be mapped differently than the legs. So, get going on making your paint model and assigning the UV maps to the surfaces as discussed earlier. Be patient, this may require some testing as mentioned. To test for problem areas, assign a grid or checker map to the surfaces.

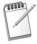 *You may still notice some major problem areas on our model that this paint version doesn't handle. Namely, an X-axis planar map on the body causes texture distortion across sections of the back, especially the hips, and across the front of the frill. We took care of problems on the belly by isolating and mapping them differently. Why didn't we just do this for the back? For one, it makes it more difficult to paint if the model is broken up too much; it requires that many more texture seams we will have to match. So, how do we get around this? The alpha map!*

Alpha Maps

Alpha is a type of blending mode—such as multiply, screen, overlay, etc.—found in most paint package layers that affects how an image map reacts to the preceding layer. Specifically, an alpha is a separate image, usually black and white, that allows portions of

one map to show through to the preceding. The best way to observe this in action is to see an example.

Look at Figure 7.83.

1. A flat plane object is planar-mapped with a color grid image.
2. The checkerboard image represents the next layer above the color grid.
3. This is the alpha map. White areas will allow the image to show through, and black will block it.
4. The resulting texture using the alpha technique.

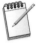 *Notice how you can get hard or soft edges blending in with the textures depending on how you paint the alpha. This soft-edge quality makes the alpha powerful in combining different images. The alpha image can be a grayscale and doesn't need to be very large either, so it doesn't take up much memory.*

FIGURE 7.83 An example of alpha mapping.

For our triceratops, we will apply an image planar map on the Y-axis to cover the back, the front of the frill, and the top of the snout, then have it blend with the other texture map using an alpha. But wait a minute. Look at that frill again and you'll notice that it doesn't exactly lie flat for a planar map on the Y-axis. We will just make another paint model to fix this. Figure 7.84 shows the paint model for the top of the model. This was made through a couple of face rotations. Remember, this is just for the top surface of the model, so don't concern yourself with areas such as the legs. The map will be long blended off by then.

Triceratops UV Setup

We are finally ready to work out those UV maps. There will be two for this model, one for the top and one for the rest of the surfaces. Load up or return your model to the main paint version and UV map all the surfaces as described earlier. This should be done with the model cut in half. When done, mirror the other half back. See Figure 7.85 for the final UV layout. For some visual continuity,

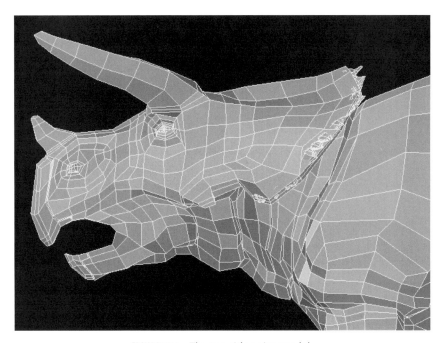

FIGURE 7.84 The top side paint model.

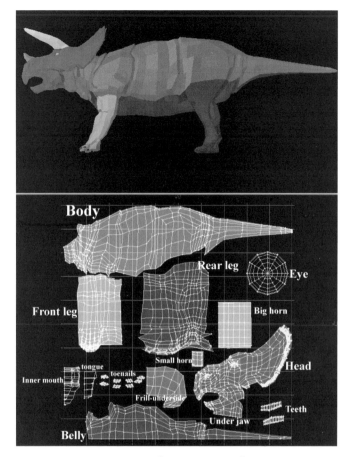

FIGURE 7.85 The main UV map layout.

keep as many UV parts close to their model counterparts as possible. For instance, notice how the legs are near the body. The underside of the jaw can be matched up with the jawbone of the head. Name this UV map "Tric_UV." In this image, the model has been colored for visual clarity. The final model has one main surface, "Tric_Skin."

Now, let us make a UV map for the top of the model. If you haven't done so already, mirror the model whole again. With your model in the top paint position (frill flattened down), assign a planar UV map on the Y-axis and call it "Tric_top." You can hide any geometry not needed in the map, such as the legs and horns.

Initially you will get something similar to Figure 7.86. To make the texturing easier, we will scale this UV mesh to the proportions of the main UV maps. (See Figure 7.87.)

Something is still wrong with this UV map. We will get a double-projection from the frill where it extends over the body. The way around it is simple. Select the frill and the head (Did you remember to name the faces for easy selection?) and move them away from the body. (See Figure 7.88.)

We are done with the UV map setup. On to the textures!

Painting the Maps

Get your reference material out. If you have been following the previous chapters in this book, you would be correct to say that

FIGURE 7.86 Starting the UV top map.

FIGURE 7.87 The scaled UV top map.

FIGURE 7.88 The top UV map with the head and frill separated to
avoid double-projections.

the next step is to make painting templates of the UV maps. In this case, we will have two, the main and the top. We will start with the main UV map. Load that into your favorite paint package with an image resolution of 2560 by 2560. We will also start with the bump map. Create a new layer above the mesh. Or, if you would rather, you may place the UV mesh layer above the painting layer, but set the blend mode to screen. This will allow the mesh to remain visible as you paint underneath it.

Layers give you many opportunities to experiment with painting maps. In this example, we will paint different levels of detail on separate layers. For example, the first layer will be a map to bring out broad detail such as the ribs, muscles, and various larger wrinkles. Fill the layer with 50-percent gray, and paint in these areas as

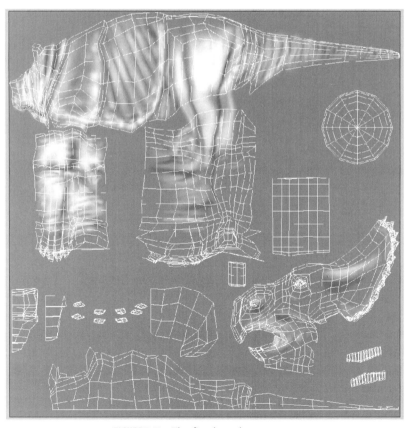

FIGURE 7.89 The first layer bump map.

you see fit. Remember, that this will be a subtle effect on the final model, but a nice one nonetheless. It also allows you to concentrate on different aspects of detail painting without losing or smudging another. Figure 7.89 shows this first layer map.

The next layer will include all the fine bumps, scales, and wrinkles. You can choose to do more layers, but this example uses two. Here use any techniques described in this book to create the detail; capture and make tillable patterns or paint by hand. Figure 7.90 shows the second bump layer.

Use the layer blending modes and/or opacity settings to create a decent combination of the two or more layers. Multiply blending mode works well with grayscale images such as bump maps. Figure 7.91 shows the two blended layers.

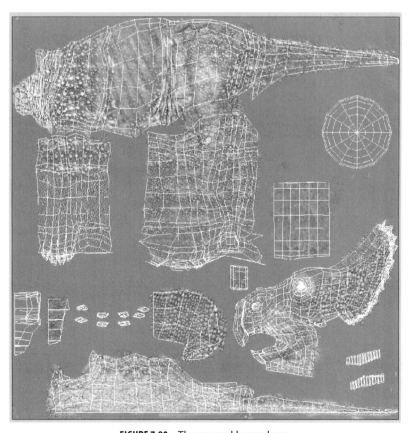

FIGURE 7.90 The second bump layer.

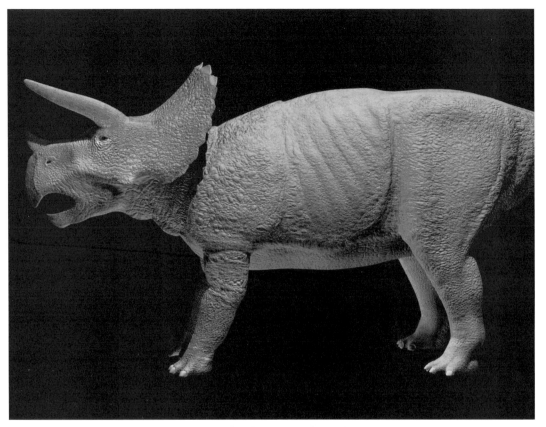

FIGURE 7.91 Blending the two bump layers.

Of course, perform numerous test renderings with the bump map on the model to see how this will appear. Make changes and adjustments as necessary. Figure 7.92 shows a bump map test render.

Paint the bump map for the top of the model, too. Be sure to use similar texture patterns to help with the match. In fact, you can probably sample areas from the main bump map to clone onto the top. Don't be concerned about painting outside the edges of the mesh, as the alpha-mapped texture will cover the excess. (See Figure 7.93.)

How do you determine where the alpha should go? It is best to perform an initial test with distinct color maps. In your rendering package, load up the triceratops model. Now assign a simple color

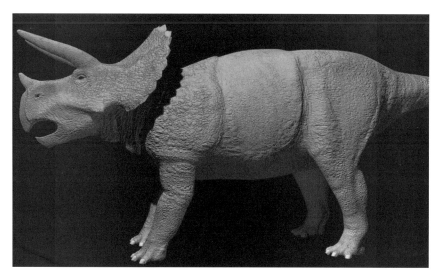

FIGURE 7.92 Bump map test render.

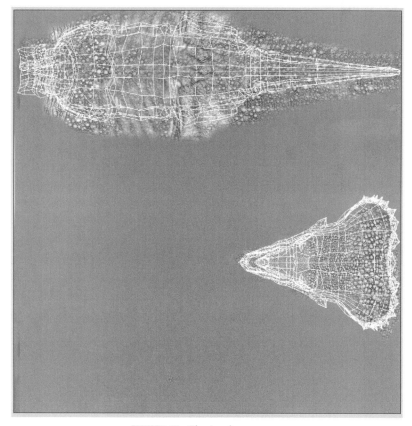

FIGURE 7.93 The top bump map.

or pattern image, such as a grid, to the main UV map. Render and view the results. If your software allows for the outlines of the faces to be rendered at the same time, then this will help give a visual clue as to specifically where the problem begins. (See Figure 7.94.) Save this test render for reference. Back in the paint package, load up your main UV template. Using the test render as a guide, paint a simple black-and-white pattern (if these are the colors your package uses as alphas) to "block out" the stretching areas (Figure 7.95). Save out the alpha map as "Tric_alpha."

Return to the rendering software to test the new alpha. For clarity, use different maps for the top and main images. Apply the maps in this sequence:

1. Top image map
2. Main image map (side view)
3. Alpha map

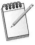 *Why apply the top map first? We could conceivably apply the top map second with an alpha to cut off where we don't want it to go. The problem with this order is that the top map might project down to areas of the model we don't want it to touch.*

FIGURE 7.94 A test render with a pattern shows where stretching occurs.

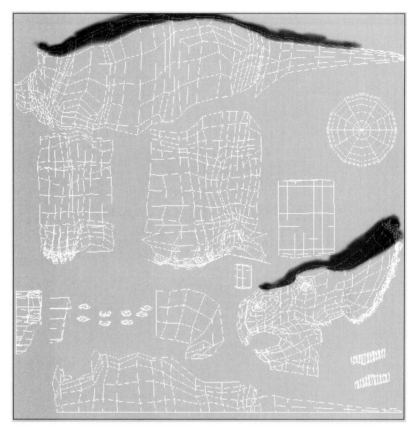

FIGURE 7.95 Painting the alpha.

Perform some test renders from different angles. Make note of problem areas and return to the paint package to adjust the alpha map. It may take several trips back and forth. (See Figure 7.96.) This alpha map can be applied to both the bump and the color maps. Speaking of which, we should paint that now.

The color map is created in much the same way as other color maps in this book. First, apply a base coat to the whole image. Then, add broad strokes of color. If needed, apply a large blur filter to the image to soften the rough strokes. Now, a noise filter can be used to add some variation to the flat areas of color. Now you can go in by hand to pick out patterns and add specific detail. Finally, add the bump map in another layer with the color burn blend mode to darken in between the scales and wrinkles. (See Figure

FIGURE 7.96 An alpha map test render.

FIGURE 7.97 The finished color map.

7.97.) Don't overdo this, as it may make the final details look too painted in. Do not forget about the top color map!

Another map type that we haven't covered yet is specularity. This is another grayscale image that controls the shininess of the surface. In general, with large animals such as dinosaurs, they won't be too shiny, but applying some in a few choice areas, such as the inside of the mouth, eyes, and lips, can create a nice effect. A dull sheen can be added to other spots, it just depends on how dry or dirty you want your dinosaur to look. In any case, a specularity map will be pretty low key. Figure 7.98 shows a close-up of the specularity map of the face.

FIGURE 7.98 Close-up of the specularity map for the face.

Congratulate yourself, because you have completed another dinosaur. Check out the triceratops (Figure 7.99). Then, turn the beast loose on the Jurassic world. (See Figure 7.100.)

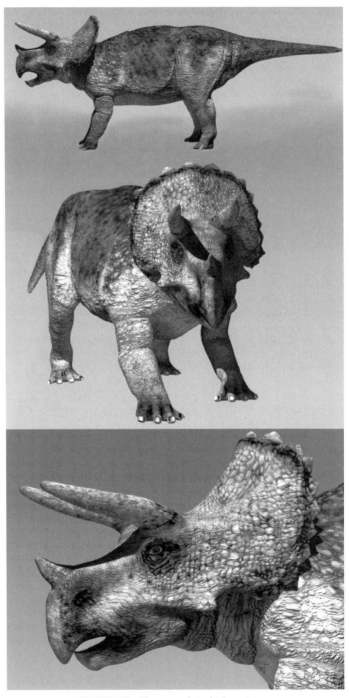

FIGURE 7.99 The completed triceratops.

FIGURE 7.100 The triceratops in a habitat.

SUMMARY

We now have another modeling technique under our belts—the box method. It is fun to see how, from such simple beginnings and small tool selection, a complex model can be built. You might prefer this method of building models, as most 3D modeling software is capable of this workflow. Paint morph models and alpha maps arm us with more techniques for surfacing problem areas on a model.

Rest up, because next we are going to tackle the most well-known predator of the Jurassic era. After all, those triceratops have to use their horns to protect them from something, right?

TYRANNOSAURUS REX

IN THIS CHAPTER

- Using Multiple Construction Techniques
- Creating a Highly Detailed Model
- Layering Texture Maps

Perhaps the best-known Cretaceous predator, the tyrannosaurus ("tyrant reptile") had several distinctive characteristics. Most notably, the thick skull that measured more than five feet long and large, serrated teeth that ranged up to eight inches long. Those, combined with strong jaw and neck muscles, made the tyrannosaurus able to crush bone and dismember prey easily. Its long legs ended in three broad, clawed toes that probably enabled it to move reasonably fast. These limbs could also serve to hold down prey. The arms, however, were in contrast to every other strong feature of the body. They were small, nearly useless appendages that just had two clawed fingers. Given the predominant fearsome features, though, one could only speculate that it didn't really need its arms for anything.

There has been debate over whether the tyrannosaurus was a predator or scavenger. It may have been both, allowing the best of all methods of survival. Whatever the case, this beast, at up to sixty-four feet long, must have been a sight to behold.

MODELING OVERVIEW

Okay, for the T-rex, we are going to pull out all the stops and create a highly detailed model using a combination of techniques covered in the previous chapters. We have a lot of ground to cover, so the pace will be quick. For those reasons, it is recommended, especially if you are new to 3D modeling, that you work through the previous chapters to become familiar with the processes described, as very little review will be covered here.

Model Construction

As mentioned, we will use a combination of techniques for the T-rex construction. This is to illustrate how you can choose and mix and match methods to best suit a particular aspect of the model. There are no set rules. You don't have to pick one method over the other. After trying the ones discussed in this book, you might determine a favorite of yours and use that for all subsequent models.

Regardless of model construction, one common starting point is to do a sketch as a guide. Do your research and come up with a

FIGURE 8.1 The starting sketch.

drawing or two, or use the one from this chapter. Load at least a profile reference into the left-side modeling window as shown in Figure 8.1. Size it to be about forty-five feet in length.

For the head, we are going to start with the flat template method covered when we constructed the pteranodon in Chapter 6. This will enable us to plan out the topology of the head and work in the detail. It will also allow us to assign the UV map while the mesh is still flat, so that when it is modeled into shape, the texture maps will conform nicely into all the contours and details. Either on paper first, or directly in the modeling package, lay down the flat polygonal mesh for the side of the head. You can do this on your own, or copy the mesh layout shown here in Figure 8.2.

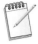

Notice that the outer edge vertices are placed slightly beyond the outline of the drawing. This will help prevent texture stretching when we curve those vertices down a bit later in the process. Also, do not worry about the top of the head or under the jaw, as these will be created later. Lastly, while it's early in the game, name the surface "Trex_skin" and don't forget to assign a planar UV map along the X-axis at this point before moving on to the next step.

Now begin the basic shaping of the head, moving large groups of faces at a time first, then working down to the details that indicate the window-like skull openings. Create a sphere to help

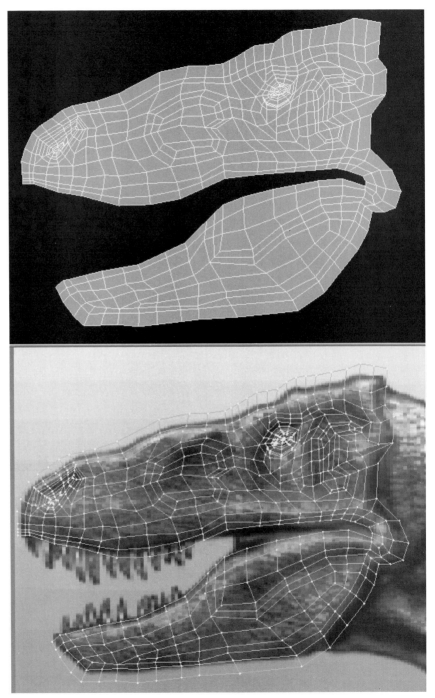

FIGURE 8.2 The flat head template.

model the eyelids. The geometry is all there in the mesh; you just need to pull it to life. Have good reference of a T-rex skull handy. Notice how the skull is quite wide in back and tapers toward the front and also notice that the eyes face forward. Think ahead to how the lower jaw will close and fit into the upper skull. You can do a quick jaw-closing test by selecting the jaw faces and rotating them until the mouth looks closed. Bear in mind that the gums and teeth will be added later inside this mesh, and leave some room for them. When the mouth is closed, the upper teeth will hang slightly over the lower jaw. This example will show a T-rex with "lips," that is, a thin bit of flesh covering the gums and teeth as opposed to the crocodile look with teeth growing directly out of the head. Mirror the head mesh to the other side to get an accurate indication of its shape. If you can work in a symmetry mode, certainly do so. Don't worry about getting it all "perfect" at this stage. You can, and will, go back and make adjustments later. (See Figure 8.3.)

We will now fill in some of the holes in the head and make it whole. If you have not done so already, mirror the side of the head. Next, weld the middle vertices toward the tip of the nose and jaw. If you are following this example, there will be ten at the nose, starting from the lip, and five on the lower jaw as shown in Figure 8.4. Make sure these newly welded points lie on the X-axis centerline.

To create the top of the head, start by building new faces that span the head halves as shown in Figure 8.5.

This will not be nearly enough geometry to effectively model the head top, so cut those new faces down the midline. There still will be a face missing toward the tip of the nose, but with the new midline cut, you can weld it to the point directly in front of it to close the hole. (See Figure 8.6.)

Perform two loop-type cuts into the top of the head as shown in Figure 8.7. This will give you enough detail to get some form into the top of the head. Before you do so, assign Y-axis planar UV coordinates to those faces. You can continue shaping. The underside of the jaw is created in much the same way, except only one loop cut is made (Figure 8.8).

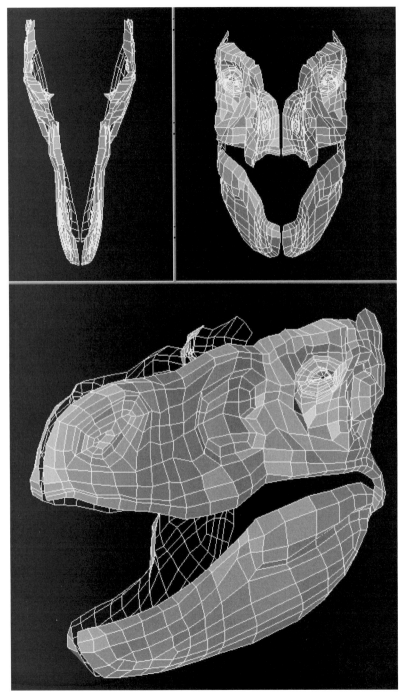

FIGURE 8.3 Giving dimension to the flat mesh. The head is also mirrored for a better indication of the volume.

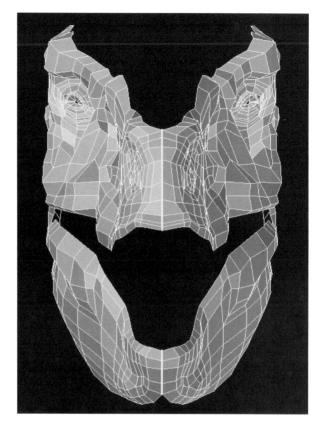

FIGURE 8.4 Weld the vertices at the front of the head.

And again, the same process is used to make the inside of the mouth as shown in Figure 8.9. While you have these new faces selected, make a new object of them. This will vary from program to program, but one method would be to copy and paste them into another layer. These faces will be used to create the detailed inside of the mouth.

From here, we will deviate from the path taken in previous chapters to create the inside of the mouth. For now, delete the inner two rows of faces inside the lower and upper inner mouth as shown in Figure 8.10. Next, create new faces along the inner lip line and drag them down into the jaw and up into the skull (Figure 8.11).

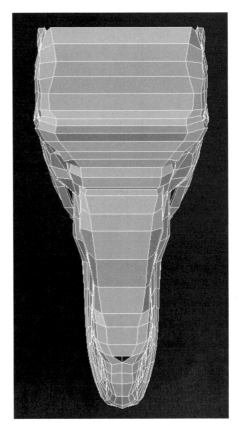

FIGURE 8.5 Creating the top of the head.

Remember those faces we copied from the inside of the mouth? We will use them to make the gums and true inner-mouth geometry. Go to that layer, or make them visible. Selecting the faces, inset them, and then extrude them deeper into where the head would be to create the inner and upper palate and the throat. Next, make new faces and drag them in the negative and positive Y-axis to make the outer edge of the gums. Perform a cut across them to help hold the shape better when subdividing. You should have something like what is shown in Figure 8.12.

To create the geometry that will represent the jaw muscles that are visible when the T-rex opens its mouth, make eight new faces that attach to the corners of the inner mouth. Be sure to check that they don't poke outside of the head geometry. (See Figure 8.13.)

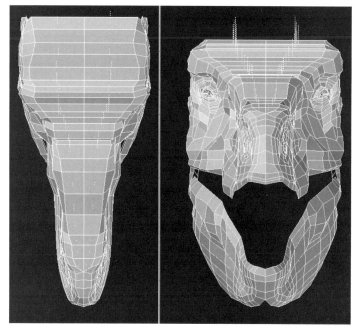

FIGURE 8.6 Cut the midline.

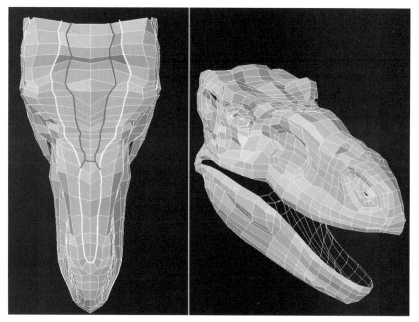

FIGURE 8.7 Cut more faces and shape the head.

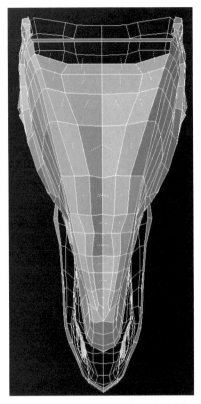

FIGURE 8.8 Creating the underside of the jaw.

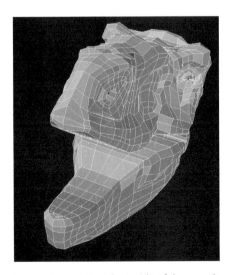

FIGURE 8.9 Creating the inside of the mouth.

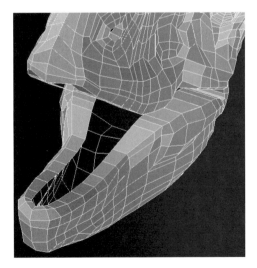

FIGURE 8.10 Delete the inner mouth faces.

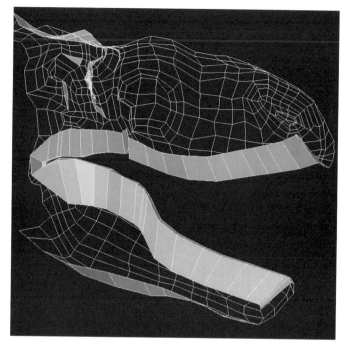

FIGURE 8.11 Create the inside of the lips.

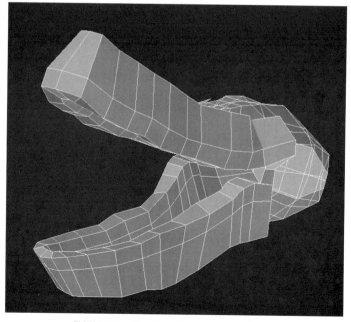

FIGURE 8.12 Creating the gums and throat.

FIGURE 8.13 Creating the jaw muscle geometry (the throat geometry was hidden for clarity).

This inner mouth geometry does not need to meet up perfectly with the edge of the lips.

Time to add some of those fearsome teeth. A tooth can be made simply by extruding and tapering a six-sided disk. To get the serrated edge look, add a couple of close rows of faces down the middle. This will give a tight, sharp edge. (See Figure 8.14.) Now that you have one tooth, you can easily turn it into a mouthful. Copy, clone, paste, and resize the teeth while placing them along the upper and lower gum line. Study the teeth placement of a real T-rex skull. For now, just align the teeth on one half and mirror them for the other. Later, when the model is done, you will go back in and add some asymmetry. (See Figure 8.15.)

The teeth look good in their positions, but we can add some more interest to the gums. Let's make them conform to the teeth better and appear as if the teeth are sitting in sockets. To do this, we will be adding more vertical detail. With the gum geometry separate from the rest of the head, we can add faces without the concern of tying them off or becoming too dense all around the model.

FIGURE 8.14 A tooth with a sharp edge.

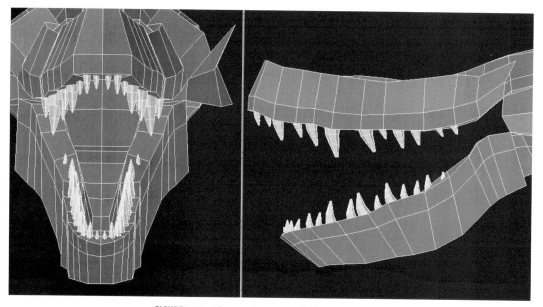

FIGURE 8.15 The teeth arranged along the gums.

Based on the individual teeth positions, add vertical cuts on either side of a tooth and pull down the center vertices where the tooth lies to give a slight dip (Figure 8.16). Do this for as many teeth as you can, but do not worry if you cannot catch every one.

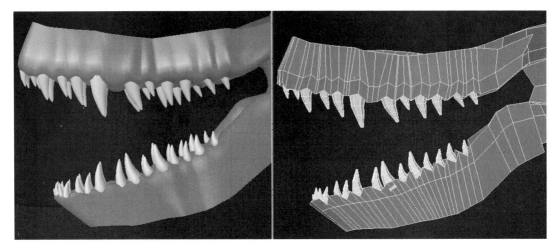

FIGURE 8.16 Detail is added to the gums.

The head is good for now. Time to move on to the body. This will be handled in much the same way as the dimetrodon in Chapter 5. Splines will be used as guides to extrude a polygon. Four will be used in this case. Create two splines along the top and bottom profile of the body. The background sketch will certainly help here. Also, create two more splines in the top view for the thickness. This will add extra control for the extrusion. Considering the T-rex anatomy will help here. For example, the hips are actually quite narrow, much more so than the rib cage. Have all these splines start just behind the head and end at the tip of the tail. (See Figure 8.17.)

Now make a twelve-sided disk that fits within the spline guides, and extrude it along the splines with approximately twenty segments. Move vertices and faces to have them conform closely to the profile of the drawing and start to add other shaping as well (Figure 8.18). For easy selection, name this new geometry "Trex_body."

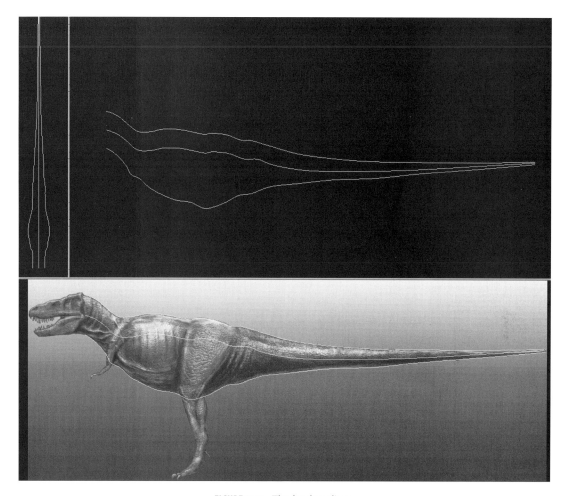

FIGURE 8.17 The body splines.

We now have a good basis for cutting in more detail. At this point, make three horizontal cuts along the body, two toward the underside and one along the back. The lowest one will travel the length of the body, but the other two will terminate on the tail with a three-sided polygon. This is to prevent the geometry from becoming too dense down at the tip of the tail. Make two vertical cuts, one at the base of the neck and the other behind the hips. Lay the groundwork for the legs by shaping the faces just under the hips. (See Figure 8.19.) Also, do not hesitate to give some form to

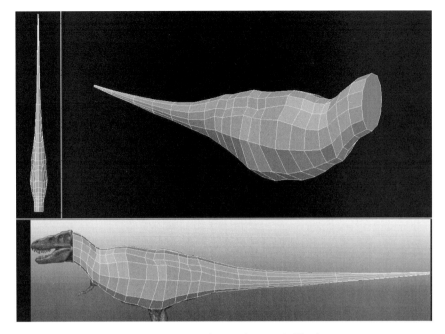

FIGURE 8.18 The spline path extruded body.

FIGURE 8.19 Cutting in more detail.

the shoulders, chest, and hips. Next, add two more cuts from the neck; end the upper one just behind the hip and the lower one before it as shown in Figure 8.20.

Time to begin the process of attaching the head to the body. Make the head geometry visible if it isn't already. Create a new

FIGURE 8.20 Two more horizontal cuts in the body.

row of faces extending off the back edge of the head and down to the underside jaw geometry. This can be done by manually making each polygon or, a quicker way if your 3D package allows it, you can "pull" edges to create new faces. Make new faces to connect the neck geometry to the head geometry, but stop the connection just at the corner of the mouth as shown in Figure 8.21.

Connect the underside of the neck to the underside of the jaw (Figure 8.22). For now, leave the unfilled area behind the jaw alone. We will need more geometry on the neck to connect it, and that will be taken care of in a few steps.

Zoom out a bit and make three more vertical cuts along the neck and a loop cut around where the scapula will be. (See Figure 8.23.) We are moving into the stage of creating some finer detail, so check your model from all angles, and make sure you are happy. It is not like you can't change it when there is more geometry, but as mentioned before, it is much easier when the model is lighter.

We will be concentrating on the neck, specifically, we will be making some skin folds and wrinkles. In previous chapters, we

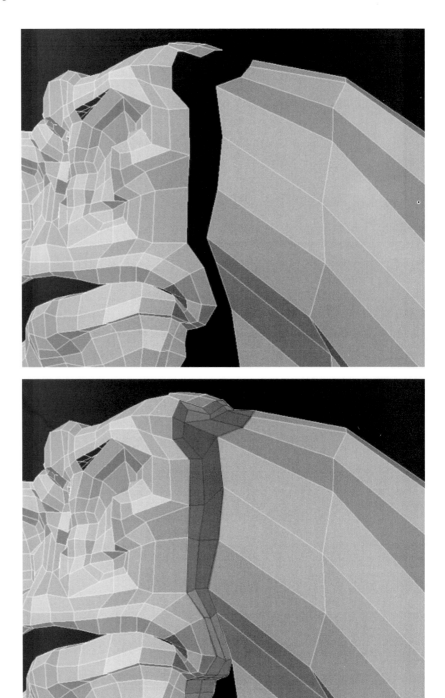

FIGURE 8.21 Connect the head to the neck.

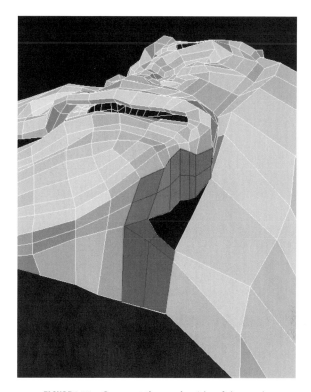

FIGURE 8.22 Connect the underside of the neck.

learned how to add detail along the edges of existing faces. This worked nicely for as long as the detail fit within the flow of the geometry already there. But nature's details seldom follow the grid-like layout of a polygonal mesh. Skin folds and wrinkles usually have a much more random and chaotic feel. We, however, do not want our mesh to be chaotic and herein lies one of the most difficult challenges of organic modeling.

For the T-rex neck, we will be cutting new faces across the existing geometry, and then cleaning up the new layout. The result will be a nice fold of flesh that appears to ride over the underlying forms. To start with, make two cuts, one ending on the scapula and one traveling to right under the hip and ending in a triangle (Figure 8.24). You will end up with two sets of coupled triangles (split quads). Merge those into quads again, but keeping with the flow of the new detail. Next, cut down the middle of the newly

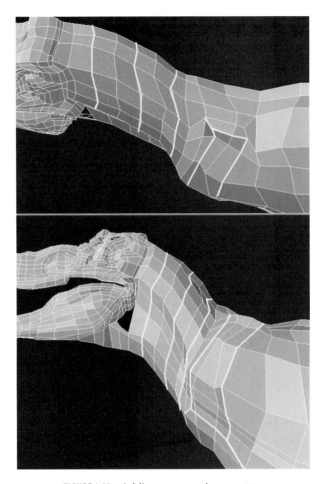

FIGURE 8.23 Adding more neck geometry.

created line of geometry. This will give you vertices to pull out for a skin fold on the neck. (See Figure 8.25.)

We will now add more vertical cuts to help form some thick wrinkles on the back of the neck. Make four vertical cuts, starting from the top of the neck and ending on the triangle faces around the midline of the neck. This also turns those triangles into quads. (See Figure 8.26.) Create another horizontal neck wrinkle below the first one using the same techniques as above. See Figure 8.27 for the cuts made. The last major cut will be the vertical one shown in Figure 8.28.

FIGURE 8.24 Adding cuts for the skin folds.

FIGURE 8.25 Adding detail to the neck skin fold.

This will give us enough geometry to form some decent wrinkles and folds. Shape them to your liking, making sure to check the subdivided model for an indication of how it will smooth out. (See Figure 8.29.) Now that there is enough geometry in the neck, fill the hole by the jaw by building new faces there.

FIGURE 8.26 Making more detail cuts.

FIGURE 8.27 An additional skin fold is made.

FIGURE 8.28 One more vertical cut.

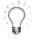 *When creating detail such as this, it is important not to obliterate the forms you had set up earlier such as muscles or prominent bony protrusions. Remember that these are topical skin forms that lay on top of the anatomy underneath.*

We are going to move on to the limbs, starting with the ridiculously small arms. For their construction, we will be UV-mapping simple shapes before modeling them into their proper form. As with the flat mesh template technique, this requires a little forethought, although it will not be as complex as the head. So, for the arms, make a simple eight-sided cylinder with ten segments. Using the background sketch, estimate how long the arm would be if stretched out. In the front view, move the middle vertices at the bottom edge close to the center. This will make room for the fingers

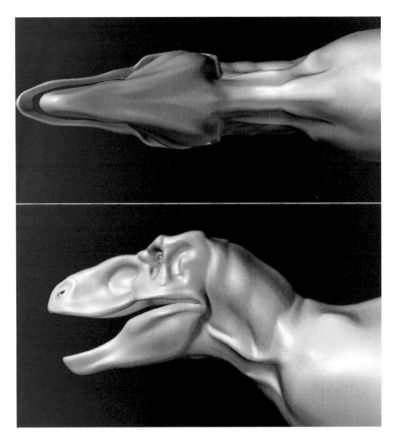

FIGURE 8.29 Checking the smoothed model.

FIGURE 8.30 The arm cylinder.

that will eventually be attached. Also make sure that three rows of vertices are close together about midway down. This will help facil-itate a decent, sharp bend in the arm. (See Figure 8.30.)

Now you can assign a Y-axis cylindrical map to this geometry. Name the part for easy selection. Since we are making a cylindrical map on a cylinder, there won't be any texture distortion to speak of except at the bottom pole, and that will be covered by the fin-gers. We will be able to model the arm with impunity and not worry about how to map it later.

Before we do that, we should make the fingers. These will fol-low the example of the arm, except that they will just be four-sided, eight-segmented elongated boxes. (See Figure 8.31.) The extra faces cut toward the tip will allow for modeling a depression in the skin where a claw will go. Assign a Y-axis cylindrical map to this geometry as well. Size the finger and move it into place near the arm where it will attach.

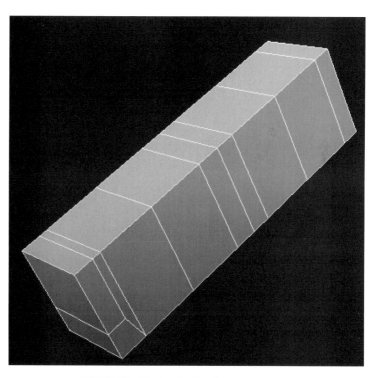

FIGURE 8.31 The beginning finger geometry.

Now you can begin to model the arm into shape. For ease of working, keep the arm and finger straight (Figure 8.32).

Before we attach the arm to the body, we will need to cut in a few more faces. Make a vertical cut from the middle of the scapula down to the belly (Figure 8.33). This will ensure a perfect match with the arm geometry.

If you have not done so already, duplicate the finger and attach them both to the arm. Then, give the arm and fingers a more natural, neutral pose. Delete four faces on the body to make a hole for the arm attachment. Connect the arm by building new polygons to the body. They should match up pretty cleanly. Once you have connected the arm, divide the new connection faces in two as shown in Figure 8.34.

We should now give an indication of more anatomy under the surface. Specifically, let us add what would be the latissimus dorsi

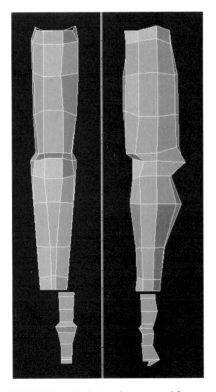

FIGURE 8.32 Modeling the arm and finger.

FIGURE 8.33 Cutting new faces for the arm attachment.

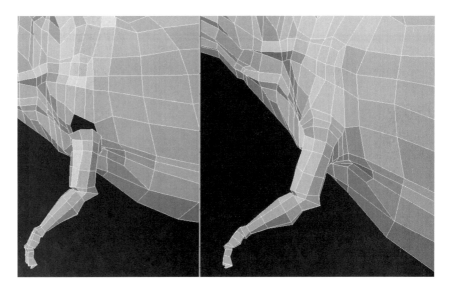

FIGURE 8.34 Connecting the arm.

muscle that connects under the arm and stretches across the back. Make a couple of cuts that travel diagonally from the arm to midway up the back. You will need to do a little polygon rearranging and should end up with something similar to Figure 8.35. This is a subtle bit of detailing, but it does make a difference in the model as a whole.

Moving down the torso, make two more vertical cuts between the shoulder and leg. Also, make a horizontal cut from under the arm to right before the leg, terminating at the triangle there. This will become another fold of skin. Pull the middle vertices of that cut out a bit. (See Figure 8.36.)

Time to give this T-rex a leg or two to stand on. To begin, cleanly arrange the six faces just under the hips. Extrude them out once so the lower edge angles out a bit more than the upper. You want there to be a smooth transition from the hip to the leg as opposed to having the leg look like it was stuck on the side like a plastic toy. While we are here, we can do a tiny bit of polygon cleanup by changing the flow of the two faces up where the leg meets the body. (See Figure 8.37.)

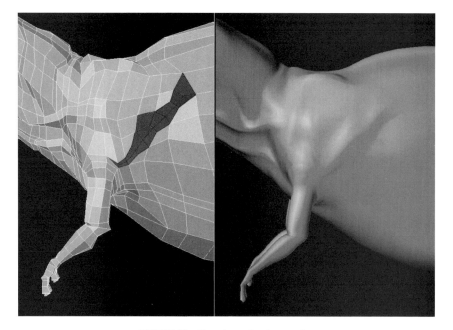

FIGURE 8.35 Creating a back muscle.

FIGURE 8.36 Adding more body detail.

The remaining bulk of the leg will be formed with our friend the spline extrusion. Using the sketch as a guide, create two splines for the front and back of the leg, ending at the toes (Figure 8.38).

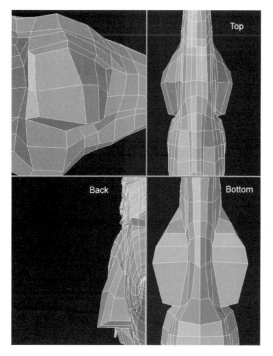

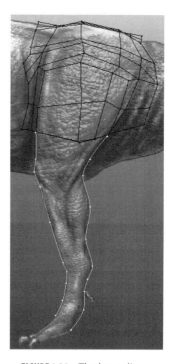

FIGURE 8.37 Starting the legs.

FIGURE 8.38 The leg splines.

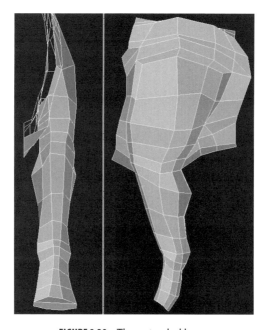

FIGURE 8.39 The extruded legs.

Select the three faces from the underside of the leg extrusion, and extrude those on the spline with twelve segments. While the legs are still light, perform additional modeling to indicate muscles and joints. (See Figure 8.39.) For extra control, make a large vertical cut all the way around the front half of the leg as shown in Figure 8.40.

For better toe separation, we will cut new faces to represent the space between the toes (Figure 8.41). Be sure to carry this around to the back of the foot as well.

And speaking of toes, make them in exactly the same manner as the arms and fingers; start with an eight-sided, eleven-segmented cylinder. Assign a Y-axis cylindrical UV map, then model it into shape. (See Figure 8.42.) Now it is simply a matter of duplicating the toe two more times and attaching it to the foot. Spread and angle the toes and create some size variation (Figure 8.43).

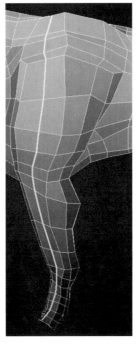

FIGURE 8.40 Make a vertical cut all around the leg.

FIGURE 8.41 Creating toe separation.

FIGURE 8.42 Modeling the toe.

FIGURE 8.43 Attaching the toes.

There is still one more toe we haven't addressed. This is actually considered the first toe, but it is quite small and located at the back of the foot, facing backward. Instead of making a whole new toe here, we can copy a finger and attach it there. Figure 8.44 shows the first toe and also contains another horizontal cut along the ankle joint.

FIGURE 8.44 Attaching the first toe.

The leg can still use some more definition. Perform three horizontal cuts starting from the calf and ending at the knee between each existing row of faces already there. Make another vertical cut starting below the hip and ending midcalf and one half-loop cut around the calf. See Figure 8.45 for where to make these cuts. Make three more vertical cuts, one down the middle of the leg, connecting the two triangles and two more toward the front of the leg starting from the back, going over the hips, and ending above the knee. Lastly, make another horizontal cut just above the knee around the leg. (See Figure 8.46.) Move down again to the foot

FIGURE 8.45 More definition is added to the leg.

FIGURE 8.46 Adding definition cuts.

area and make a loop cut starting just below the ankle and running behind the toes as shown in Figure 8.47. Now that you have all this extra geometry, take the time to work it into shape. Figure 8.48 shows the smooth, subdivided leg so far.

Add four more vertical cuts to the tail for more complex bending should you decide to put bones in it. (See Figure 8.49.) Now add a very long horizontal cut starting from the first third of the tail, running under the leg, along the belly, and ending at the midpoint under the chin (Figure 8.50). This will help sharpen some of the skin fold detail and ease the stress of the faces where the leg meets the body when they subdivide.

In keeping with cutting in detail, add two vertical cuts behind the tail and one across the leg as shown in Figure 8.51. Figure 8.52 shows nine more vertical cuts made to form more wrinkles in the flesh around the tail and belly.

FIGURE 8.47 Defining the foot.

FIGURE 8.48 The smooth, subdivided leg.

FIGURE 8.49 Adding segments to the tail.

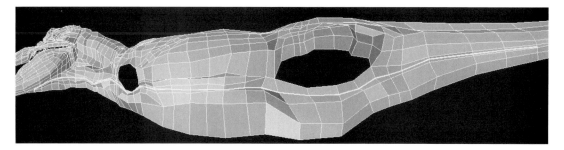

FIGURE 8.50 Adding a long, horizontal cut.

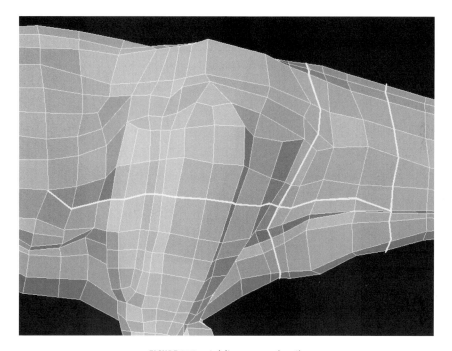

FIGURE 8.51 Adding more detail.

 With all the forms in place, we can really go to town with adding detail. How much detail is too much? Couldn't these folds and wrinkles be added with bump maps? Yes, more detail can be added with bump maps and we will do that. But bump maps are more an illusion of detail; they don't change the actual surface of the model. This is most noticeable as the model turns, the surface contour will not change with a bump map. Light will play much better over modeled detail since it really does exist. Back to the question about how much detail is enough. There will be a point where the model will become unwieldy with too much geometry. Experience and viewing the results in the final output medium, whether that be games,

television, film, or print will help illustrate what works and what doesn't. Time is a factor when working on commercial jobs as to where you should stop, but if you are creating a model for your pleasure or portfolio, experiment to see to what level, and how far you like to take your models.

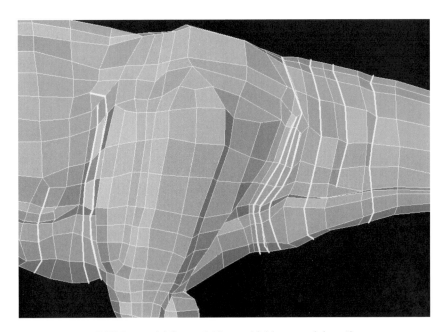

FIGURE 8.52 Adding wrinkles and folds around the tail.

FIGURE 8.53 The claws in place.

One body part we haven't dealt with yet are the claws. By now, you should be familiar with a number of modeling options for these forms, so pick one and give the T-rex the means to really take down another dinosaur. Figure 8.53 shows the feet claws in place. Another part you should be able to model now is a tongue. Fit one into the tooth-lined mouth.

For this tutorial, we will stop modeling and move on to texture creation. That does not mean you have to. Add more detail if you like, or just tweak the geometry that is there. Be sure to view the model from all angles and in different lighting conditions. When you are happy, move on to the next section. Figure 8.54 shows the model so far.

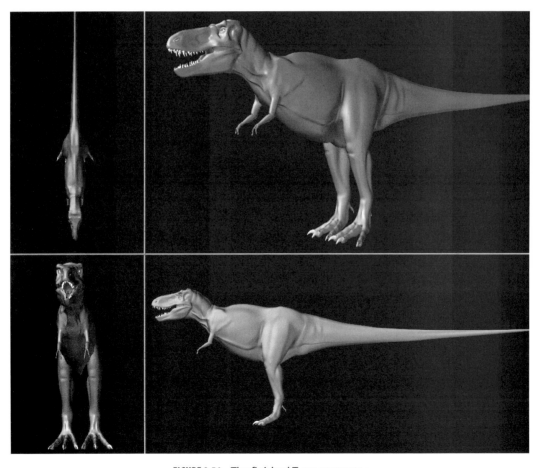

FIGURE 8.54 The finished T-rex geometry.

T-Rex UV Setup

We've taken care of UV maps for certain body parts earlier while modeling. But there are still the body and legs and the issue of arranging them all for optimum painting. So let us get started.

In the triceratops chapter, we created a special "paint model" to facilitate better UV mapping. This was essentially a morph target model that was modeled to fit the chosen UV mapping method, as opposed to making the UV mapping fit the model. We will do something similar for the T-rex.

Although cylindrical mapping is an obvious choice for areas such as the body, it can be tricky to apply it without some distortion. Our T-rex's body, while essentially cylindrical, has several areas of varying widths and thicknesses, which could lead to texture distortion. Planar maps are the easiest to visualize and predict. Not too many models lend themselves to straight planar mapping for obvious reasons. This is where the paint model will come in handy. We are going to alter the model to make it as planar-mapping friendly as we can.

Start by making just the body geometry visible (Figure 8.55). The plan is to apply a planar map along the X-axis. This means we want to get this mesh flatter to allow for minimal texture stretching. This is not just a matter of flattening all the faces to one axis. We want to flatten it in a way that helps maintain polygonal proportions, that is, their size ratio doesn't change drastically. So, in the case of a planar map for this geometry, the model will also get wider.

Figure 8.56 shows the flattened body geometry for the paint model. It wasn't completely flattened; it was flattened just enough

FIGURE 8.55 Making the body geometry visible for UV mapping.

to allow for a clean UV map. Remember to eliminate any overlapping geometry at this point, too. As with all UV mapping, apply a grid or pattern image to the model to find out if there is any unacceptable texture stretching. If there is, go back to the paint model and make adjustments.

The last major parts to map are the legs. Again, a cylindrical map could be made to work, but as with the body, we will employ a planar map—actually, four of them. Although you could flatten the leg mesh as in the body example, we will assign a planar map on four separate axes, each catching the leg front, inside, outside, and back. These map pieces will then be placed together in the UV map window for easy painting. In effect, we will be unrolling the leg geometry as if it were a blanket. This will allow for the least

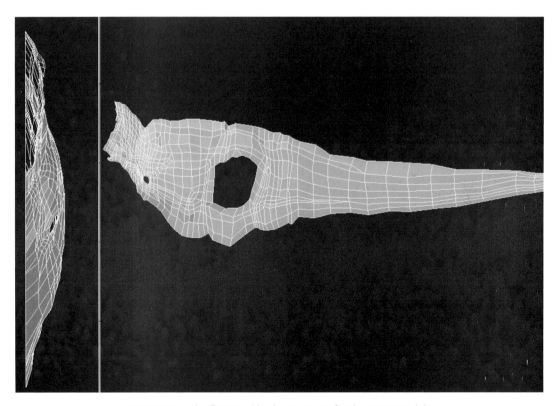

FIGURE 8.56 The flattened body geometry for the paint model.

amount of texture distortion all around the leg. It is a little more work to set up, but the results are worth it.

Start by making just the leg geometry visible. From here, a slightly altered paint model version will be made. Straighten out any sharp curves or bends in the leg, and soften any deep cuts or overhanging geometry. (See Figure 8.57.)

Think about the way the surfaces will be mapped. You will want to select the faces that best represent the perpendicular angle to the mapping axis. You can eyeball this and perform tests by assigning a texture to one axis, then taking note of where the texture starts to fall off and stretch, map just the faces for a particular axis that don't distort. Do this for the front, back, inside, and outside of the leg, which are just the X- and Z-axis. Nothing will be mapped on the Y-axis here. Figure 8.58 shows how the leg was mapped, with colors for demonstration purposes.

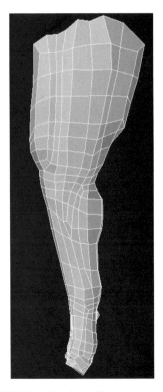

FIGURE 8.57 The altered leg paint model.

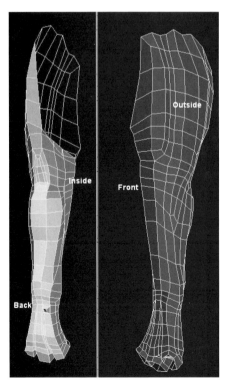

FIGURE 8.58 The leg is broken down into four separate planar maps.

If you have not done so already, assign planar maps to the other body parts such as the teeth, nails, tongue, and inner mouth.

Now that we have all the surfaces, it is time to arrange them in an order that helps with painting. There are a few things we can do to make the process even easier. Take the head, for example. If you recall, we assigned planar maps to three different sections, the head sides, top, and bottom (under the jaw). You should move these pieces close together so when you paint, it will be easy to carry a color or texture over to those adjoining pieces. (See Figure 8.59.)

Wait! We are not done here. There is still more we can do to make painting across these separate surfaces easier. The technique

FIGURE 8.59 The head UV map.

involves lining up the individual vertices and edges on the corresponding parts. Move a part, such as the top of the head, as close as you can to the edge of the faces on the side of the head. Then, carefully adjust the head top mesh so that it lies naturally along the face edge. Some alteration of the mesh shape will be necessary, but as long as it isn't distorted too much there will not be a problem. Do the same for the underside of the jaw faces. (See Figure 8.60.)

A similar process will be applied to the legs, although this area has more pieces. First, line up the front, sides, and back of the leg in the UV map view (Figure 8.61). Much like you did with the

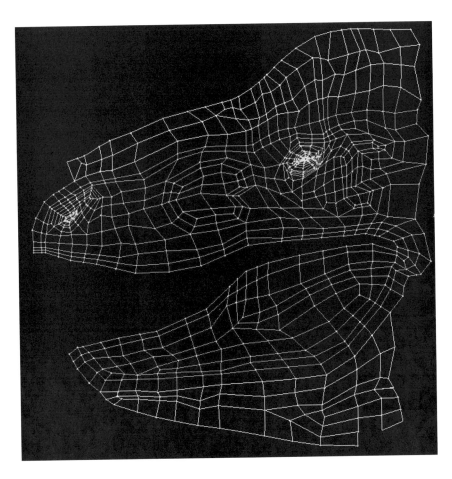

FIGURE 8.60 The altered head UV map.

head, carefully align the various edges of the separate parts, taking care not to distort any one part too much to meet another. When you are done, you will have something similar to Figure 8.62. Now we have only one major seam to match up along the leg as opposed to six.

The rest of the UV mapping layout is handled in much the same way as in previous chapters. In short, you'll want to have as many pieces as possible as proportional to each other as possible. Exceptions are parts such as the teeth, eyes, inner mouth, and nails. The head in this UV map tutorial was also enlarged slightly

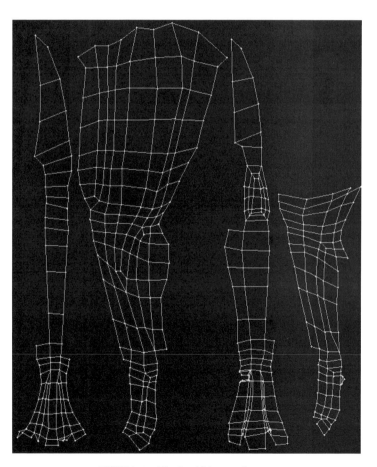

FIGURE 8.61 The leg UV map pieces.

FIGURE 8.62 The adjusted leg UV map.

in comparison to its relationship to the body to allow for a higher level of detail. Figure 8.63 shows the finished UV map layout.

Now that we have our UV map all taken care of, we can go back and add one final bit of modeling—asymmetry. As you know, nothing in nature is perfectly even on both sides of its body. There are always variations, which, in the case of recreating something organic, is what really helps it look less machined. Computers are great for saving work by allowing us to mirror model halves, but we must also go in there and mix things up a bit. The level of asymmetry is up to you, but some key spots to concentrate on are the teeth and neck folds. These are areas that are most likely to be seen from both sides at once.

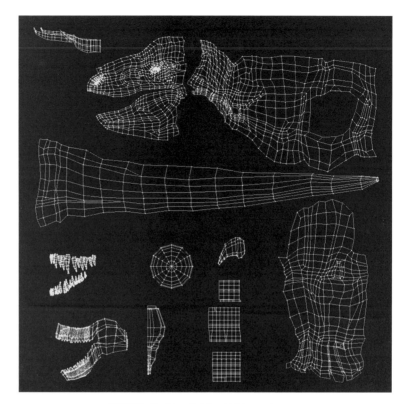

FIGURE 8.63 The finished UV map layout.

Painting the Maps

We will be creating the maps in very much the same way as in the previous chapters. However, for this model, we will take advantage of the ability to layer image maps in the 3D rendering package. Many programs support this. In the triceratops chapter, we used layers in our paint program to have a little more individual control over separate types of detail. The layers were collapsed into one map in the end. This time, we will keep the layers separate and load them individually into the 3D software and layer them there. We will then have the option to adjust each map's strength and blend on its own. That will give us even more control over the outcome. This layering technique will be applied to the bump maps, but you can use it anywhere you see fit.

As always, create a painting template with which to start. The other good quality about making layered maps is that they all don't need to be the same size. Less-detailed maps can be small, thus conserving memory and hard drive space. The philosophy behind the layering technique here is that the maps will define levels of detail ranging from muscles, to thick wrinkles to fine scales. In this example there will be three layers, but you can use more.

We will start with a map that determines details such as the ribs and subtle muscle definition. Keeping in mind your knowledge of the T-rex anatomy, paint a grayscale image that brings out the ribs and a few other muscle forms using broad, wide strokes. No need to get detailed here. Save it out as "Trex_Bump_Layer1." Figure 8.64 shows a portion of the map. The rest of the map didn't contain any data. Do not feel as if you have to cover every inch with some detail of sorts especially at this layer. Rest assured that your model will be highly detailed in the end.

FIGURE 8.64 The first layer bump map.

The next bump map layer will consist of slightly smaller wrinkles than the ones you modeled into the geometry. Here, you can get a bit more detailed, but don't add any extremely fine details such as scales, as they will be reserved for the next layer. See Figure 8.65 for an example of this bump map layer.

Finally, paint the most-detailed bump map that contains all the fine scales and wrinkles. (See Figure 8.66.) You can use any technique you like for making these maps. For this chapter, it is up to you! Of course, you should perform numerous test renders to see how each layer is working and make the necessary adjustments. Figures 8.67 through 8.69 show test renders for each layer.

FIGURE 8.65 The second layer bump map.

FIGURE 8.66 The third layer bump map.

If you have been following the tutorials in this book, then you have a number of options for painting the color map. Figure 8.70 shows the T-rex color map.

We have been creating UV maps that cover both sides of the model at once. This saves space and work involved, but the price to pay is that the model texture is symmetrical, which is something we should avoid when making organic creatures. There are ways to add differences to one side of the model that don't involve painting a whole new side. It usually takes just a slight alteration or detail to help break up a symmetrical map. For instance, what if we gave our T-rex a scar or some scratches on one side of his muzzle? On your model, select the faces on which you want to paint new texture. Then, in the UV window, move those faces off the main map. You should have something similar to Figure 8.71.

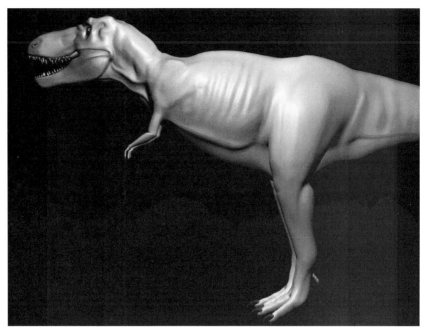

FIGURE 8.67 First layer bump map test render.

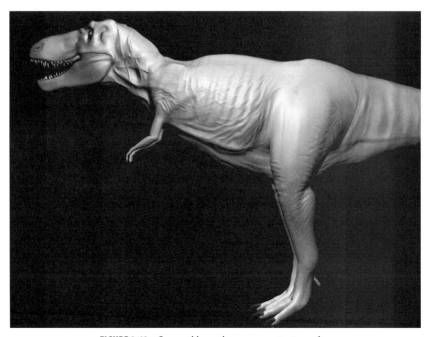

FIGURE 8.68 Second layer bump map test render.

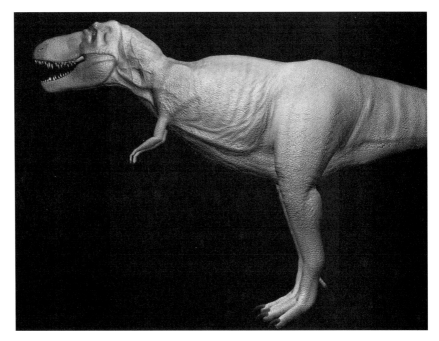

FIGURE 8.69 Third layer bump map test render.

Back in the paint software, copy the texture from that area of the face to the newly sectioned-off piece. This will ensure that the piece matches up texture-wise. Now you can add variations, such as the above-mentioned scars. Figure 8.72 shows the scratches painted in the color map and Figure 8.73 shows how they look on the model. Be sure to perform the same for the bump maps.

 To create asymmetry, you don't have to make radical changes such as scars, but just subtle differences in the natural textures. This can be as simple as adding a few spots here and there. No place are symmetrical textures more apparent than at the midpoint or center of the model where the texture flips and continues on the other half. Making some alterations here will go a long way in breaking that pattern. The above technique can be used to move a section of geometry at the midline. Apply this technique to wherever you want to add variation to the texture. Figure 8.74 shows a section of the belly that has been moved to allow for asymmetrical texture painting.

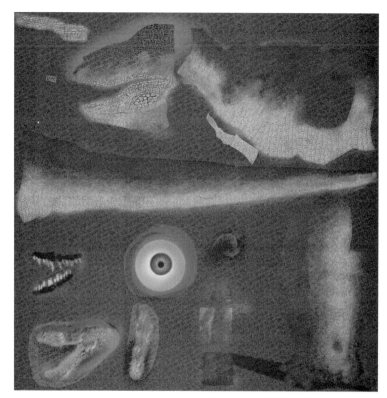

FIGURE 8.70 The T-rex color map.

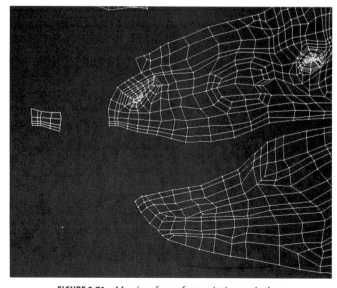

FIGURE 8.71 Moving faces for variation painting.

FIGURE 8.72 Painting in scratches.

FIGURE 8.73 Asymmetrical details are added to the model.

FIGURE 8.74 A section of the belly is moved for asymmetrical painting.

FIGURE 8.75 The finished tyrannosaurus ready to leap off the computer screen.

FIGURE 8.76 The T-rex out for a snack.

Don't forget to add a specularity map. The details of this were covered in the triceratops chapter. It is yet another touch that will help to bring your dinosaur to life.

It looks as though we are ready to turn our tyrannosaurus out into the world. Set him free and then get out of the way. You don't want to be at the receiving end of those jaws (Figure 8.75). As soon as he gets out, he will be on the prowl for a meal (Figure 8.76), but not all dinners come easily (Figure 8.77).

Watch the tyrannosaurus come to life on the "Trex_walk" movie on the CD-ROM

ON THE CD

SUMMARY

Congratulations on getting through this chapter. Here, we put all we have learned into practice, and even added a few more techniques, showing that there is no one way to construct and texture a model.

FIGURE 8.77 The battle for life.

9

WRAPPING IT UP

This wraps up our journey back to an incredible period in Earth's history, and with the amazing animals that existed. Through art, science, and today's digital tools, we can bring the dinosaurs back to life.

The examples in this book represent just a small fraction of the variety and number of dinosaurs that lived. There are plenty more to choose from for your own projects should you decide to look beyond the most popular species. You will find that there are a few basic body types, and with a little finessing, you can get a lot more use out of the models you build. For example, Figure 9.1 shows a brachiosaurus that was quickly created from the apatosaurus mesh shown in Chapter 4. The textures were altered slightly, too.

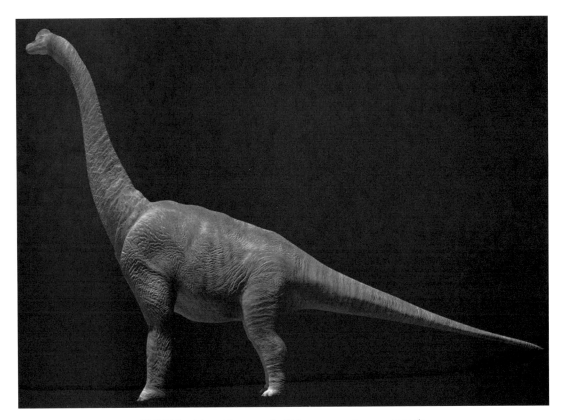

FIGURE 9.1 A brachiosaurus built from an apatosaurus mesh.

Do not hesitate to cannibalize meshes or parts of them to construct totally new dinosaurs. You will have a menagerie in no time.

The exercises in this book have given you a good arsenal of modeling and texturing techniques. Armed with these tools, you can tackle creating any dinosaur, no matter how large or ferocious.

ABOUT THE CD-ROM

The CD-ROM accompanying this book includes the files you need to complete the tutorials. The color images of all the step-by-step figures in the book are arranged by chapter, along with any files needed to complete the tutorials in the book. In addition, there are demos of a few popular programs, and links to other popular software applications that offer free demo versions you may wish to download and try.

DEMOS INCLUDED

In the Eovia folder you will find a full version of Amapi 4.15 and trial editions of Amapi 6.1 and Carrara Studio 1.1.

SYSTEM REQUIREMENTS

To perform the techniques discussed in the book you need the following:

Any Windows 95, ME, 2000, XP, NT or Mac OS based operation systems, QuickTime 4 or higher, and a 3D modeling program that has a strong polygonal tool set. Some examples include: LightWave 3D, Maya, SoftImage XSI, Cinema 4D, Amapi, trueSpace 5, and 3ds max. In addition, an image editing and painting program that supports layers, such as Adobe Photoshop or Procreate Painter, is required.

LINKS TO FREE DOWNLOADS OF POPULAR PROGRAMS

2D Programs

Adobe Photoshop 6 Tryout Version

Adobe® Photoshop® 7.0 software, the professional image-editing standard, helps you work more efficiently, explore new creative options, and produce the highest quality images for print, the Web, and anywhere else. Create exceptional imagery with easier access to file data; streamlined Web design; faster, professional-quality photo retouching; and more.

http://www.adobe.com/products/photoshop/main.html

3D Programs

3ds max

Discreet

3ds max 4 delivers CG professionals advanced tools for character animation, next generation game development, and visual effects production. Numerous key new feature additions and architectural enhancements compliment these three major initiatives, making **3ds max 4** an ideal tool for the 3D animation industry. A highly tuned animation system allows artists to bring their ideas to life with the most advanced tools for modeling and animating characters.

http://www.discreet.com/products/3dsmax/ (select order demo CD)

CINEMA 4D XL or BodyPaint

Maxon Computer

Download a demo version of CINEMA 4D GO, CINEMA 4D ART, CINEMA 4D XL or BodyPaint 3D and Explore MAXON's world. It's a stable, fast paced world of fun.

http://www.maxon.net/index_e.html

LightWave Free Discovery Edition

NewTek

NewTek announced today two options for students who want to learn 3D graphics—the LightWave Free Discovery Edition—a no cost version of LightWave with limited saving and watermarked rendering—and a full-featured educational version of LightWave 3D® available to students for $395US, The software is compatible with both Macintosh and Windows-based computers

http://www.lightwave3d.com/

Maya Personal Learning Edition

Alias/Wavefront

Maya Personal Learning Edition gives 3D graphics and animation students, current industry professionals, and those interested in breaking into the world of computer graphics (CG) an opportunity to explore all aspects of the award winning Maya Complete software in a non-commercial capacity.

http://www.aliaswavefront.com

INDEX